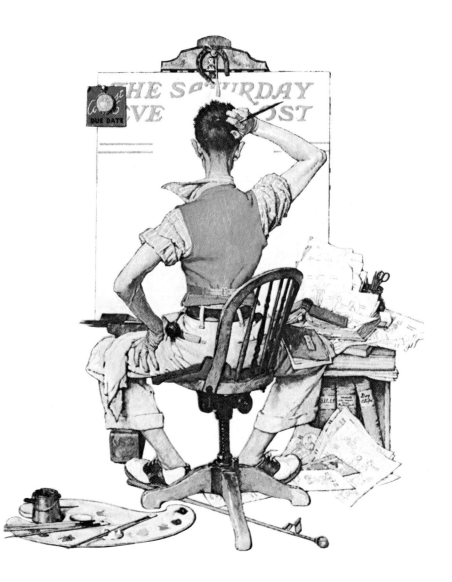

THE SATURDAY EVENING POST Norman Rockwell Book

THE SATURDAY
EVENING POST Norman

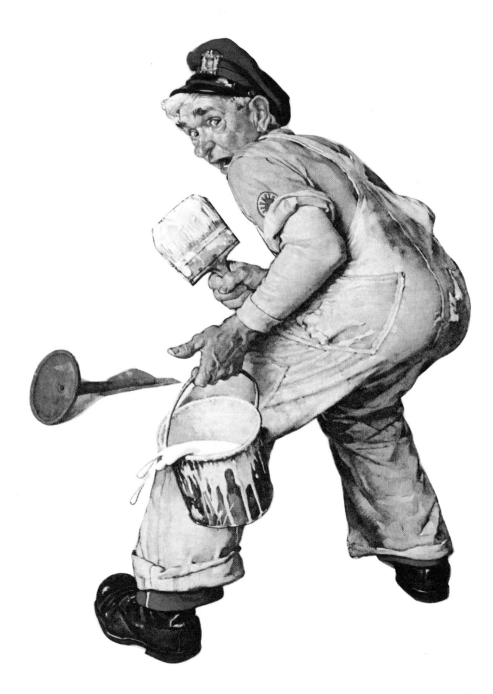

Rockwell Book

BONANZA BOOKS

New York

Contents

This 1986 edition is published by Bonanza Books, distributed by Crown Publishers, Inc., 225 Park Avenue South, New York, New York 10003, by arrangement with The Curtis Publishing Company, Inc.

Manufactured in Italy

Library of Congress Cataloging-in-Publication Data

The Saturday evening post Norman Rockwell book.

1. Rockwell, Norman, 1894-1978. 2. Saturday evening post—Illustrations. I. Rockwell, Norman, 1894-1978. II. Title: Norman Rockwell book.
ND237.R68A4 1986b 759.13 86-17642

ISBN 0-517-62607-1
h g f e d c b a

Words and Pictures - A Scrapbook 57

A scrapbook of excerpts from stories, essays and memoirs by *Post* authors, with Norman Rockwell illustrations.

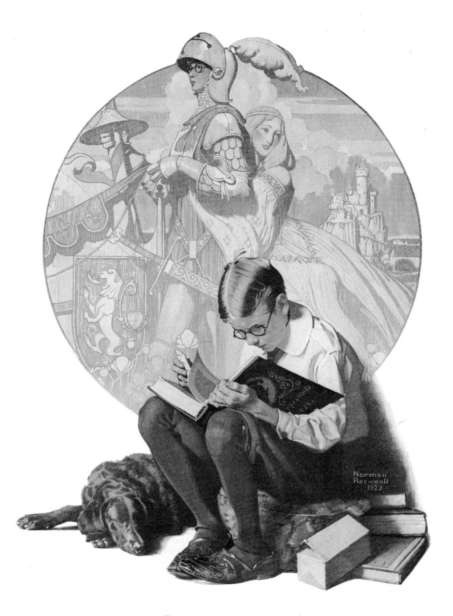

Foreword

A BOOK IS THE GREATEST INVENTION OF MAN. The wheel may take you far, but disappointment invariably meets you there. Memories of locale are dissipated by the sharp edges of experience and reality. But the land to which a book takes us is new, always summer, forever young.

Through a book we share in the eternal spirit of hope and fun that is man's best quality. History may discourage him but it can never keep him down. Its lessons have life. Kindness and fairness exist, naturally, in the human spirit. Books encourage these happy qualities, build mind upon nature.

The first books were books of the spirit. Their intention was to make man's soul happy. This book is a book of hope and fun. It is a machine to use and play with, to learn from, to eat and drink from, to sing from, to create from, to come to know the capability of hands from.

It is illustrated by the work of a man's hand, one Norman Rockwell, the best loved and best known painter in America's history.

He was born in New York City but it was the people he learned from, not the buildings. Rockwell made America home, a comfortable sort of place where Main Street and Fifth Avenue exist in an easy truce and the great and the small have equal-sized emotions, pleasures and pains.

There has never been anyone like him, either as a painter or a thinker of good thoughts. His knowledge of anatomy and situation is exceeded only by his knowledge and affection of the human heart.

This book is for families and people in love. For people who like Norman Rockwell. For rainy days and perfect, cloudless-sky days. For long winter evenings before the fire.

Make a quilt. Play marbles, croquet. Look up your family tree. Eat, drink. And be merry.

STARKEY FLYTHE, JR.

Norman Rockwell and the POST

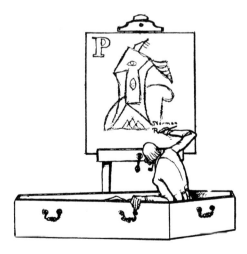

Norman Rockwell and the POST

NORMAN ROCKWELL was born February 3, 1894, in a Manhattan brownstone. His father was a New York textile company executive who sometimes copied drawings for his own amusement. His mother was a chronic invalid; her father had been a not-very-successful artist sometimes reduced to painting houses.

There were just two children. The elder son, Jarvis, was a strapping athlete; Norman was small for his age and he had to wear eyeglasses and corrective shoes. Fortunately the boy had teachers who encouraged him to develop his talent for drawing. By the time he was 14 he was making weekly trips from Mamaroneck, where the family lived then, to New York City for art classes. He dropped out of high school in the middle of his sophomore year to attend art school full time. Evenings he served as a non-singing "spear carrier" at the Metropolitan Opera, work that he found easy and pleasant except for one time when he was expected to lift an overweight soprano larger than he was. By the time he was 18 jobs of this kind were no longer necessary; Rockwell was a full-time professional, supporting himself as an illustrator of children's books and magazines.

The story of his long and fruitful relationship with *The Saturday Evening Post* began in 1916 when the painter was barely 22. He tells the story himself in *My Adventures as an Illustrator*, which appeared in the *Post* in 1960.

Portrait of the artist, by a 19-year-old Illinois painter whose style is much like Rockwell's own.

Robert
Charles
Howe

I had a secret ambition: a cover on *The Saturday Evening Post*. In those days the cover of the *Post* was the greatest show window in America for an illustrator. If you did a cover for the *Post* you had arrived.

But I was scared. I used to sit in the studio with a copy of the *Post* laid across my knees. "Must be two million people look at that cover," I'd say to myself. "At least. Probably more. Two million subscribers and then their wives, sons, daughters, aunts, uncles, friends. Wow! All looking at my cover." And then I'd conjure up a picture of myself as a famous illustrator and gloat over it, putting myself in various happy situations: surrounded by admiring females, deferred to by office flunkies at the magazines, wined and dined by the editor of the *Post*, Mr. George Horace Lorimer.

But the minute I thought of that name the spunk and dreams got soft and rotten. Mr. George Horace Lorimer had built the *Post* from a two-bit family journal with a circulation in the hundreds to an influential mass magazine with a circulation in the millions. He was THE GREAT MR. GEORGE HORACE LORIMER, the baron of publishing. What if he didn't like my work? I'd think. Supposing he denounced me as an instance of incompetence, banished me. He's got a lot of influence. I'd go down, down, down. The kids' magazines would drop me, then the dime novels and pulps would refuse to use me; I'd end up doing the

Norman
Rockwell

"A great actor," Rockwell said of Billy Paine who posed three times for this, the first of the artist's Post *covers. (1916)*

wrappers for penny candies. And visions of a pale starving wretch with a huge Adam's apple lying in a flophouse on the Bowery would rise in my boiling brain.

Well, one day as I was mentally rolling on my lousy cot in the flophouse Clyde came into the studio and asked me what in God's name made me moan so. I hemmed and hawed but finally told him. "Why don't you do a cover and show it to them?" he said. Oh, I was scared; maybe they'd reject it; THE GREAT MR. GEORGE HORACE LORIMER was tough. "For Lord's sake,"

shouted Clyde, "stop chewing on your tongue and do a cover. What the hell, you're as good as anybody. Lorimer's not the Dalai Lama." Then he set himself to encouraging me, convincing me I was good, the *Post* and Mr. Lorimer would love my work. Finally he extracted a promise from me that I'd think up some ideas for *Post* covers and do at least one of them during the next two weeks while he was away.

I had had my ideas ready for a long time; all I'd needed was the push Clyde gave me. I set to work the next morning on a painting of a handsome Gibson man

in evening dress leaning over the back of a sofa to kiss a gorgeous Gibson Girl in evening dress seated on the sofa. High Society, just the sort of thing the *Post* was using at that time. The next day I left that painting to start another: a beautiful ballerina curtsying before a great curtain in the glare of a spotlight. Two weeks later when Clyde returned, I had both of them nearly finished. I was pretty well pleased with myself.

"C-R-U-D, crud," he said on seeing them. "Terrible. Awful. Hopeless. You can't do a beautiful seductive woman. She looks like a tomboy who's been scrubbed with a rough washcloth and pinned into a new dress by her mother. Give it up." Then he snatched up one of the illustrations I'd just completed for a story in *Boys' Life*. "Do that," said Clyde. "Do what you're best at. Kids. Just adapt it to the *Post*. Hell, they don't want warmed-over Gibson. If they take your stuff it'll havta be good. And you're a terrible Gibson, but a pretty good Rockwell." (I didn't start the vogue for *Post* covers of kids, Clyde Forsythe did.)

So I junked the girl on the sofa and the ballerina, called in Billy Paine, and set to work. I thought up six or seven ideas: two boys in baseball uniforms scoffing at another boy who was dressed in his Sunday suit and pushing a baby carriage; a kids' circus, one kid in long underwear as a strong man, another in a top hat as barker, others as spectators, etc. I made finished paintings in black, white, and red of the two ideas I've described and rough sketches of three others.

Meanwhile I'd been making other preparations for my trip to Philadelphia to see the editors of *The Saturday Evening Post*. I purchased a new suit—gray herringbone tweed, I remember—and a new hat—black and conservative. But the big problem was how to carry my pictures. Usually when I went to see an editor I tied up my paintings and sketches with brown paper and twine. It made a neat package. But after I'd shown my work to the editor I had to rewrap. That was the fly in

the butter, because the paper would get frayed and rumpled and the string snarled. And while I struggled with the pictures, paper, and string the editor would have to wait, making exasperated and sporadic attempts to help me or just fuming and rustling the papers on his desk. I felt it would be bad business to keep the great Mr. George Horace Lorimer waiting; I wanted everything to go smoothly.

So I went to a harness maker in New Rochelle and asked him to make me a suitcase. "I want it big," I told him. "Oh, about thirty by forty inches and a foot wide. And as inconspicuous as possible; I guess black would be best." He followed my instructions conscientiously and when he brought it around to the studio it was long, thick, tall, and *all black*—even the little gadgets which kept the lid closed were painted black. It was, bluntly speaking, a gruesome affair, but just what I wanted and I was satisfied.

So one cold morning in March of 1916 I set out for Philadelphia and the *Post* (and Mr. Lorimer, though I tried not to think of that). The trip didn't begin auspiciously. When I tried to board the subway at Grand Central to go to Penn Station, "Here," said a guard, pointing to my suitcase, "you can't go on the subway with that thing in the rush. You'll have to wait." So I tried the el, but a guard stopped me, saying: "Not until after rush hour, young man. You'd be takin' a place from three men or five children with that black box of yours." So I walked to Penn Station.

As I sidled up the broad steps of the Curtis Publishing Company building—white marble gleaming and sparkling in the sun, imposing, magnificent—all I could think of was what Adelaide Klenke had told me once. "Norman," she'd said, "you have the eyes of an angel and the neck of a chicken." I could feel my Adam's apple sink beneath my collar. Maybe I'd better work on the paintings some more. Then I thought of Clyde— *"You mean you didn't even go into the office?"*

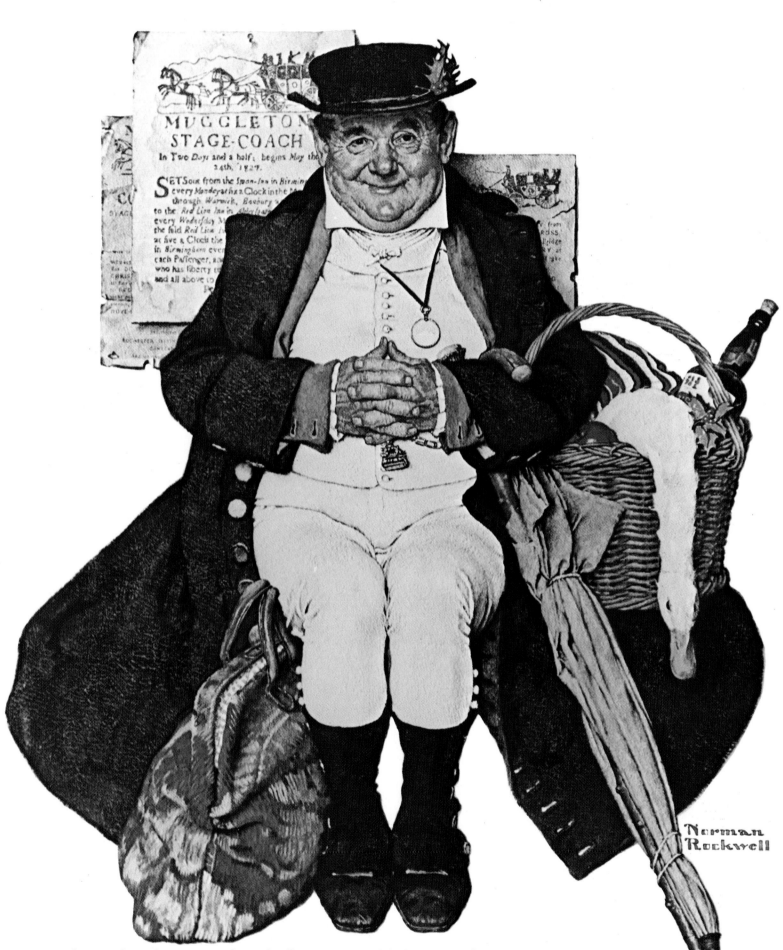

Character by Dickens, painting by Rockwell. This was one of the last "costume" pictures to appear on the Post. *(1938)*

7

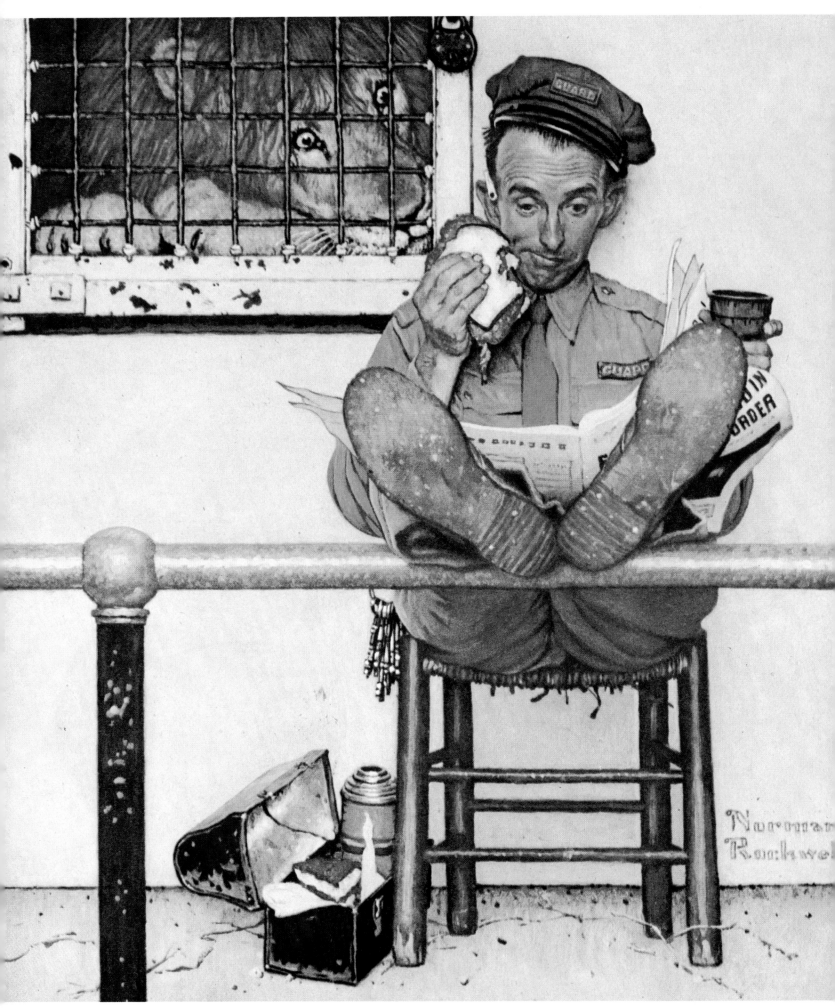

The contemporary setting and gentle humor of this 1954 Post cover make it typical of the postwar period.

I asked the receptionist which floor Mr. Lorimer's office was on. Sixth. "Hold on," said the elevator attendant, pointing at my box. "You can't bring that in here. Take the freight elevator. Outside the building and around the corner to your left." So I entered the anteroom of the editorial offices by the back door.

When I asked to see Mr. Lorimer (I hadn't called for an appointment; I was afraid he'd refuse to see me), the receptionist asked me why. I explained and she said she'd call Walter M. Dower, the art editor, and would I please sit down. I did, thinking, "The eyes of an angel and the neck of a chicken."

There were two men walking around the reception room. The secretary had greeted them as Mr. Cobb and Mr. Blythe. Lord, I thought, it must be Irvin S. Cobb and Samuel G. Blythe, the famous writers. Pretty soon Mr. Cobb came over to where I was sitting, stared quizzically at my box, tapped it lightly with his fist, and listened intently. Then he looked at me and walked back to Mr. Blythe. They put their heads together and discussed something in whispers. Mr. Blythe came over and examined my box.

The discussion continued.

Finally Mr. Cobb said to me, "Young man, will you answer a question?" "Oh yes, Mr. Cobb," I said (I was very impressed at seeing him). "Tell me," he said very solicitously, looking hard at my box, "is the body in there now?"

Mr. Dower showed my paintings and sketches to Mr. Lorimer and brought back word that Mr. Lorimer was pleased, would accept the two finished paintings, and had okayed the three sketches for future *Post* covers. He added that I was to receive seventy-five dollars for each cover. (WOW!)

I went down on the *passenger* elevator and strode like a conquering hero across the marble steps. I was elated. A cover on the *Post! Two* covers on the *Post*. Seventy-five dollars for one painting. An audience of

two million! I had arrived. All my problems were solved: I would live in ease, comfort, and distinction for the rest of my life. As I crossed a grating in the sidewalk, blissfully contemplating my success, I happened to look down and for a moment I thought I was walking on air.

In the years that followed Norman Rockwell painted more than 300 covers for the *Post*, superlative examples of an art form that has certain built-in limitations. A painting that is to appear on a magazine cover must relate to the size and shape of the magazine. It must not obscure the magazine's name, date, price, and so on. The painting must be meaningful and pleasing to a vast number of people and offend no one—or as few as possible. It must be instantly understandable without a title or caption. It may amuse, edify or inspire, but it must do so at first glance. No one will take time to puzzle out the meaning of an obscure picture.

The first Rockwell *Post* cover appeared in 1916, the last in 1971. During those years the world changed, public taste changed, and the magazine itself changed. The early covers, painted when the artist was a very young man, feature mostly children, awkward adolescents and dogs involved in humorous situations. During the middle period of the '20s and '30s many portrayed romantic historical figures. After 1940 all the subjects are contemporary; many portray children but the viewpoint is that of an adult. The early covers show cut-out figures on a white background, while the later ones (during and after World War II) include an often-elaborate painted background. Among the later covers are a series of portraits of world leaders: John Kennedy, Nehru, Nasser, Adlai Stevenson and others. There is even a portrait of Rockwell himself, at his easel (page i).

Which is the greatest of all the Norman Rockwell

Post covers? Long-time Post editor Ben Hibbs claimed "Homecoming Soldier" (page 11) as his favorite; he once called it the greatest magazine cover ever published. Art Editor Ken Stuart preferred "The Gossips," a 1948 cover that showed many different people hearing, and passing on, an interesting bit of news. "The Doctor and the Doll" (page 45) is the all-time favorite of the general public.

Many of the paintings that have proved enduringly popular portray poignant moments most adults have experienced at some time in their lives— taking a girl to the prom, applying for a marriage license, seeing a son off to college or bringing a daughter home from summer camp. The settings—barber shop, doctor's office, railroad station—show a small-town America most adults have known, at least during summer vacations. Here is the familiar, but always a little nicer than it was in real life. Rockwell himself has said that the world he painted was an idealized one.

"I sometimes think we paint to fulfill ourselves and our lives, to supply the things we want and don't have," he wrote in his autobiography. "I knew a real country yokel in art school. Five years later I met him again. He wore spats, carried a cane, and kept his black derby on when he painted. He had become a famous fashion illustrator and cosmopolite.

"Maybe as I grew up and found that the world wasn't the perfectly pleasant place I had thought it to be I unconsciously decided that, even if it wasn't an ideal world, it should be and so painted only the ideal aspects of it—pictures in which there were no drunken slatterns of self-centered mothers, in which, on the contrary, there were only Foxy Grandpas who played baseball with the kids and boys fished from logs and got up circuses in the back yard. If there was sadness in this created world of mine, it was a pleasant sadness. If there were problems, they were humorous problems. The people in my pictures aren't mentally ill or deformed. The situations they get into are commonplace, everyday situations, not the agonizing crises and tangles of life."

Real world or not, it is a wonderful world and America loves it.

Magazine covers are ephemeral things, appearing one week and disappearing the next, except for a few preserved in bound volumes on library shelves. Most magazine covers, that is. The Rockwell Post covers have acquired a life of their own and they will be with us for a long, long time.

Historians a thousand years from now will be able to learn a great deal about what life was like in the United States in the twentieth century from studying these warm, human impressions by an artist who obviously loved his subjects.

Steve Allen

Some of us grew up thinking that Uncle Sam's real name was Norman Rockwell: I still do.

Paul Harvey

Norman Rockwell is forever a part of American innocence, which in turn is also the indestructible dead center of the American soul and character.

William Saroyan

Norman Rockwell's covers on The Saturday Evening Post *were always exciting to me as a child because so many of the situations depicted echoed happy and festive situations in our own family life.*

Beverly Sills

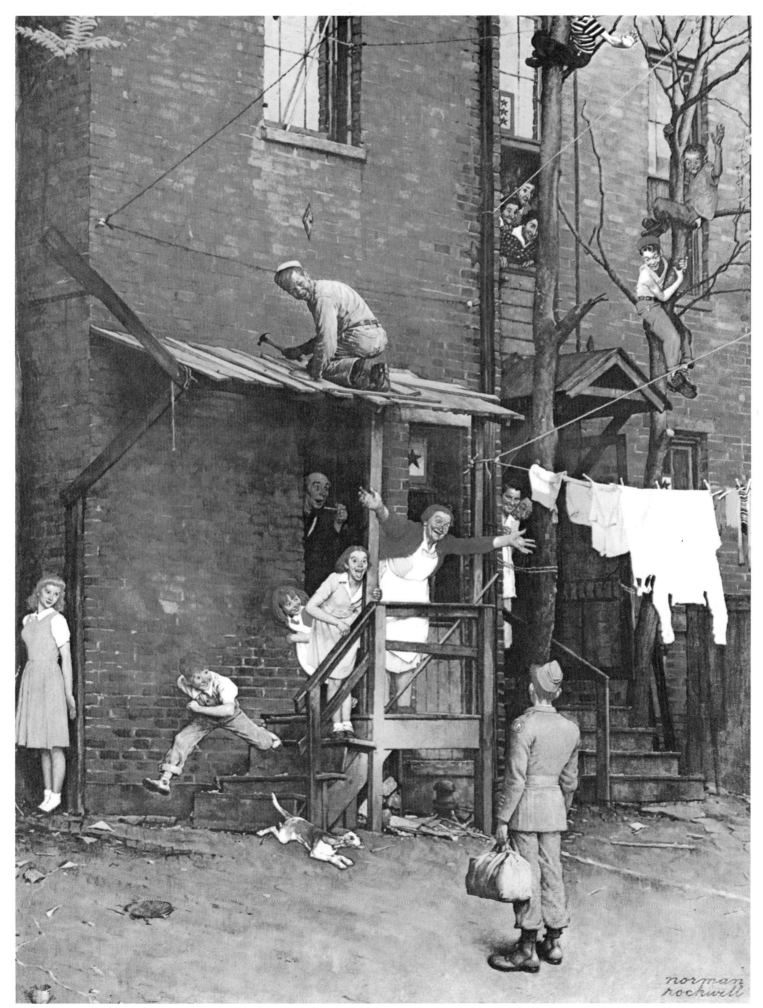

Post Editor Ben Hibbs called "Homecoming Soldier" (1945) the greatest magazine cover ever published; he hung the original over his desk.

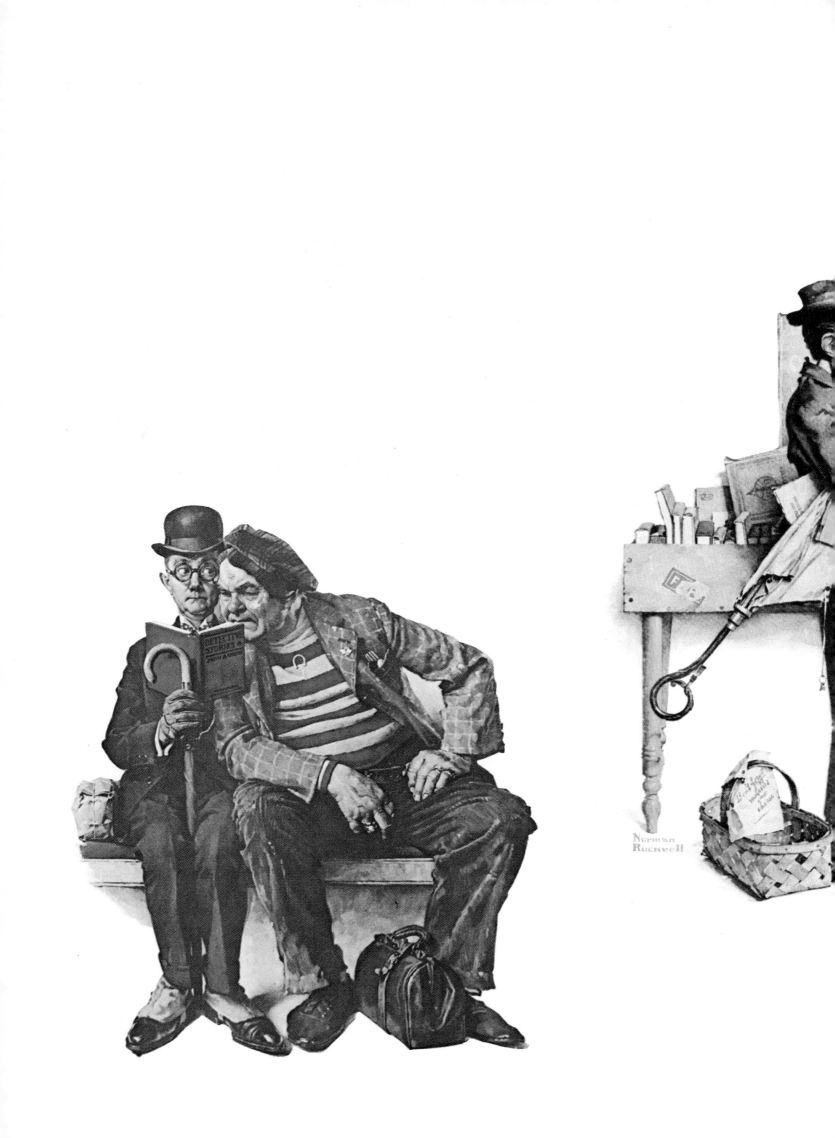

Things to Read

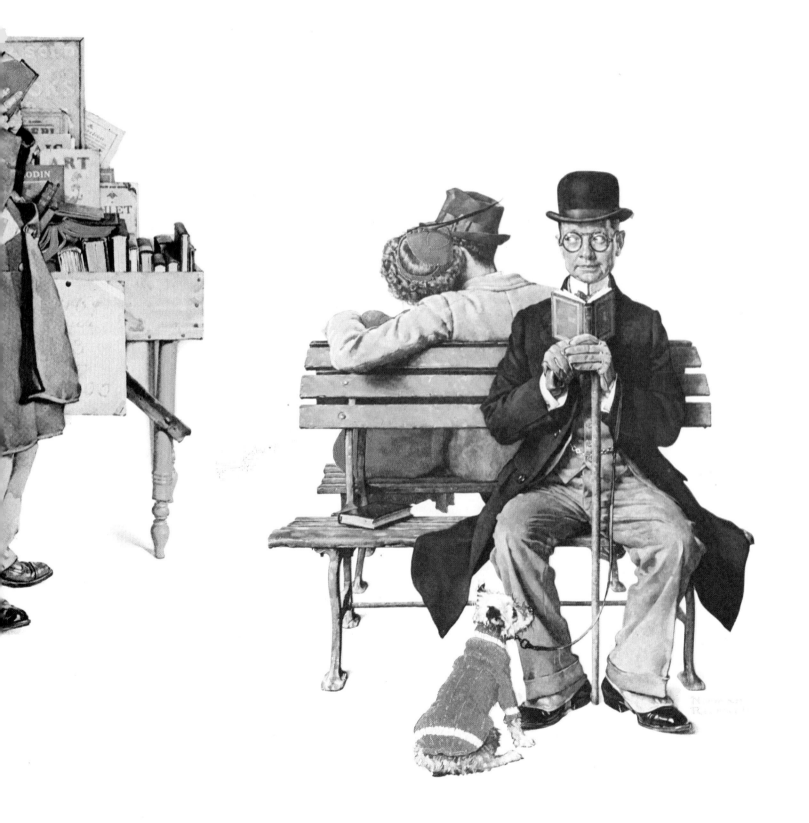

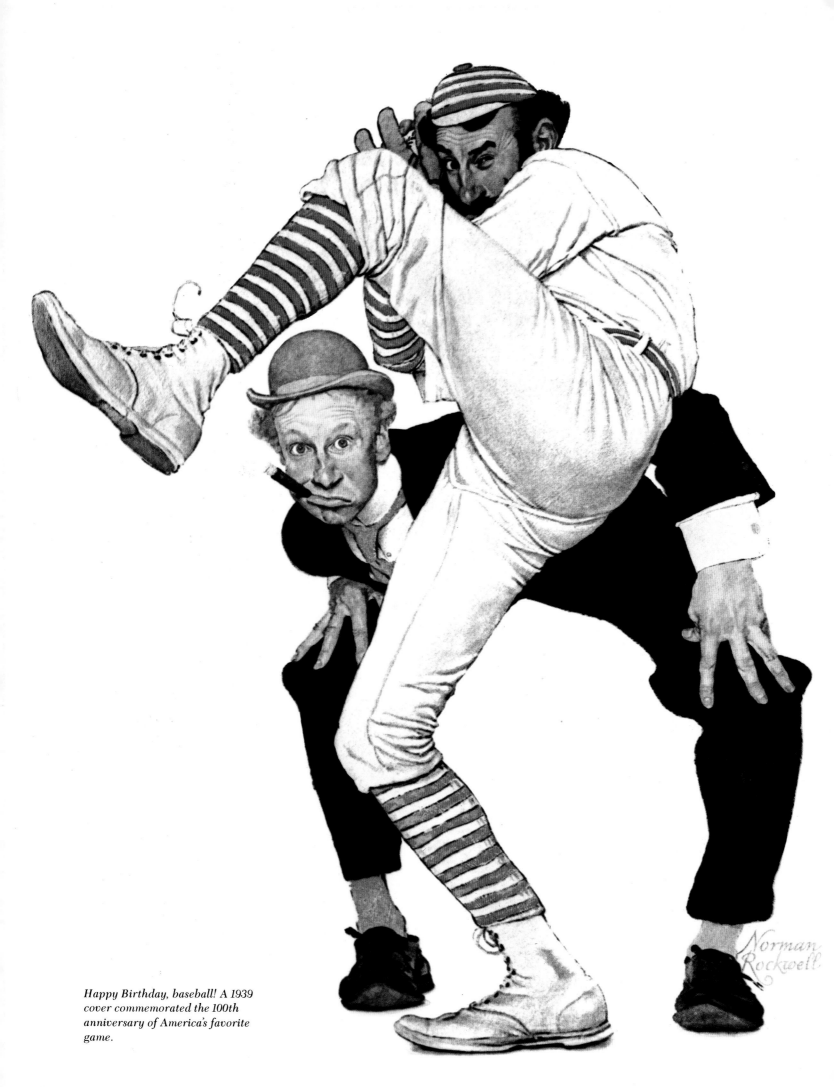

Happy Birthday, baseball! A 1939 cover commemorated the 100th anniversary of America's favorite game.

14

James Thurber
You Could Look It Up

IT ALL BEGUN when we dropped down to C'lumbus, Ohio, from Pittsburgh to play a exhibition game on our way out to St. Louis. It was gettin' on into September, and though we'd been leadin' the league, by six, seven games most of the season, we was now in first place by a margin you could 'a' got it into the eye of a thimble, bein' only a half a game ahead of St. Louis. Our slump had given the boys the leapin' jumps, and they was like a bunch a old ladies at a lawn fete with a thunderstorm comin' up, runnin' around snarlin' at each other, eatin' bad and sleepin' worse, and battin' for a team average of maybe .186.

Half the time nobody'd speak to nobody else, without it was to bawl 'em out.

Squawks Magrew was managin' the boys at the time, and he was darn near crazy. They called him "Squawks" 'cause when things was goin' bad he lost his voice, or perty near lost it, and squealed at you like a little girl you stepped on her doll or somethin'. He yelled at everybody and wouldn't listen to nobody, without maybe it was me. I'd been trainin' the boys for ten year, and he'd take more lip from me than from anybody else. He knowed I was smarter'n him, anyways, like you're goin' to hear.

This was thirty, thirty-one year ago; you could look it up, 'cause it was the same year C'lumbus decided to call itself the Arch City, on account of a lot of iron arches with electric-light bulbs into 'em which stretched acrost High Street. Thomas Albert Edison sent 'em a telegram, and they was speeches and maybe even President Taft opened the celebration by pushin' a button. It was a great week for the Buckeye capital, which was why they got us out there for this exhibition game.

Well, we just lose a double-header to Pittsburgh, 11 to 5 and 7 to 3, so we snarled all the way to C'lumbus, where we put up at the Chittaden Hotel, still snarlin'. Everybody was tetchy, and when Billy Klinger took a sock at Whitey Cott at breakfast, Whitey threw marmalade all over his face.

"Blind each other, whatta I care?" says Magrew. "You can't see nothin' anyways."

C'lumbus win the exhibition game, 3 to 2, whilst Magrew set in the dugout, mutterin' and cursin' like a fourteen-year-old Scotty. He bad-mouthed everybody on the ball club and he bad-mouthed everybody offa the ball club, includin' the Wright brothers, who, he claimed, had yet to build a airship big enough for any of our boys to hit it with a ball bat.

"I wisht I was dead," he says to me. "I wisht I was in heaven with the angels."

I told him to pull hisself together, 'cause he was drivin' the boys crazy, the way he was goin' on, sulkin' and bad-mouthin' and whinin'. I was older'n he was and smarter'n he was, and he knowed it. I was ten times smarter'n he was about this Pearl du Monville, first time I ever laid eyes on the little guy, which was one of the saddest days of my life.

Now, most people name of Pearl is girls, but this Pearl du Monville was a man, if you could call a fella a man who was only thirty-four, thirty-five inches high. Pearl du Monville was a midget. He was part French and part Hungarian, and maybe even part Bulgarian or somethin'. I can see him now, a sneer on his little pushed-in pan, swingin' a bamboo cane and smokin' a big cigar. He had a gray suit with a big black check into it, and he had a gray felt hat with one of them rainbow-colored hatbands onto it, like the young fellas wore in them days. He talked like he was talkin' into a tin can, but he didn't have no foreign accent. He might 'a' been fifteen or he might 'a' been a hunderd, you couldn't tell. Pearl du Monville.

After the game with C'lumbus, Magrew headed straight for the Chittaden bar—the train for St. Louis wasn't goin' for three, four hours—and there he set, drinkin' rye and talkin' to this bartender.

Batter Up!—a sequence from Day in the Life of a Boy, *the May 24, 1952 cover. The model was 10-year-old Charles Marsh, Jr.*

"How I pity me, brother," Magrew was tellin' this bartender. "How I pity me." That was alwuz his favorite tune. So he was settin' there, tellin' this bartender how heartbreakin' it was to be manager of a bunch a blindfolded circus clowns, when up pops this Pearl du Monville outa nowheres.

It give Magrew the leapin' jumps. He thought at first maybe the D.T.'s had come back on him; he claimed he'd had 'em once, and little guys had popped up all around him, wearin' red, white and blue hats.

"Go on, now!" Magrew yells. "Get away from me!"

But the midget clumb up on a chair acrost the table from Magrew and says, "I seen that game today, Junior, and you ain't got no ball club. What you got there, Junior," he says, "is a side show."

"Whatta ya mean, 'Junior'?" says Magrew, touchin' the little guy to satisfy hisself he was real.

"Don't pay him no attention, mister," says the bartender. "Pearl calls everybody 'Junior,' 'cause it alwuz turns out he's a year older'n anybody else."

"Yeh?" says Magrew. "How old is he?"

"How old are you, Junior?" says the midget.

"Who, me? I'm fifty-three," says Magrew.

"Well, I'm fifty-four," says the midget.

Magrew grins and asts him what he'll have, and that was the beginnin' of their beautiful friendship, if you don't care what you say.

Pearl du Monville stood up on his chair and waved his cane around and pretended like he was ballyhooin' for a circus. "Right this way, folks!" he yells. "Come on in and see the greatest collection of freaks in the world! See the armless pitchers, see the eyeless batters, see the infielders with five thumbs!" and on and on like that, feedin' Magrew gall and handin' him a laugh at the same time, you might say.

You could hear him and Pearl du Monville hootin' and hollerin' and singin' way up to the fourth floor of the Chittaden, where the boys was packin' up. When it

come time to go to the station, you can imagine how disgusted we was when we crowded into the doorway of that bar and seen them two singin' and goin' on.

"Well, well, well," says Magrew, lookin' up and spottin' us. "Look who's here. . . . Clowns, this is Pearl du Monville, a monseer of the old, old school. . . . Don't shake hands with 'em, Pearl, 'cause their fingers is made of chalk and would bust right off in your paws," he says, and he starts guffawin' and Pearl starts titterin' and we stand there givin' 'em the iron eye, it bein' the lowest ebb a ball-club manager'd got hisself down to since the national pastime was started.

Then the midget begun givin' us the ballyhoo. "Come on in!" he says, wavin' his cane. "See the legless base runners, see the outfielders with the butter fingers. Come in and see the southpaw with the arm of a little chee-ild!"

Then him and Magrew begun to hoop and holler and nudge each other till you'd of thought this little guy was the funniest guy than even Charlie Chaplin. The fellas filed outa the bar without a word and went on up to the Union Depot, leavin' me to handle Magrew and his newfound crony.

Well, I got 'em outa there finely. I had to take the little guy along, 'cause Magrew had a holt onto him like a vise and I couldn't pry him loose.

"He's comin' along as masket," says Magrew, holdin' the midget in the crouch of his arm like a football. And come along he did, hollerin' and protestin' and beatin' at Magrew with his little fists.

"Cut it out, will ya, Junior?" the little guy kept whinin'. "Come on now, leave a man loose, will ya, Junior?"

But Junior kept a holt onto him and begun yellin', "See the guys with the glass arm, see the guys with the cast-iron brains, see the fielders with the feet on their wrists!"

So it goes, right through the whole Union Depot,

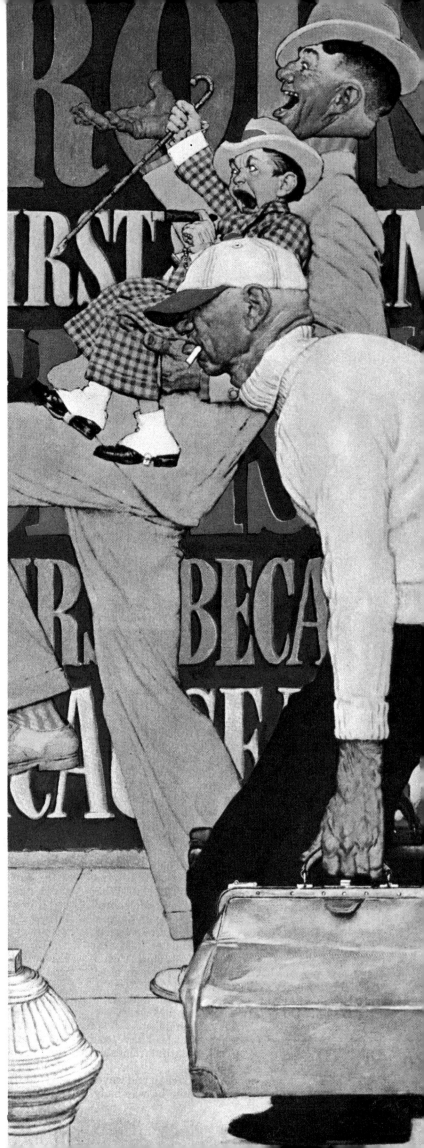

with people starin' and catcallin', and he don't put the midget down till he gets him through the gates.

"How'm I goin' to go along without no toothbrush?" the midget asts. "What'm I goin' to do without no other suit?" he says.

"Doc here," says Magrew, meanin' me—"doc here will look after you like you was his own son, won't you, doc?"

I give him the iron eye, and he finely got on the train and prob'ly went to sleep with his clothes on.

This left me alone with the midget. "Lookit," I says to him. "Why don't you go on home now? Come mornin', Magrew'll forget all about you. He'll prob'ly think you was somethin' he seen in a nightmare maybe. And he ain't goin' to laugh so easy in the mornin', neither," I says. "So why don't you go on home?"

"Nix," he says to me. "Skiddoo," he says, "twenty-three for you," and he tosses his cane up into the vestibule of the coach and clam'ers on up after it like a cat. So that's the way Pearl du Monville come to go to St. Louis with the ball club.

I seen 'em first at breakfast the next day, settin' opposite each other; the midget playin' Turkey in the Straw on a harmonium and Magrew starin' at his eggs and bacon like they was a uncooked bird with its feather still on.

"Remember where you found this?" I says, jerkin' my thumb at the midget. "Or maybe you think they come with breakfast on these trains," I says, bein' a good hand at turnin' a sharp remark in them days.

The midget puts down the harmonium and turns on me. "Sneeze," he says; "your brains is dusty." Then he snaps a couple drops of water at me from a tumbler. "Drown," he says, tryin' to make his voice deep.

Now, both them cracks is Civil War cracks but you'd of thought they was brand new and the funniest than any crack Magrew'd ever heard in his whole life. He started hoopin' and hollerin', and the midget started

"See the guys with the glass arm, with the cast-iron brains!"
Rockwell illustrated this story for the Post *in 1941.*

hoopin' and hollerin', so I walked on away and set down with Bugs Courtney and Hank Metters, payin' no attention to this weakminded Damon and Phidias acrost the aisle.

Well, sir, the first game with St. Louis was rained out, and there we was facin' a double-header next day. Like maybe I told you, we lose the last three double-headers we play, makin' maybe twenty-five errors in the six games, which is all right for the intimates of a school for the blind, but is disgraceful for the world's champions. It was too wet to go to the zoo, and Magrew wouldn't let us go to the movies, 'cause they flickered so bad in them days. So we just set around, stewin' and frettin'.

One of the newspaper boys come over to take a pitture of Billy Klinger and Whitey Cott shakin' hands—this reporter'd heard about the fight—and whilst they was standin' there, toe to toe, shakin' hands, Billy give a back lunge and a jerk, and throwed Whitey over his shoulder into a corner of the room, like a sack a salt. Whitey come back at him with a chair, and Bethlemen broke loose in that there room. The camera was tromped to pieces like a berry basket. When we finely got 'em pulled apart, I heard a laugh, and there was Magrew and the midget standin' in the door and givin' us the iron eye.

"Wrasslers," says Magrew, cold-like, "that's what I got for a ball club, Mr. Du Monville, wrasslers—and not very good wrasslers at that, you ast me."

"A man can't be good at everythin'," says Pearl, "but he oughta be good at somethin'."

This sets Magrew guffawin' again, and away they go, the midget taggin' along by his side like a hound dog and handin' him a fast line of so-called comic cracks.

When we went out to face that battlin' St. Louis club in a double-header the next afternoon, the boys was jumpy as tin toys with keys in their back. We lose the first game, 7 to 2, and are trailin', 4 to 0, when the second game ain't but ten minutes old. Magrew set there like a stone statue, speakin' to nobody. Then, in their half a the fourth, somebody singled to center and knocked in two more runs for St. Louis.

That made Magrew squawk. "I wisht one thing," he says. "I wisht I was manager of a old ladies' sewin' circus 'stead of a ball club."

"You are, Junior, you are," says a familyer and disagreeable voice.

It was that Pearl du Monville again, poppin' up outa nowheres, swingin' his bamboo cane and smokin' a cigar that's three sizes too big for his face. By this time we'd finely got the other side out, and Hank Metters slithered a bat acrost the ground, and the midget had to jump to keep both his ankles from bein' broke.

I thought Magrew'd bust a blood vessel. "You hurt Pearl and I'll break your neck!" he yelled.

Hank muttered somethin' and went on up to the plate and struck out.

We managed to get a couple runs acrost in our half a the sixth, but they come back with three more in their half a the seventh, and this was too much for Magrew.

"Come on, Pearl," he says. "We're gettin' outa here."

"Where you think you're goin'?" I ast him.

"To the lawyer's again," he says cryptly.

"I didn't know you'd been to the lawyer's once, yet," I says.

"Which that goes to show how much you don't know," he says.

With that, they was gone, and I didn't see 'em the rest of the day, nor know what they was up to, which was a God's blessin'. We lose the nightcap, 9 to 3, and that puts us into second place plenty, and as low in our mind as a ball club can get.

The next day was a horrible day, like anybody that lived through it can tell you. Practice was just over and the St. Louis club was takin' the field, when I hears this strange sound from the stands. It sounds like the ner-

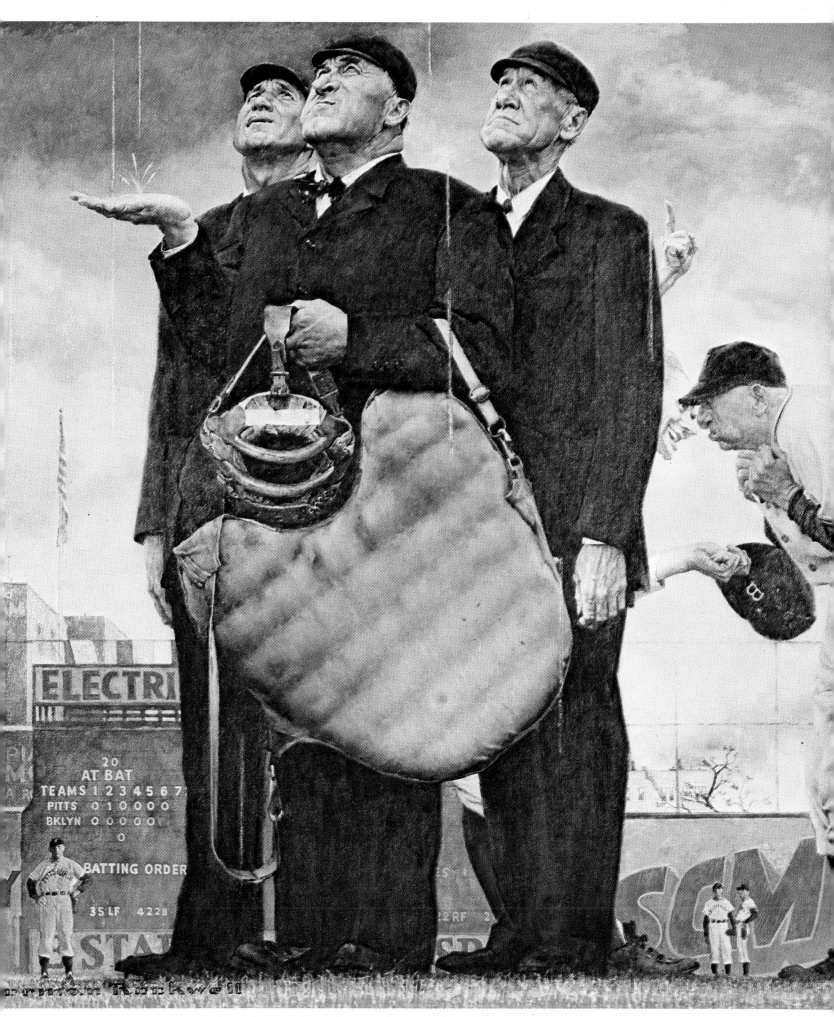

Umpires Larry Goetz, Beans Reardon and Lou Jorda, Dodgers coach Clyde Sukeforth and Pirates manager Bill Meyer posed for a 1949 cover.

vous whickerin' a horse gives when he smells somethin' funny on the wind. It was the fans ketchin' sight of Pearl du Monville, like you have prob'ly guessed. The midget had popped up onto the field all dressed up in a minacher club uniform, sox, cap, little letters sewed onto his chest, and all. He was swingin' a kid's bat and the only thing kept him from lookin' like a real ballplayer seen through the wrong end of a microscope was this cigar he was smokin'.

Bugs Courtney reached over and jerked it outa his mouth and threw it away. "You're wearin' that suit on the playin' field," he says to him, severe as a judge. "You go insultin' it and I'll take you out to the zoo and feed you to the bears."

Pearl just blowed some smoke at him which he still has in his mouth.

Whilst Whitey was foulin' off four or five prior to strikin' out, I went on over to Magrew. "If I was as comic as you," I says, "I'd laugh myself to death," I says. "Is that any way to treat the uniform, makin' a mockery out of it?"

"It might surprise you to know I ain't makin' no mockery outa the uniform," says Magrew. "Pearl du Monville here has been made a bone-of-fida member of this so-called ball club. I fixed it up with the front office by long-distance phone."

"Yeh?" I says. "I can just hear Mr. Dillworth or Bart Jenkins agreein' to hire a midget for the ball club. I can just hear 'em." Mr. Dillworth was the owner of the club and Bart Jenkins was the secretary, and they never stood for no monkey business. "May I be so bold as to inquire," I says, "just what you told 'em?"

"I told 'em," he says, "I wanted to sign up a guy they ain't no pitcher in the league can strike him out."

"Uh-huh," I says, "and did you tell 'em what size of a man he is?"

"Never mind about that," he says. "I got papers on me, made out legal and proper, constitutin' one Pearl du Monville a bone-of-fida member of this former ball club. Maybe that'll shame them big babies into gettin' in there and swingin', knowin' I can replace any one of 'em with a midget, if I have a mind to. A St. Louis lawyer I seen twice tells me it's all legal and proper."

"A St. Louis lawyer would," I says, "seein' nothin' could make him happier than havin' you makin' a mockery outa this one-time baseball outfit," I says.

Well, sir, it'll all be there in the papers of thirty, thirty-one year ago, and you could look it up. The game went along without no scorin' for seven innings, and since they ain't nothin' much to watch but guys poppin' up or strikin' out, the fans pay most of their attention to the goin's-on of Pearl du Monville. He's out there in front a the dugout, turnin' handsprings, balancin' his bat on his chin, walkin' a imaginary line, and so on. The fans clapped and laughed at him, and he ate it up.

So it went up to the last a the eighth, nothin' to nothin', not more'n seven, eight hits all told, and no errors on neither side. Our pitcher gets the first two men out easy in the eighth. Then up come a fella name of Porter or Billings, or some such name, and he lammed one up against the tobacco sign for three bases. The next guy up slapped the first ball out into left for a base hit, and in come the fella from third for the only run of the ball game so far. The crowd yelled, the look a death come onto Magrew's face again, and even the midget quit his tom-foolin'. Their next man fouled out back a third, and we come up for our last bats like a bunch a schoolgirls steppin' into a pool of cold water. I was lower in my mind than I'd been since the day in Nineteen-four when Chesbro throwed the wild pitch in the ninth inning with a man on third and lost the pennant for the Highlanders. I knowed something just as bad was goin' to happen, which shows I'm a clairvoyun, or was then.

When Gordy Mills hit out to second, I just closed my eyes. I opened 'em up again to see Dutch Muller

standin' on second, dustin' off his pants, him havin' got his first hit in maybe twenty times to the plate. Next up was Harry Loesing, battin' for our pitcher, and he got a base on balls, walkin' on a fourth one you could 'a' combed your hair with.

Then up come Whitey Cott, our lead-off man. He crotches down in what was prob'ly the most fearsome stanch in organized ball, but all he can do is pop out to short. That brung up Billy Klinger, with two down and a man on first and second. Billy took a cut at one you could 'a' knocked a plug hat offa this here Carnera with it, but then he gets sense enough to wait 'em out, and finely he walks, too, fillin' the bases.

Yes, sir, there you are; the tyin' run on third and the winnin' run on second, first a the ninth, two men down, and Hank Metters comin' to the bat. Hank was built like a Pope-Hartford and he couldn't run no faster'n President Taft, but he had five home runs to his credit for the season, and that wasn't bad in them days. Hank was still hittin' better'n anybody else on the ball club, and it was mighty heartenin', seein' him stridin' up towards the plate. But he never got there.

"Wait a minute!" yells Magrew, jumpin' to his feet. "I'm sendin' in a pinch hitter!" he yells.

You could 'a' heard a bomb drop. When a ball-club manager says he's sendin' in a pinch hitter for the best batter on the club, you know and I know and everybody knows he's lost his holt.

"They're goin' to be sendin' the funny wagon for you, if you don't watch out," I says, grabbin' a holt of his arm.

But he pulled away and run out towards the plate, yellin', "Du Monville battin' for Metters!"

All the fellas begun squawlin' at once, except Hank, and he just stood there starin' at Magrew like he'd gone crazy and was claimin' to be Ty Cobb's grandma or somethin'. Their pitcher stood there with his hands on his hips and a disagreeable look on his face, and the plate umpire told Magrew to go on and get a batter up.

Magrew told him again Du Monville was battin' for Metters, and the St. Louis manager finely got the idea. It brung him outa his dugout, howlin' and bawlin' like he'd lost a female dog and her seven pups.

Magrew pushed the midget towards the plate and he says to him, he says, "Just stand up there and hold that bat on your shoulder. They ain't a man in the world can throw three strikes in there 'fore he throws four balls!" he says.

"I get it, Junior!" says the midget. "He'll walk me and force in the tyin' run!" And he starts on up to the plate as cocky as if he was Willie Keeler.

I don't need to tell you Bethlemen broke loose on that there ball field. The fans got onto their hind legs, yellin' and whistlin', and everybody on the field begun wavin' their arms and hollerin' and shovin'. The plate umpire stalked over to Magrew like a traffic cop, waggin' his jaw and pointin' his finger, and the St. Louis manager kept yellin' like his house was on fire. When Pearl got up to the plate and stood there, the pitcher slammed his glove down onto the ground and started stompin' on it, and they ain't nobody can blame him. He's just walked two normal-sized human bein's, and now here's a guy up to the plate they ain't more'n twenty inches between his knees and his shoulders.

The plate umpire called in the field umpire, and they talked a while, like a couple doctors seein' the bucolic plague or somethin' for the first time. Then the plate umpire come over to Magrew with his arms folded acrost his chest, and he told him to go on and get a batter up, or he'd forfeit the game to St. Louis. He pulled out his watch, but somebody batted it outa his hand in the scufflin', and I thought there'd be a free-for-all, with everybody yellin' and shovin' except Pearl du Monville, who stood up at the plate with his little bat on his shoulder, not movin' a muscle.

Then Magrew played his ace. I seen him pull some papers outa his pocket and show 'em to the plate um-

pire. The umpire begun lookin' at 'em like they was bills for somethin' he not only never bought it, he never even heard of it. The other umpire studied 'em like they was a death warren, and all this time the St. Louis manager and the fans and the players is yellin' and hollerin'.

Well, sir, they fought about him bein' a midget, and they fought about him usin' a kid's bat, and they fought about where'd he been all season. They was eight or nine rule books brung out and everybody was thumbin' through 'em, tryin' to find out what it says about midgets, but it don't say nothin' about midgets, 'cause this was somethin' never'd come up in the history of the game before, and nobody'd ever dreamed about it, even when they has nightmares. Maybe you can't send no midgets in to bat nowadays, 'cause the old game's changed a lot, mostly for the worst, but you could then, it turned out.

The plate umpire finely decided the contrack papers was all legal and proper, like Magrew said, so he waved the St. Louis players back to their places and he pointed his finger at their manager and told him to quit hollerin' and get on back in the dugout. The manager says the game is percedin' under protest, and the umpire bawls, "Play ball!" over 'n' above the yellin' and booin', him havin' a voice like a hog-caller.

The St. Louis pitcher picked up his glove and beat at it with his fist six or eight times, and then got set on the mound and studied the situation. The fans realized he was really goin' to pitch to the midget, and they went crazy, hoopin' and hollerin' louder'n ever, and throwin' pop bottles and hats and cushions down onto the field. It took five, ten minutes to get the fans quieted down again, whilst our fellas that was on base set down on the bags and waited. And Pearl du Monville kept standin' up there with the bat on his shoulder, like he'd been told to.

So the pitcher starts studyin' the setup again, and

you got to admit it was the strangest setup in a ball game since the players cut off their beards and begun wearin' gloves. I wisht I could call the pitcher's name—it wasn't old Barney Pelty nor Nig Jack Powell nor Harry Howell. He was a big righthander, but I can't call his name. You could look it up. Even in a crotchin' position, the ketcher towers over the midget like the Washington Monument.

The plate umpire tries standin' on his tiptoes, then he tries crotchin' down, and he finely gets hisself into a stanch nobody'd ever seen on a ball field before, kinda squattin' down on his hanches.

Well, the pitcher is sore as a old buggy horse in fly time. He slams in the first pitch, hard and wild, and maybe two foot higher 'n the midget's head.

"Ball one!" hollers the umpire over 'n' above the racket, 'cause everybody is yellin' worsten ever.

The ketcher goes on out towards the mound and talks to the pitcher and hands him the ball. This time the big right-hander tries a undershoot, and it comes in a little closer, maybe no higher'n a foot, foot and a half above Pearl's head. It would 'a' been a strike with a human bein' in there, but the umpire's got to call it, and he does.

"Ball two!" he bellers.

The ketcher walks on out to the mound again, and the whole infield comes over and gives advice to the pitcher about what they'd do in a case like this, with two balls and no strikes on a batter that oughta be in a bottle of alcohol 'stead of up there at the plate in a big-league game between teams fightin' for first place.

For the third pitch, the pitcher stands there flat-footed and tosses up the ball like he's playin' ketch with a little girl.

Pearl stands there motionless as a hitchin' post, and the ball comes in big and slow and high—high for Pearl, that is, it bein' about on a level with his eyes, or a little higher'n a grown man's knees.

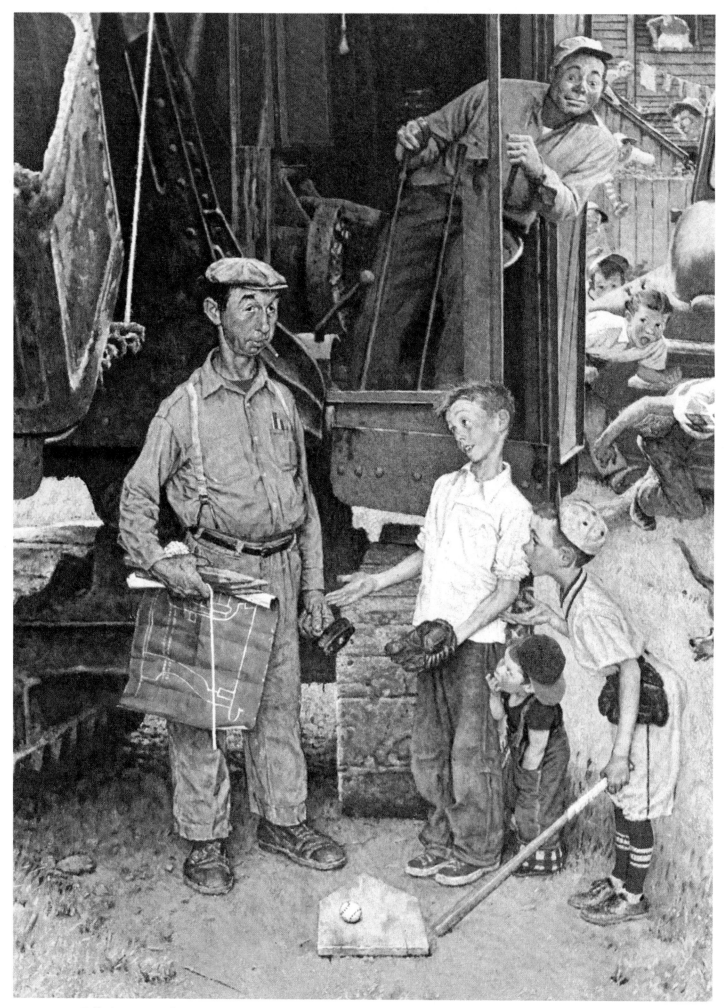

Ball players were losing ground to suburban developers and highway planners in 1954, a boom year for builders.

They ain't nothin' else for the umpire to do, so he calls, "Ball three!"

Everybody is onto their feet, hoopin' and hollerin', as the pitcher sets to throw ball four. The St. Louis manager is makin' signs and faces like he was a contorturer, and the infield is givin' the pitcher some more advice about what to do this time. Our boys who was on base stick right onto the bag, runnin' no risk of bein' nipped for the last out.

Well, the pitcher decides to give him a toss again, seein' he come closer with that than with a fast ball. They ain't nobody ever seen a slower ball throwed. It come in big as a balloon and slower'n any ball ever throwed before in the major leagues. It come right in over the plate in front of Pearl's chest, lookin' prob'ly big as a full moon to Pearl. They ain't never been a minute like the minute that followed since the United States was founded by the Pilgrim grandfathers.

Pearl du Monville took a cut at that ball, and he hit it! Magrew give a groan like a poleaxed steer as the ball rolls out in front a the plate into fair territory.

"Fair ball!" yells the umpire, and the midget starts runnin' for first, still carryin' that little bat, and makin' maybe ninety foot an hour. Bethlehem breaks loose on that ball field and in them stands. They ain't never been nothin' like it since creation was begun.

The ball's rollin' slow, on down towards third, goin' maybe eight, ten foot. The infield comes in fast and our boys break from their bases like hares in a brush fire. Everybody is standin' up, yellin' and hollerin', and Magrew is tearin' his hair outa his head, and the midget is scamperin' for first with all the speed of one of them little dashounds carryin' a satchel in his mouth.

The ketcher gets to the ball first, but he boots it on out past the pitcher's box, the pitcher fallin' on his face tryin' to stop it, the shortstop sprawlin' after it full length and zaggin' it on over towards the second basemen, whilst Muller is scorin' with the tyin' run and Loesing is roundin' third with the winnin' run. Ty Cobb could 'a' made a three-bagger outa that bunt, with everybody fallin' over theirself tryin' to pick the ball up. But Pearl is still maybe fifteen, twenty feet from the bag, toddlin' like a baby and yeepin' like a trapped rabbit, when the second baseman finely gets a holt of that ball and slams it over to first. The first baseman ketches it and stomps on the bag, the base umpire waves Pearl out, and there goes the ball game, craziest ever played in the history of the organized world.

Their players start runnin' in, and then I see Magrew. He starts after Pearl, runnin' faster'n any man ever run before. Pearl sees him comin' and runs behind the base umpire's legs and gets a holt onto 'em. Magrew comes up, pantin' and roarin', and him and the midget plays ring-around-a-rosy with the umpire, who keeps shovin' at Magrew with one hand and tryin' to slap the midget loose from his legs with the other.

Finely Magrew ketches the midget, who is still yeepin' like a stuck sheep. He gets holt of that little guy by both his ankles and starts whirlin' him round and round his head like Magrew was a hammer thrower and Pearl was the hammer. Nobody can stop him without gettin' their head knocked off, so everybody just stands there and yells. Then Magrew lets the midget fly. He flies on out towards second, high and fast, like a human home run, headed for the soap sign in center field.

Their shortstop tries to get to him, but he can't make it, and I knowed the little fella was goin' to bust to pieces like a dollar watch on a asphalt street when he hit the ground. But it so happens their center fielder is just crossin' second, and he starts runnin' back, tryin' to get under the midget, who had took to spiralin' like a football 'stead of turnin' head over foot, which give him more speed and more distance.

I know you never seen a midget ketched, and you prob'ly never even seen one throwed. To ketch a midget that's been throwed by a heavy-muscled man

and is flyin' through the air, you got to run under him and with him and pull your hands and arms back and down when you ketch him, to break the compact of his body, or you'll bust him in two like a matchstick. I seen Bill Lange and Willie Keeler and Tris Speaker make some wonderful ketches in my day, but I never seen nothin' like that center fielder. He goes back and back and still further back and he pulls that midget down outa the air like he was liftin' a sleepin' baby from a cradle. They wasn't a bruise onto him, only his face was the color of cat's meat and he ain't got no air in his chest. In his excitement, the base umpire, who was runnin' back with the center fielder when he ketched Pearl, yells, "Out!" and that give hysteries to the Bethlehem which was ragin' like Niagry on that ball field.

Everybody was hoopin' and hollerin' and yellin' and runnin', with the fans swarmin' onto the field, and the cops tryin' to keep order, and some guys laughin' and some of the women fans cryin', and six or eight of us holdin' onto Magrew to keep him from gettin' at that midget and finishin' him off. Some of the fans picks up the St. Louis pitcher and the center fielder, and starts carryin' 'em around on their shoulders, and they was the craziest goin's-on knowed to the history of organized ball on this side of the 'Lantic Ocean.

I seen Pearl du Monville strugglin' in the arms of a lady fan with a ample bosom, who was laughin' and cryin' at the same time, and him beatin' at her with his little fists and bawlin' and yellin'. He clawed his way loose finely and disappeared in the forest of legs which made that ball field look like it was Coney Island on a hot summer's day.

That was the last I ever seen of Pearl du Monville. I never seen hide nor hair of him from that day to this, and neither did nobody else. He just vanished into the thin air, as the fella says. He was ketched for the final out of the ball game and that was the end of him, just like it was the end of the ball game, you might say, and also the end of our losin' streak, like I'm goin' to tell you.

That night we piled onto a train for Chicago, but we wasn't snarlin' and snappin' anymore. No, sir, the ice was finely broke and a new spirit come into that ball club. The old zip come back with the disappearance of Pearl du Monville out back a second base. We got to laughin' and talkin' and kiddin' together, and 'fore long Magrew was laughin' with us. He got a human look onto his pan again, and he quit whinin' and complainin' and wishtin' he was in heaven with the angels.

Well, sir, we wiped up that Chicago series, winnin' all four games, and makin' seventeen hits in one of 'em. Funny thing was, St. Louis was so shook up by that last game with us, they never did hit their stride again. Their center fielder took to misjudgin' everything that come his way, and the rest a the fellas followed suit, the way a club'll do when one guy blows up.

'Fore we left Chicago, I and some of the fellas went out and bought a pair of them little baby shoes, which we had 'em golded over and give 'em to Magrew for a souvenir, and he took it all in good spirit. Whitey Cott and Billy Klinger made up and was fast friends again, and we hit our home lot like a ton of dynamite and they was nothin' could stop us from then on.

I don't recollect things as clear as I did thirty, forty year ago. I can't read no fine print no more, and the only person I got to check with on the golden days of the national pastime, as the fella says, is my friend, old Milt Kline, over in Springfield, and his mind ain't as strong as it once was.

He gets Rube Waddell mixed up with Rube Marquard, for one thing, and anybody does that oughta be put away where he won't bother nobody. So I can't tell you the exact margin we win the pennant by. Maybe it was two and a half games, or maybe it was three and a half. But it'll all be there in the newspapers and record books of thirty, thirty-one year ago and, like I was sayin', you could look it up.

Laura Ingalls Wilder

Summertime

Almanzo is already well known to many readers. As a teenager he homesteaded in South Dakota, where he met and married the Laura who'd lived in The Little House in the Big Woods and The Little House on the Prairie. Real people, Laura and Almanzo had one child. She became a successful writer whose by-line "Rose Wilder Lane" appeared regularly in the Post and other leading magazines during the 1930's. It was then that Rose urged her 60-year-old mother to try her hand at writing by setting down memories of her own and her husband's childhoods. During the same years Laura was writing her enormously popular books, Norman Rockwell was recording on canvas his own memories of happy boyhood summers spent on farms in upstate New York where he, like Almanzo, helped with the farm work, and fished and swam in the creeks.

THE SUNSHINE WAS HOTTER NOW, and all the green things grew quickly. The corn thrust its rustling, narrow leaves waist-high; Father plowed it again, and Royal and Almanzo hoed it again. Then the corn was laid by. It had gained so much advantage against the weeds that it could hold the field with no help.

The bushy rows of potatoes almost touched, and their white blossoms were like foam on the field. The oats rippled gray-green, and the wheat's thin heads were rough with young husks where the kernels would grow. The meadows were rosy-purple with the blossoms that the bees loved best.

Work was not so pressing now. Almanzo had time to weed the garden, and to hoe the row of potato plants he was raising from seed. He had planted a few potato seeds, just to see what they would do. And every morning he fed his pumpkin, that he was growing for the County Fair.

Father had shown him how to raise a milk-fed pumpkin. They had picked out the best vine in the field, and snipped off all the branches but one, and all the yellow pumpkin blossoms but one. Then between the root and the wee green pumpkin they carefully made a little slit on the under side of the vine. Under the slit Almanzo made a hollow in the ground and set a bowl of milk in it. Then he put a candle wick in the milk, and the end of the candle wick he put carefully into the slit.

Every day the pumpkin vine drank up the bowlful of milk, through the candle wick, and the pumpkin was growing enormously. Already it was three times as big as any other pumpkin in the field.

Almanzo had his little pig now, too. He had bought her with his half-dollar, and she was so small that he fed her, at first, with a rag dipped in milk. But soon she learned to drink. He kept her in a pen in the shade, because young pigs grow best in the shade, and he fed her all she could eat. She was growing fast, too.

So was Almanzo, but he was not growing fast enough. He drank all the milk he could hold, and at mealtimes he filled his plate so full that he could not eat it all. Father looked stern because he left food on his plate, and asked:

"What's the matter, son? Your eyes bigger than your stomach?"

Then Almanzo tried to swallow a little more. He did not tell anyone he was trying to grow up faster so he could help break the colts.

Every day Father took the two-year-olds out, one by one on a long rope, and trained them to start and to stop when he spoke. He trained them to wear bridles and harness, and not to be afraid of anything. Pretty soon he would hitch each one up with a gentle old horse, and teach it to pull a light cart behind it without being scared. But he wouldn't let Almanzo even go into the barnyard while he was training them.

Almanzo was sure he wouldn't frighten them; he wouldn't teach them to jump, or balk, or try to run away. But Father wouldn't trust a nine-year-old.

That year Beauty had the prettiest colt Almanzo had ever seen. He had a perfect white star on his forehead, and Almanzo named him Starlight. He ran in the pasture with his mother, and once when Father was in town Almanzo went into the pasture.

Beauty lifted her head and watched him coming, and the little colt ran behind her. Almanzo stopped, and stood perfectly still. After a while Starlight peeked at him, under Beauty's neck. Almanzo didn't move. Little by little the colt stretched its neck toward Almanzo, looking at him with wondering, wide eyes. Beauty nuzzled his back and switched her tail; then she took a step and bit off a clump of grass. Starlight stood trembling, looking at Almanzo. Beauty watched them both, chewing placidly. The colt made one step, then another. He was so near that Almanzo could almost have touched him, but he didn't; he didn't move. Starlight came a step nearer. Almanzo didn't even breathe. Suddenly the colt turned and ran back to its mother. Almanzo heard Eliza Jane calling: "'Ma-a-a-nzo!"

She had seen him. That night she told Father. Almanzo said he hadn't done a thing, honest he hadn't, but Father said:

"Let me catch you fooling with that colt again and I'll tan your jacket. That's too good a colt to be spoiled. I won't have you teaching it tricks that I'll have to train out of it."

The summer days were long and hot now, and Mother said this was good growing weather. But Almanzo felt that everything was growing but him. Day after day went by, and nothing seemed to change. Almanzo weeded and hoed the garden, he helped mend the stone fences, he chopped wood and did the chores. In the hot afternoons when there wasn't much to do, he went swimming.

Sometimes he woke in the morning and heard rain drumming on the roof. That meant he and Father might go fishing.

He didn't dare speak to Father about fishing, because it was wrong to waste time in idleness. Even on rainy days there was plenty to do. Father might mend harness, or sharpen tools, or shave shingles. Silently Almanzo ate breakfast, knowing that Father was struggling against temptation. He was afraid Father's conscience would win.

"Well, what are you going to do today?" Mother would ask. Father might answer, slowly:

"I did lay out to cultivate the carrots and mend fence."

"You can't do that, in this rain."

"No," Father would say. After breakfast he would stand looking at the falling rain, till at last he would say:

"Well! It's too wet to work outdoors. What say we go fishing, Almanzo?"

Then Almanzo ran to get the hoe and the bait-can, and he dug worms for bait. The rain drummed on his old straw hat, it ran down his arms and back, and the mud squeezed cool between his toes. He was already sopping wet when he and Father took their rods and went down across the pasture to Trout River.

Nothing ever smelled so good as the rain on clover. Nothing ever felt so good as raindrops on Almanzo's face, and the wet grass swishing around his legs. Nothing ever sounded so pleasant as the drops pattering on the bushes along Trout River, and the rush of the water over the rocks.

They stole quietly along the bank, not making a sound, and they dropped their hooks into the pool. Father stood under a hemlock tree, and Almanzo sat under a tent of cedar boughs, and watched the raindrops dimpling the water.

Suddenly he saw a silver flash in the air. Father had hooked a trout! It slithered and gleamed through the

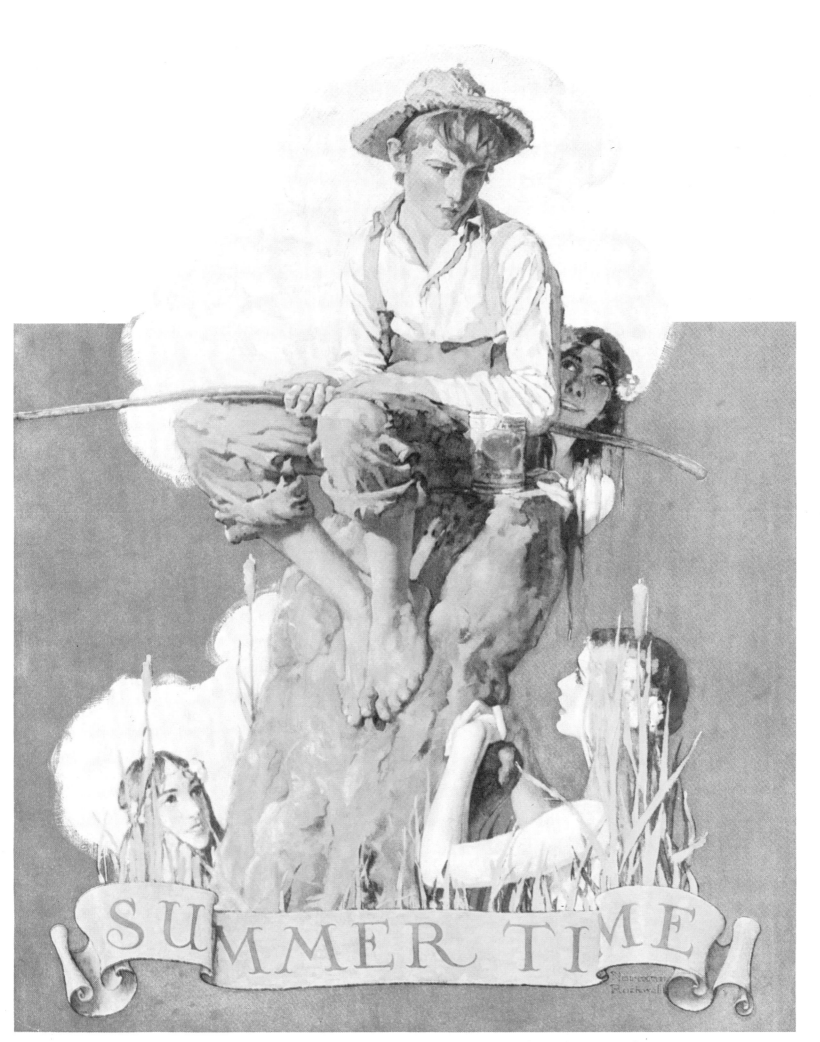

Rockwell remembered boyhood vacations on a farm as "sheer blissfulness, one long radiant summer." (1933)

falling rain as Father flipped it to the grassy bank. Almanzo jumped up, and remembered just in time not to shout.

Then he felt a tug at his line, the tip of his rod bent almost to the water, and he jerked it upward with all his might. A shimmering big fish came up on the end of his line! It struggled and slipped in his hands, but he got it off the hook—a beautiful speckled trout, even larger than Father's. He held it up for Father to see. Then he baited his hook and flung out his line again.

Fish always bite well when raindrops are falling on the river. Father got another one, then Almanzo got two; then Father pulled out two more, and Almanzo got another one even bigger than the first. In no time at all they had two strings of good trout. Father admired Almanzo's, and Almanzo admired Father's, and they tramped home through the clover in the rain.

They were so wet they couldn't be wetter, and their skins were glowing warm. Out in the rain, by the chopping-block at the wood-pile, they cut off the heads of the fish and they scraped off the silvery scales, and they cut the fish open and stripped out their insides. The big milk-pan was full of trout, and Mother dipped them in cornmeal and fried them for dinner.

The Old Swimmin'-Hole

Oh! the old swimmin'-hole! whare the crick so still and
 deep
Looked like a baby-river that was laying half asleep,
And the gurgle of the worter round the drift jest below
Sounded like the laugh of something we onc't ust to
 know
Before we could remember anything but the eyes
Of the angels lookin' out as we left Paradise:
But the merry days of youth is beyond our controle,
And it's hard to part ferever with the old
 swimmin'-hole.

Oh! the old swimmin'-hole! In the happy days of yore,
When I ust to lean above it on the old sickamore,
Oh! it showed me a face in its warm sunny tide
That gazed back at me so gay and glorified,
It made me love myself, as I leaped to caress
My shadder smilin' up at me with sich tenderness.
But them days is past and gone, and old Time's tuck his
 toll
From the old man come back to the old swimmin'-hole.

Oh! the old swimmin'-hole! In the long, lazy days
When the humdrum of school made so many
 run-a-ways,
How plesant was the jurney down the old dusty lane,
Whare the tracks of our bare feet was all printed so
 plane
You could tell by the dent of the heel and the sole
They was lots o' fun on hands at the old swimmin'-hole.
But the lost joys is past! Let your tears in sorrow
 roll
Like the rain that ust to dapple up the old
 swimmin'-hole.

Thare the bullrushes growed, and the cattails so tall,
And the sunshine and shadder fell over it all;
And it mottled the worter with amber and gold
Tel the glad lilies rocked in the ripples that rolled;
And the snake-feeder's four gauzy wings fluttered by
Like the ghost of a daisy dropped out of the sky,
Or a wounded apple-blossom in the breeze's controle
As it cut acrost some orchurd to'rds the old
 swimmin'-hole.

James Whitcomb Riley

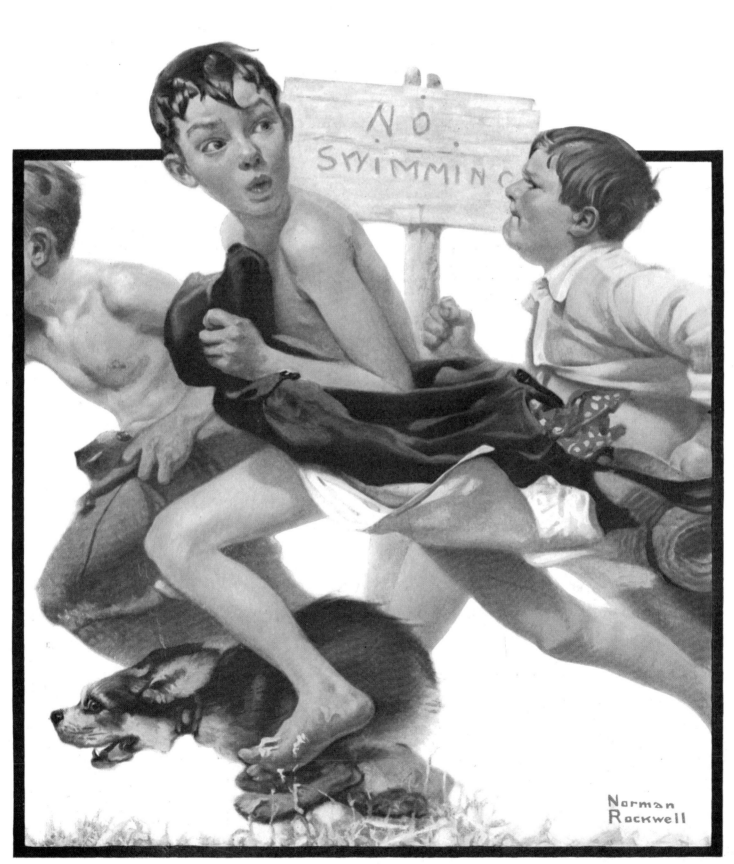

A 1921 cover featured Eddie Carson and Billie Payne, favorite models whose faces became familiar to Post subscribers.

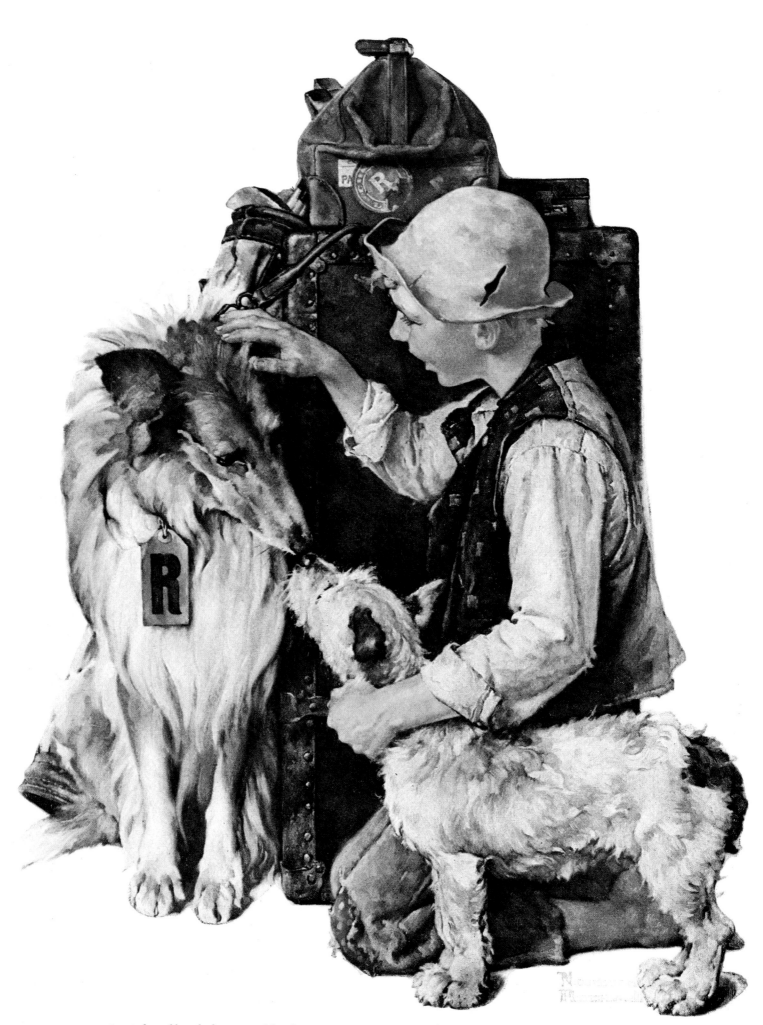

Lassie herself might have posed for the aristocratic canine on a 1929 Post. More often, cover dogs were mutts.

Eric Knight
Lassie Come-Home

The world's most famous collie—possibly the world's most famous dog—first appeared in this story in the Post, *December 17, 1938. The story was later expanded to book length. Then came a movie that made stars of Elizabeth Taylor and Roddy McDowall, and a television series that went on for years, with a series of dog-actors outliving one family after another. Behind all this was a native of the Yorkshire moors who lived in Pennsylvania, writing books and stories, between the wars. Eric Knight had studied for a career in art but World War I service in France left him color-blind; he died in a World War II army plane crash.*

THE DOG HAD MET THE BOY by the school gate for five years. Now she couldn't understand that times were changed and she wasn't supposed to be there any more. But the boy knew.

So when he opened the door of the cottage, he spoke before he entered.

"Mother," he said, "Lassie's come home again."

He waited a moment, as if in hope of something. But the man and woman inside the cottage did not speak.

"Come in, Lassie," the boy said.

He held the door open, and the tricolor collie walked in obediently. Going head down, as a collie when it knows something is wrong, it went to the rug and lay down before the hearth, a black-white-and-gold aristocrat. The man, sitting on a low stool by the fireside, kept his eyes turned away. The woman went to the sink and busied herself there.

"She were waiting at school for me, just like always," the boy went on. He spoke fast, as if racing against time. "She must ha' got away again. I thought, happen this time, we might just——"

"No!" the woman exploded.

The boy's carelessness dropped. His voice rose in pleading.

"But this time, mother! Just this time. We could hide her. They wouldn't ever know."

"Dogs, dogs, dogs!" the woman cried. The words poured from her as if the boy's pleading had been a signal gun for her own anger. "I'm sick o' hearing about tykes round this house. Well, she's sold and gone and done with, so the quicker she's taken back the better.

Now get her back quick, or first thing ye know we'll have Hynes round here again. Mr. Hynes!"

Her voice sharpened in imitation of the Cockney accent of the south: "Hi know you Yorkshiremen and yer come-'ome dogs. Training yer dogs to come 'ome so's yer can sell 'em hover and hover again.

"Well, she's sold, so ye can take her out o' my house and home to them as bought her!"

The boy's bottom lip crept out stubbornly, and there was silence in the cottage. Then the dog lifted its head and nudged the man's hand, as a dog will when asking for patting. But the man drew away and stared, silently, into the fire.

The boy tried again, with the ceaseless guile of a child, his voice coaxing.

"Look, feyther, she wants thee to bid her welcome. Aye, she's that glad to be home. Happen they don't tak' good care on her up there? Look, her coat's a bit poorly, don't ye think? A bit o' linseed strained through her drinking water—that's what I'd gi' her."

Still looking in the fire, the man nodded. But the woman, as if perceiving the boy's new attack, sniffed.

"Aye, tha wouldn't be a Carraclough if tha didn't know more about tykes nor breaking eggs wi' a stick. Nor a Yorkshireman. My goodness, it seems to me sometimes that chaps in this village thinks more on their tykes nor they do o' their own flesh and blood. They'll sit by their firesides and let their own bairns starve so long as t' dog gets fed."

The man stirred, suddenly, but the boy cut in quickly.

"But she does look thin. Look, truly—they're not feeding her right. Just look!"

"Aye," the woman chattered. "I wouldn't put it past Hynes to steal t' best part o' t' dog meat for himself. And Lassie always was a strong eater."

"She's fair thin now," the boy said.

Almost unwillingly the man and woman looked at the dog for the first time.

"My gum, she is off a bit," the woman said. Then she caught herself. "Ma goodness, I suppose I'll have to fix her a bit o' summat. She can do wi' it. But soon as she's fed, back she goes. And never another dog I'll have in my house. Never another. Cooking and nursing for 'em, and as much trouble to bring up as a bairn!"

So, grumbling and chatting as a village woman will, she moved about, warming a pan of food for the dog. The man and boy watched the collie eat. When it was done, the boy took from the mantelpiece a folded cloth and a brush, and began prettying the collie's coat. The man watched for several minutes, and then could stand it no longer.

"Here," he said.

He took the cloth and brush from the boy and began working expertly on the dog, rubbing the rich, deep coat, then brushing the snowy whiteness of the full ruff and the apron, bringing out the heavy leggings on the forelegs. He lost himself in his work, and the boy sat on the rug, watching contentedly. The woman stood it as long as she could.

"Now will ye please tak' that tyke out o' here?"

The man flared in anger.

"Well, ye wouldn't have me tak' her back looking like a mucky Monday wash, wouldta?"

He bent again, and began fluffing out the collie's petticoats.

"Joe!" the woman pleaded. "Will ye tak' her out o' here? Hynes'll be nosing round afore ye know it. And I won't have that man in my house. Wearing his hat

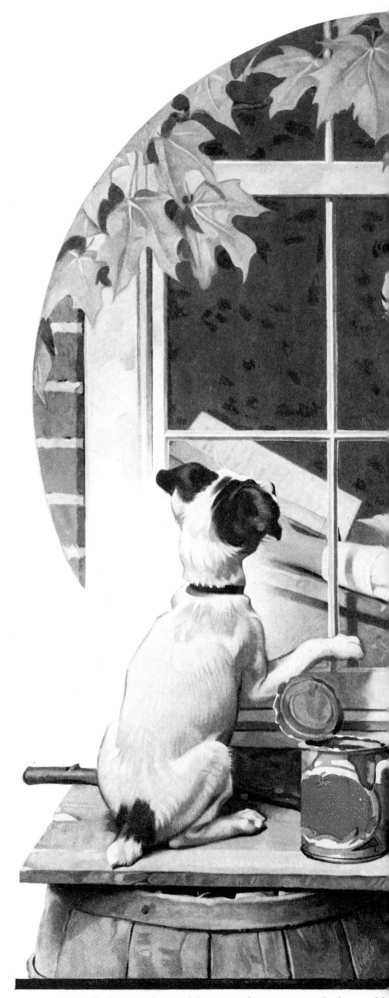

Rockwell's favorite dog model was Lambert, a mongrel who would

34

"sit there with his head cocked, thinking, hour after hour." (1922)

inside, and going on like he's the duke himself—him and his leggings!"

"All right, lass."

"And this time, Joe, tak' young Joe wi' ye."

"What for?"

"Well, let's get the business done and over with. It's him that Lassie runs away for. She comes for young Joe. So if he went wi' thee, and told her to stay, happen she'd be content and not run away no more, and then we'd have a little peace and quiet in the home—though heaven knows there's not much hope o' that these days, things being like they are." The woman's voice trailed away, as if she would soon cry in weariness.

The man rose. "Come, Joe," he said. "Get thy cap."

The Duke of Rudling walked along the gravel paths of his place with his granddaughter, Philippa. Philippa was a bright and knowing young woman, allegedly the only member of the duke's family he could address in unspotted language. For it was also alleged that the duke was the most irascible, vile-tempered old man in the three Ridings of Yorkshire.

"Country going to pot!" the duke roared, stabbing at the walk with his great blackthorn stick. "When I was a young man! Hah! Women today not as pretty. Horses today not as fast. As for dogs—ye don't see dogs today like——"

Just then the duke and Philippa came round a clump of rhododendrons and saw a man, a boy and a dog.

"Ah," said the duke, in admiration. Then his brow knotted. "Damme, Carraclough! What're ye doing with my dog?"

He shouted it quite as if the others were in the next county, for it was also the opinion of the Duke of Rudling that people were not nearly so keen of hearing as they used to be when he was a young man.

"It's Lassie," Carraclough said. "She runned away again and I brought her back."

Carraclough lifted his cap, and poked the boy to do the same, not in any servile gesture, but to show that they were as well brought up as the next.

"Damme, ran away again!" the duke roared. "And I told that utter nincompoop Hynes to—where is he? Hynes! Hynes! Damme, Hynes, what're ye hiding for?"

"Coming, your lordship!" sounded a voice, far away behind the shrubberies. And soon Hynes appeared, a sharp-faced man in check coat, riding breeches, and the cloth leggings that grooms wear.

"Take this dog," roared the duke, "and pen her up! And damme, If she breaks out again, I'll—I'll——"

The duke waved his great stick threateningly, and then, without so much as a thank you or kiss the back of my hand to Joe Carraclough, he went stamping and muttering away.

"I'll pen 'er up," Hynes muttered, when the duke was gone. "And if she ever gets awye agyne, I'll——"

He made as if to grab the dog, but Joe Carraclough's hobnailed boot trod heavily on Hynes' foot.

"I brought my lad wi' me to bid her stay, so we'll pen her up this time. Eigh—sorry! I didn't see I were on thy foot. Come, Joe, lad."

They walked down the crunching gravel path, along by the neat kennel buildings. When Lassie was behind the closed door, she raced into the high wire run where she could see them as they went. She pressed close against the wire, waiting.

The boy stood close, too, his fingers through the meshes touching the dog's nose.

"Go on, lad," his father ordered. "Bid her stay!"

The boy looked around, as if for help that he did not find. He swallowed, and then spoke, low and quickly.

"Stay here, Lassie, and don't come home no more," he said. "And don't come to school for me no more. Because I don't want to see ye no more. 'Cause tha's a bad dog, and we don't love thee no more, and we don't

want thee. So stay there forever and leave us be, and don't never come home no more."

Then he turned, and because it was hard to see the path plainly, he stumbled. But his father, who was holding his head very high as they walked away from Hynes, shook him savagely, and snapped roughly: "Look where tha's going!"

Then the boy trotted beside his father. He was thinking that he'd never be able to understand why grown-ups sometimes were so bad-tempered with you, just when you needed them most.

After that, there were days and days that passed, and the dog did not come to the school gate anymore. So then it was not like old times. There were so many things that were not like old times.

The boy was thinking that as he came wearily up the path and opened the cottage door and heard his father's voice, tense with anger: ". . . walk my feet off. If tha thinks I like——"

Then they heard his opening of the door and the voice stopped and the cottage was silent.

That's how it was now, the boy thought. They stopped talking in front of you. And this, somehow, was too much for him to bear.

He closed the door, ran out into the night, and onto the moor, that great flat expanse of land where all the people of the village walked in lonesomeness when life and its troubles seemed past bearing.

A long while later, his father's voice cut through the darkness.

"What's tha doing out here, Joe lad?"

"Walking."

"Aye."

They went on together, aimlessly, each following his own thoughts. And they thought about the dog that had been sold.

"Tha maun't think we're hard on thee, Joe," the man

said at last. "It's just that a chap's got to be honest. There's that to it. Sometimes, when a chap doesn't have much, he clings right hard to what he's got. And honest is honest, and there's no two ways about it.

"Why, look, Joe. Seventeen year I worked in that Clarabelle Pit till she shut down, and a good collier too. Seventeen year! And butties I've had by the dozen, and never a man of 'em can ever say that Joe Carraclough kept what wasn't his, nor spoke what wasn't true. Not a man in his Riding can ever call a Carraclough mis-honest.

"And when ye've sold a man summat, and ye've taken his brass, and ye've spent it—well, then done's done. That's all. And ye've got to stand by that."

"But Lassie was——"

"Now, Joe! Ye can't alter it, ever. It's done—and happen it's for t' best. No two ways, Joe, she were getting hard to feed. Why, ye wouldn't want Lassie to be going around getting peaked and pined, like some chaps round here keep their tykes. And if ye're fond of her, then just think on it that now she's got lots to eat, and a private kennel, and a good run to herself, and living like a veritable princess, she is. Ain't that best for her?"

"We wouldn't pine for her. We've always got lots to eat."

The man blew out his breath, angrily. "Eigh, Joe, nowt pleases thee. Well then, tha might as well have it. Tha'll never see Lassie no more. She run home once too often, so the duke's taken her wi' him up to his place in Scotland, and there she'll stay. So it's good-bye and good luck to her, and she'll never come home no more, she won't. Now, I weren't off to tell thee, but there it is, so put it in thy pipe and smoke it, and let's never say a word about it no more—especially in front of thy mother."

The boy stumbled on in the darkness. Then the man halted.

"We ought to be getting back, lad. We left thy mother alone."

He turned the boy about, and then went on, but as if he were talking to himself.

"Tha sees, Joe, women's not like men. They have to stay home and manage best they can, just spend the time in wishing. And when things don't go right, well, they have to take it out in talk and give a man hell. But it don't mean nowt, really, so tha shouldn't mind when thy mother talks hard.

"Ye just got to learn to be patient and let 'em talk, and just let it go up t' chimney wi' th' smoke."

Then they were quiet, until, over the rise, they saw the lights of the village. Then the boy spoke: "How far away is Scotland, feyther?"

"Nay, lad, it's a long, long road."

"But how far, feyther?"

"I don't know—but it's a longer road than thee or me'll ever walk. Now, lad. Don't fret no more, and try to be a man—and don't plague thy mother no more, wilta?"

Joe Carraclough was right. It is a long road, as they say in the north, from Yorkshire to Scotland. Much too far for a man to walk—or a boy. And though the boy often thought of it, he remembered his father's words on the moor, and he put the thought behind him.

But there is another way of looking at it; and that's the distance from Scotland to Yorkshire. And that is just as far as from Yorkshire to Scotland. A matter of about four hundred miles, it would be, from the Duke of Rudling's place far up in the Highlands, to the village of Holdersby. That would be for a man, who could go fairly straight.

To an animal, how much farther would it be? For a dog can study no maps, read no signposts, ask no directions. It could only go blindly, by instinct, knowing that it must keep on to the south, to the south. It

would wander and err, quest and quarter, run into firths and lochs that would send it side-tracking and back-tracking before it could go again on its way—south.

A thousand miles, it would be, going that way—a thousand miles over strange terrain.

There would be moors to cross, and burns to swim. And then those great, long lochs that stretch almost from one side of that dour land to another would bar the way and send a dog questing a hundred miles before it could find a crossing that would allow it to go south.

And, too, there would be rivers to cross, wide rivers like the Forth and the Clyde, the Tweed and the Tyne, where one must go miles to find bridges. And the bridges would be in towns. And in the towns there would be officials—like the one in Lanarkshire. In all his life he had never let a captured dog get away—except one. That one was a gaunt, snarling collie that whirled on him right in the pound itself, and fought and twisted loose to race away down the city street—going south.

But there are also kind people, too; ones knowing and understanding in the ways of dogs. There was an old couple in Durham who found a dog lying exhausted in a ditch one night—lying there with its head to the south. They took that dog into their cottage and warmed it and fed it and nursed it. And because it seemed an understanding, wise dog, they kept it in their home, hoping it would learn to be content. But, as it grew stronger, every afternoon toward four o'clock it would go to the door and whine, and then begin pacing back and forth between door and window, back and forth as the animals pace back and forth in their cages at the zoo.

They tried every wile and kindness to make it bide with them, but finally, when the dog began to refuse food, the old people knew what they must do. Because they understood dogs, they opened the door one afternoon and they watched a collie go, not down the road to the right, or to the left, but straight across a field toward the south; going steadily at a trot, as if he knew it still had a long, long road to travel.

Ah, a thousand miles of tor and brae, of shire and moor, of path and road and plowland, of river and stream and burn and brook and beck, of snow and rain and fog and sun, is a long way, even for a human being. But it would seem too far—much, much too far—for any dog to travel blindly and win through.

And yet—and yet—who shall say why, when so many weeks had passed that hope against hope was dying, a boy coming out of school, out of the cloakroom that always smelled of damp wool drying, across the concrete play yard with the black, waxed slides, should turn his eyes to a spot by the school gate from force of five years of habit, and see there a dog? Not a dog, this one, that lifted glad ears above a proud slim head with its black-and-gold mask; but a dog that lay weakly, trying to lift a head that would no longer lift, trying to wag a tail that was torn and blotched and matted with dirt and burs, and managing to do nothing much except to whine in a weak, happy, crying way as a boy on his knees threw arms about it, and hands touched it that had not touched it for many a day.

Then who shall picture the urgency of a boy, running, awkwardly, with a great dog in his arms running through the village, past the empty mill, past the Labor Exchange where the men looked up from their deep ponderings on life and the dole? Or who shall describe the high tones of a voice—a boy's voice, calling as he runs up a path: "Mother! Oh, mother! Lassie's come home! Lassie's come home!"

Nor does anyone who ever owned a dog need to be told the sound a man makes as he bends over a dog that has been his for many years; nor how a woman moves quickly, preparing food—which might be the family's condensed milk stirred into warm water; nor how the jowl of a dog is lifted so that raw egg and brandy, bought with precious pence, should be spooned in; nor how bleeding pads are bandaged, tenderly.

That was one day. There was another day when the woman in the cottage sighed with pleasure, for a dog lifted itself to its feet for the first time to stand over a bowl of oatmeal, putting its head down and lapping again and again while its pinched flanks quivered.

And there was another day when the boy realized that, even now, the dog was not to be his again. So the cottage rang again with protests and cries, and a woman shrilling: "Is there never to be no peace in my house and home?" Long after he was in bed that night the boy heard the rise and fall of the woman's voice, and the steady, reiterative tone of the man's. It went on long after he was asleep.

In the morning the man spoke, not looking at the boy, saying the words as if he had long rehearsed them.

"Thy mother and me have decided upon it that Lassie shall stay here till she's better. Anyhow, nobody could nurse her better than us. But the day that t' duke comes back, then back she goes, too. For she belongs to him, and that's honest, too. Now tha has her for awhile, so be content."

In childhood, "for a while" is such a stretch of days when seen from one end. It is a terribly short time seen from the other.

The boy knew how short it was that morning as he went to

school and saw a motorcar driven by a young woman. And in the car was a gray-thatched, terrible old man, who waved a cane and shouted: "Hi! Hi, there! Damme, lad! You there! Hi!"

Then it was no use running, for the car could go faster than you, and soon it was beside you and the man was saying: "Damme, Philippa, will you make this smelly thing stand still a moment? Hi, lad!"

"Yes, sir."

"You're What's-'is-Name's lad, aren't you?"

"Ma feyther's Joe Carraclough."

"I know. I know. Is he home now?"

"No, sir. He's away to Allerby. A mate spoke for him at the pit and he's gone to see if there's a chance."

"When'll he be back?"

"I don't know. I think about tea."

"Eh, yes. Well, yes. I'll drop round about fivish to see that father of yours. Something important."

It was hard to pretend to listen to lessons. There was only waiting for noon. Then the boy ran home.

"Mother! T' duke is back and he's coming to take Lassie away."

"Eigh, drat my buttons. Never no peace in this house. Is tha sure?"

"Aye. He stopped me. He said tell feyther he'll be round at five. Can't we hide her? Oh, mother."

"Nay, thy feyther——"

"Won't you beg him? Please, please. Beg feyther to——"

"Young Joe, now it's no use. So stop thy teasing! Thy feyther'll not lie. That much I'll give him. Come good, come bad, he'll not lie."

"But just this once, mother. Please beg him, just this once. Just one lie wouldn't hurt him. I'll make it up to him. I will. When I'm growed up, I'll get a job. I'll make money. I'll buy him things—and you too. I'll buy you both anything you want if you'll only——"

For the first time in his trouble the boy became a

child, and the mother, looking over, saw the tears that ran openly down his contorted face. She turned her face to the fire, and there was a pause. Then she spoke.

"Joe, tha mustn't," she said softly. "Tha must learn never to want nothing in life like that. It don't do, lad. Tha mustn't want things bad, like tha wants Lassie."

The boy shook his clenched fists in impatience.

"It ain't that, mother. Ye don't understand. Don't yer see—it ain't me that wants her. It's her that wants us! Tha's wha made her come all them miles. It's her that wants us, so terrible bad!"

The woman turned and stared. It was as if, in that moment, she were seeing this child, this boy, this son of her own, for the first time in many years. She turned her head down toward the table. It was surrender.

"Come and eat, then," she said. "I'll talk to him. I will that, all right. I feel sure he won't lie. But I'll talk to him, all right. I'll talk to Mr. Carraclough. I will indeed."

At five that afternoon, the Duke of Rudling, fuming and muttering, got out of a car at a cottage gate to find a boy barring his way. This was a boy who stood, stubbornly, saying fiercely: "Away wi' thee! Thy tyke's net here!"

"Damme, Philippa, th' lad's touched," the duke said. "He is. He's touched."

Scowling and thumping his stick, the old duke advanced until the boy gave way, backing down the path out of the reach of the waving blackthorn stick.

"Thy tyke's net here," the boy protested.

"What's he saying?" the girl asked.

"Says my dog isn't here. Damme, you going deaf? I'm supposed to be deaf, and I hear him plainly enough. Now, ma lad, what tyke o' mine's net here?"

As he turned to the boy, the duke spoke in broadest Yorkshire, as he did always to the people of the cottages—a habit which the Duchess of Rudling, and

many more members of the duke's family, deplored.

"Coom, coom ma lad. Whet tyke's net here?"

"No tyke o' thine. Us hasn't got it." The words began running faster and faster as the boy backed away from the fearful old man who advanced. "No tyke could have done it. No tyke can come all them miles. It isn't Lassie. It's another one that looks like her. It isn't Lassie!"

"Why, bless ma heart and sowl," the duke puffed. "Where's thy father, ma lad?"

The door behind the boy opened, and a woman's voice spoke.

"If it's Joe Carraclough ye want, he's out in the shed—and been there shut up half the afternoon."

"What's this lad talking about—a dog of mine being here?"

"Nay," the woman snapped quickly. "He didn't say a tyke o' thine was here. He said it wasn't here."

"Well, what dog o' mine isn't here, then?"

The woman swallowed, and looked about as if for help. The duke stood, peering from under his jutting eyebrows. Her answer, truth or lie, was never spoken, for then they heard the rattle of a door opening, and a man making a pursing sound with his lips, as he will when he wants a dog to follow, and then Joe Carraclough's voice said: "This is t' only tyke us has here. Does it look like any dog that belongs to thee?"

With his mouth opening to cry one last protest, the boy turned. And his mouth stayed open. For there he saw his father, Joe Carraclough, the collie fancier, standing with a dog at his heels—a dog that sat at his left heel patiently, as any well-trained dog should do—as Lassie used to do. But this dog was not Lassie. In fact, it was ridiculous to think of it at the same moment as you thought of Lassie.

For where Lassie's skull was aristocratic and slim this dog's head was clumsy and rough. Where Lassie's ears stood in twin-lapped symmetry, this dog had one ear

draggling and the other standing up Alsatian fashion in a way to give any collie breeder the cold shivers. Where Lassie's coat was rich tawny gold, this dog's coat had ugly patches of black; and where Lassie's apron was a billowing stretch of snow-white, this dog had puddles of off-color blue-merle mixture. Besides, Lassie had four white paws, and this one had one paw dirty-brown, and one almost black.

That is the dog they all looked at as Joe Carraclough stood there, having told no lie, having only asked a question. They all stood, waiting the duke's verdict.

But the duke said nothing. He only walked forward, slowly, as if he were seeing a dream. He bent beside the collie, looking with eyes that were as knowing about dogs as any Yorkshireman alive. And those eyes did not waste themselves upon twisted ears, or blotched marking, or rough head. Instead they were looking at a paw that the duke lifted, looking at the underside of the paw, staring intently at five black pads, crossed and recrossed with the scars where thorns had lacerated, and stones had torn.

For a long time the duke stared, and when he got up he did not speak in Yorkshire accents any more. He spoke as a gentleman should, and he said: "Joe Carraclough. I never owned this dog. 'Pon my soul, she's never belonged to me. Never!"

Then he turned and went stumping down the path, thumping his cane and saying: "Bless my soul. Four hundred miles! Damme, wouldn't ha' believed it. Damme—five hundred miles!"

He was at the gate when his granddaughter whispered to him fiercely.

"Of course," he cried. "Mind your own business. Exactly what I came for. Talking about dogs made me forget. Carraclough! Carraclough! What're ye hiding for?"

"I'm still here, sir."

"Ah, there you are. You working?"

"Eigh, now. Working," Joe said. That's the best he could manage.

"Yes, working, working!" The duke fumed.

"Well, now——" Joe began.

Then Mrs. Carraclough came to his rescue, as a good housewife in Yorkshire will.

"Why, Joe's got three or four things that he's been considering," she said, with proper display of pride. "But he hasn't quite said yes or no to any of them yet."

"Then say no, quick," the old man puffed. "Had to sack Hynes. Didn't know a dog from a drunken filly. Should ha' known no damn Londoner could handle dogs fit for Yorkshire taste. How much, Carraclough?"

"Well, now," Joe began.

"Seven pounds a week, and worth every penny," Mrs. Carraclough chipped in. "One o' them other of-fers may come up to eight," she lied, expertly. For there's always a certain amount of lying to be done in life, and when a woman's married to a man who has, made a lifelong cult of being honest, then she's got to learn to do the lying for two.

"Five," roared the duke—who, after all, was a Yorkshireman, and couldn't help being a bit sharp about things that pertained to money.

"Six," said Mrs. Carraclough.

"Five pound ten," bargained the duke, cannily.

"Done," said Mrs. Carraclough, who would have been willing to settle for three pounds in the first place. "But, o' course, us gets the cottage too."

"All right," puffed the duke. "Five pounds ten and the cottage. Begin Monday. But—on one condition. Carraclough, you can live on my land, but I won't have that thick-skulled, screw-lugged, gay-tailed eyesore of a misshapen mongrel on my property. Now never let me see her again. You'll get rid of her?"

He waited, and Joe fumbled for words. But it was the boy who answered, happily, gaily: "Oh, no, sir. She'll be waiting at school for me most o' the time. And, anyway, in a day or so we'll have her fixed up and coped up so's ye'd never, never recognize her."

"I don't doubt that," puffed the duke, as he went to the car. "I don't doubt ye could do just exactly that."

It was a long time afterward, in the car, that the girl said: "Don't sit there like a lion on the Nelson column. And I thought you were supposed to be a hard man."

"Fiddlesticks, m'dear. I'm a ruthless realist. For five years I've sworn I'd have that dog by hook or crook, and now, egad, at last I've got her."

"Pooh! You had to buy the man before you could get his dog."

"Well, perhaps that's not the worst part of the bargain."

The year was 1870. A Missouri lawyer named George C. Vest was representing in court a farmer whose hunting dog had been shot by a neighbor. He said:

"Gentlemen of the jury, the best friend a man has in this world may turn against him and become his enemy. His son or daughter whom he has reared with loving care may prove ungrateful. Those who are nearest and dearest to us—those whom we trust with our happiness and our good name—may become traitors to their faith. The money that a man has he may lose. It flies away from him, perhaps when he needs it most. A man's reputation may be sacrificed in a moment of ill-considered action. The people who are prone to fall on their knees to do us honor when success is with us may be the first to throw the stone of malice when failure settles its clouds upon our heads. The one absolutely unselfish friend that man can have in this selfish world—the one that never deserts him, the one that never proves ungrateful or treacherous—is his dog."

Moved, the jury awarded compensation of $500.

Sooner or later boy and dog must part. In "Breaking Home Ties" (1954) a loving dog like Lassie is left behind when the farm boy goes off to college.

Stephen Vincent Benét

Doc Mellhorn and the Pearly Gates

DOC MELLHORN had never expected to go anywhere at all when he died. So, when he found himself on the road again, it surprised him. But perhaps I'd better explain a little about Doc Mellhorn first. He was seventy-odd when he left our town; but when he came, he was as young as Bates or Filsinger or any of the boys at the hospital. Only there wasn't any hospital when he came. He came with a young man's beard and a brand-new bag and a lot of newfangled ideas about medicine that we didn't take to much. And he left, forty-odd years later, with a first-class county health record and a lot of people alive that wouldn't have been alive if he hadn't been there. Yes, a country doctor. And nobody ever called him a man in white or a death grappler that I know of, though they did think of giving him a degree at Pewauket College once. But then the board met again and decided they needed a new gymnasium, so they gave the degree to J. Prentiss Parmalee instead.

Rockwell illustrated "Doc Mellhorn" for the Post *in 1938.*

They say he was a thin young man when he first came, a thin young man with an Eastern accent who'd wanted to study in Vienna. But most of us remember him chunky and solid, with white hair and a little bald spot that always got burned bright red in the first hot weather. He had about four card tricks that he'd do for you, if you were a youngster—they were always the same ones—and now and then, if he felt like it, he'd take a silver half-dollar out of the back of your neck. And that worked as well with the youngsters who were going to build rocket ships as it had with the youngsters who were going to be railway engineers. It always worked.

I guess it was Doc Mellhorn more than the trick. But there wasn't anything unusual about him, except maybe the card tricks. Or, anyway, he didn't think so. He was just a good doctor and he knew us inside out. I've heard people call him a pigheaded, obstinate old mule—that was in the fight about the water supply. And I've heard a weepy old lady call him a saint. I took the tale to him once, and he looked at me over his glasses and said, "Well, I've always respected a mule. Got ten times the sense of a—horse." Then he took a silver half-dollar out of my ear.

Well, how do you describe a man like that?

You don't—you call him up at three in the morning. And when he sends in his bill, you think maybe it's a little steep.

All the same, when it came to it, there were people who drove a hundred and fifty miles to the funeral. And the Masons came down from Bluff City, and the Poles came from across the tracks, with a wreath the size of a house, and you saw cars in town that you didn't often see there. But it was after the funeral that the queer things began for Doc Mellhorn.

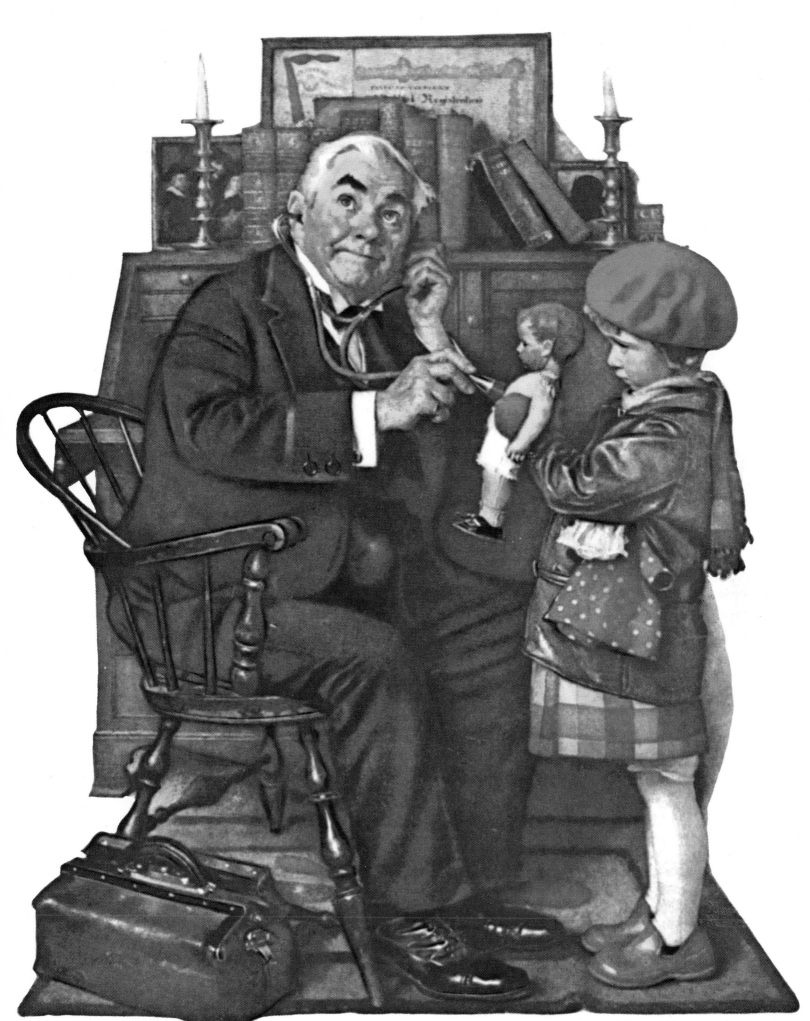

The definitive portrait *of the kindly small-town physician like Doc Mellhorn was painted for a 1929 Post cover.*

Dr. George A. Russell of Arlington, Vermont, appears in "Norman Rockwell Visits a Family Doctor," a 1947 Post *feature.*

The last thing he remembered, he'd been lying in bed, feeling pretty sick, on the whole, but glad for the rest. And now he was driving his Model T down a long straight road between rolling, misty prairies that seemed to go from nowhere to nowhere.

It didn't seem funny to him to be driving the Model T again. That was the car he'd learned on, and he kept to it till his family made him change. And it didn't seem funny to him not to be sick anymore. He hadn't had much time to be sick in his life—the patients usually attended to that. He looked around for his bag, first thing, but it was there on the seat beside him. It was the old bag, not the presentation one they'd given him at the hospital, but that was all right too. It meant he was out on a call and, if he couldn't quite recollect at the moment just where the call was, it was certain to come to him. He'd wakened up often enough in his buggy, in the old days, and found the horse was taking him home, without his doing much about it. A doctor gets used to things like that.

On the doctor's desk, a photo of his daughter, an Army nurse. On the wall, his diploma. In the rocker, his dog Bozo.

All the same, when he'd driven and driven for some time without raising so much as a traffic light, just the same rolling prairies on either hand, he began to get a little suspicious. He thought, for a while, of stopping the car and getting out, just to take a look around, but he'd always hated to lose time on a call. Then he noticed something else. He was driving without his glasses. And yet he hadn't driven without his glasses in fifteen years.

"H'm," said Doc Mellhorn. " Either I'm crazy as a June bug. Or else—— Well, it might be so, I suppose."

But this time he did stop the car. He opened his bag and looked inside it, but everything seemed to be in order. He opened his wallet and looked at that, but there were his own initials, half rubbed away, and he recognized them. He took his pulse, but it felt steady.

"H'm," said Doc Mellhorn. "Well."

Then, just to prove that everything was perfectly normal, he took a silver half-dollar out of the steering wheel of the car.

Dr. Russell made house calls in a battered Ford coupe.

"Never did it smoother," said Doc Mellhorn. "Well, all the same, if this is the new highway, it's longer than I remember it."

Just then a motorcycle came roaring down the road and stopped with a flourish, the way motor cops do.

"Any trouble?" said the motor cop. Doc Mellhorn couldn't see his face for his goggles, but the goggles looked normal.

"I am a physician," said Doc Mellhorn, as he'd said a thousand times before to all sorts of people, "on my way to an urgent case." He passed his hand across his forehead. "Is this the right road?" he said.

"Straight ahead to the traffic light," said the cop. "They're expecting you, Doctor Mellhorn. Shall I give you an escort?"

"No; thanks all the same," said Doc Mellhorn, and the motor cop roared away. The Model T ground as Doc Mellhorn gassed her. "Well, they've got a new breed of traffic cop," said Doc Mellhorn, "or else——"

But when he got to the light, it was just like any light at a crossroads. He waited till it changed and the officer waved him on. There seemed to be a good deal of traffic going the other way, but he didn't get a chance to notice it much, because Lizzie bucked a little, as she usually did when you kept her waiting. Still, the sight of traffic relieved him, though he hadn't passed anybody on his own road yet.

Pretty soon he noticed the look of the country had changed. It was a parkway now and very nicely landscaped. There was dogwood in bloom on the little hills, white and pink against the green; though, as Doc Mellhorn remembered it, it had been August when he left his house. And every now and then there'd be a nice little white-painted sign that said TO THE GATES.

"H'm," said Doc Mellhorn. "New State Parkway, I guess. Well, they've fixed it up pretty. But I wonder

When he could take a day off, the doctor went fishing . . .

. . . Or he just loafed, at a hideaway cabin with no phone.

"Ought to have looked up Paisley," he said. "Yes, I ought. Didn't amount to a hill of beans, I guess, but I always liked him. I wonder if he still plays the Jew's harp. Pshaw, I know he's been dead for at least twenty years."

He was passing other cars now and other cars were passing him, but he didn't pay much attention, except when he happened to notice a license you didn't often see in the state, like Rhode Island or Mississippi. He was too full of his own thoughts. There were foot passengers, too, plenty of them—and once he passed a man driving a load of hay. He wondered what the man

Russell was Rockwell's own physician, also a long-time friend.

where they got the dogwood. Haven't seen it bloom like that since I was East."

Then he drove along in a sort of dream for a while, for the dogwood reminded him of the days when he was a young man in an Eastern college. He remembered the look of that college and the girls who'd come to dances, the girls who wore white gloves and had rolls of hair. They were pretty girls, too, and he wondered what had become of them. "Had babies, I guess," thought Doc Mellhorn. "Or some of them, anyway." But he liked to think of them as the way they had been when they were just pretty, and excited at being at a dance.

He remembered other things too—the hacked desks in the lecture rooms, and the trees on the campus, and the first pipe he'd ever broken in, and a fellow called Paisley Grew that he hadn't thought of in years—a rawboned fellow with a gift for tall stories and playing the Jew's harp.

would do with the hay when he got to the Gates. But probably there were arrangements for that.

"Not that I believe a word of it," he said, "but it'll surprise Father Kelly. Or maybe it won't. I used to have some handsome arguments with that man, but I always knew I could count on him, in spite of me being a heretic."

Then he saw the Wall and the Gates, right across the valley. He saw them, and they reached to the top of the sky. He rubbed his eyes for a while, but they kept on being there.

"Quite a sight," said Doc Mellhorn.

No one told him just where to go or how to act, but it seemed to him that he knew. If he'd thought about it, he'd have said that you waited in line, but there wasn't any waiting in line. He just went where he was expected to go and the reception clerk knew his name.

"Yes, Doctor Mellhorn," he said. "And now, what would you like to do first?"

Doc Mellhorn doesn't know what he wants to do because he doesn't really believe any of this. The clerk suggests calling one of Doc's relatives or some distinguished member of the medical profession (Hippocrates, perhaps? Aesculapius?) to show him around.

Doc demurs, asking if there isn't, instead, some work he can do. The clerk explains there is no illness here.

Idleness in this comfortable but bland Heaven is not attractive to Doc. To escape, he insists that he is really on a call; some patient needs him. The patient's name? Doc dredges up from memory the name of his old classmate, Paisley Grew. Luck is with him; the clerk finds no one by that name registered in Heaven. Paisley Grew must be in the "other establishment," Doc decides, and he asks how to get there.

"There is, I believe, a back road in rather bad repair," said the reception clerk icily. "I can call Information if you wish."

"Oh, don't bother," said Doc Mellhorn. "I'll find it. And I never saw a road beat Lizzie yet." He took a silver half-dollar from the door-knob of the door. "See that?" he said, "Slick as a whistle. Well, good-bye, young man."

But it wasn't till he'd cranked up Lizzie and was on his way that Doc Mellhorn really felt safe. He found the back road and it was all the reception clerk had said it was and more. But he didn't mind—in fact, after one particularly bad rut, he grinned.

"I suppose I ought to have seen the folks," he said. "Yes, I know I ought. But—not so much as a case of mumps in the whole abiding dominion! Well, it's lucky I took a chance on Paisley Grew."

Well, the road got worse and worse and the sky above it darker and darker, and, what with one thing and another, Doc Mellhorn was glad enough when he got to the other gates. They were pretty impressive gates, too, though of course in a different way, and reminded Doc Mellhorn a little of the furnaces outside Steeltown, where he'd practiced for a year when he was young.

This time Doc Mellhorn wasn't going to take any advice from reception clerks, and he had his story all ready. All the same, he wasn't either registered or expected, so there was a little fuss. Finally they tried to scare him by saying he came at his own risk and that there were some pretty tough characters about. But Doc Mellhorn remarked that he'd practiced in Steeltown. So, after he'd told them what seemed to him a million times that he was a physician on a case, they finally let him in and directed him to Paisley Grew. Paisley was on Level 346 in Pit 68,953 and Doc Mellhorn recognized him the minute he saw him. He even had the Jew's harp with him, stuck in the back of his overalls.

"Well, Doc," said Paisley finally, when the first greetings were over, "you certainly are a sight for sore eyes!

Though, of course, I'm sorry to see you here," and he grinned.

"Well, I can't see that it's so different from a lot of places," said Doc Mellhorn, wiping his forehead. "Warmish, though."

"It's the humidity, really," said Paisley Grew. "That's what it really is."

"Yes, I know," said Doc Mellhorn. "And now tell me, Paisley; how's that indigestion of yours?"

"Well, I'll tell you, Doc ," said Paisley. "When I first came here, I thought the climate was doing it good. I did for a fact. But now I'm not so sure. I've tried all sorts of things for it—I've even tried being transferred to the boiling asphalt lakes. But it just seems to hang on, and every now and then, when I least expect it, it catches me. Take last night. I didn't have a thing to eat that I don't generally eat—well, maybe I did have one little snort of hot sulphur, but it wasn't the sulphur that did it. All the same, I woke up at four, and it was just like a knife. Now——"

He went on from there and it took him some time. And Doc Mellhorn listened, happy as a clam. He never thought he'd be glad to listen to a hypochondriac, but he was. And when Paisley was all through, he examined him and prescribed for him. It was just a little soda bicarb and pepsin, but Paisley said it took hold something wonderful. And they had a fine time that evening, talking over the old days.

Finally, of course, the talk got around to how Paisley liked it where he was. And Paisley was honest enough about that.

"Well, Doc," he said, "of course this isn't the place for you, and I can see you're just visiting. But I haven't many real complaints. It's hot, to be sure, and they work you, and some of the boys here are rough. But they've had some pretty interesting experiences, too, when you get them talking—yes, sir. And anyhow, it isn't Peabodyville, New Jersey," he said with vehe-

mence. "I spent five years in Peabodyville, trying to work up in the leather business. After that I busted out, and I guess that's what landed me here. But it's an improvement on Peabodyville." He looked at Doc Mellhorn sidewise. "Say, Doc," he said, "I know this is a vacation for you, but all the same there's a couple of the boys—nothing really wrong with them of course—but—well, if you could just look them over——"

"I was thinking the office hours would be nine to one," said Doc Mellhorn.

So Paisley took him around and they found a nice little place for an office in one of the abandoned mine galleries, and Doc Mellhorn hung out his shingle. And right away patients started coming around. They didn't get many doctors there, in the first place, and the ones they did get weren't exactly the cream of the profession, so Doc Mellhorn had it all to himself. It was mostly sprains, fractures, bruises and dislocations, of course, with occasional burns and scalds—and, on the whole, it reminded Doc Mellhorn a good deal of his practice in Steeltown, especially when it came to foreign bodies in the eye. Now and then Doc Mellhorn ran into a more unusual case—for instance, there was one of the guards that got part of himself pretty badly damaged in a rock slide. Well, Doc Mellhorn had never set a tail before, but he managed it all right, and got a beautiful primary union, too, in spite of the fact that he had no X-ray facilities. He thought of writing up the case for the State Medical Journal, but then he couldn't figure out any way to send it to them, so he had to let it slide. And then there was an advanced carcinoma of the liver—a Greek named Papadoupolous or Prometheus or something. Doc Mellhorn couldn't do much for him, considering the circumstances, but he did what he could, and he and the Greek used to have long conversations. The rest was just everyday practice—run of the mine—but he enjoyed it.

Now and then it would cross his mind that he ought to get out Lizzie and run back to the other place for a visit with the folks. But that was just like going back East had been on earth—he'd think he had everything pretty well cleared up, and then a new flock of patients would come in. And it wasn't that he didn't miss his wife and children and grandchildren—he did. But there wasn't any way to get back to them, and he knew it. And there was the work in front of him and the office crowded every day. So he just went along, hardly noticing the time.

Now and then, to be sure, he'd get a suspicion that he wasn't too popular with the authorities of the place. But he was used to not being popular with authorities and he didn't pay much attention. But finally they sent an inspector around. The minute Doc Mellhorn saw him, he knew there was going to be trouble.

Not that the inspector was uncivil. In fact, he was a pretty high-up official—you could tell by his antlers.

There is, it seems, bureaucratic red tape in Hell. In the first place, Doc is not supposed to be there. He has no license to practice. He has turned in unauthorized requests for supplies. Furthermore, the management does not favor making the inhabitants more comfortable; they are supposed to suffer. The management is willing to give Doc a farewell banquet to express the community's appreciation, but he must leave.

When he was back on the road again and the lights of the gates had faded into a low ruddy glow behind him, Doc Mellhorn felt alone for the

first time. He'd been lonely at times during his life, but he'd never felt alone like this before. Because, as far as he was able to see, there was only him and Lizzie left now.

"Now, maybe if I'd talked to Aesculapius——" he said. "But pshaw, I always was pigheaded."

He didn't pay much attention to the way he was driving and it seemed to him that the road wasn't quite the same. But he felt tired for a wonder—bone-tired and beaten—and he didn't much care about the road. He hadn't felt tired since he left earth, but now the loneliness tired him.

"Active—always been active," he said to himself. "I can't just lay down on the job. But what's a man to do?

"What's a man to do?" he said. "I'm a doctor. I can't work miracles."

Then the black fit came over him and he remembered all the times he'd been wrong and all the people he couldn't do anything for. "Never was much of a doctor, I guess," he said. "Maybe, if I'd gone to Vienna. Well, the right kind of man would have gone. And about that Bigelow kid," he said. "How was I to know he'd hemorrhage? But I should have known.

"I've diagnosed walking typhoid as appendicitis. Just the once, but that's enough. And I still don't know what held me back when I was all ready to operate. I used to wake up in a sweat, afterwards, thinking I had.

"I could have saved those premature twins, if I'd known as much then as I do now. But I didn't. And that finished the Gorhams' having children. That's a dandy doctor, isn't it? Makes you feel fine.

"I could have pulled Old Man Halsey through. And Edna Biggs. And the little Lauriat girl. No, I couldn't have done it with her. That was before insulin. I couldn't have cured Ted Allen. No, I'm clear on that. But I've never been satisfied about the Collins woman. Bates is all right—good as they come. But I knew her, inside and out—ought to, too—she was the biggest

nuisance that ever came into the office. And if I hadn't been down with the flu——

"Then there's the flu epidemic. I didn't take my clothes off, four days and nights. But what's the good of that, when you lose them? Oh, sure, the statistics looked good. You can have the statistics.

"Should have started raising hell about the water supply two years before I did.

"Oh, yes, it makes you feel fine, pulling babies into the world. Makes you feel you're doing something. And just fine when you see a few of them, twenty, thirty years later, not worth two toots on a cow's horn. Can't say I ever delivered a Dillinger. But there's one or two in state's prison. And more that ought to be. Don't mind even that so much as a few of the fools. Makes you wonder.

"And then, there's incurable cancer. That's a daisy. What can you do about it, doctor? Well, doctor, we can alleviate the pain in the last stages. Some. Ever been in a cancer ward, doctor? Yes, doctor, I have.

"What do you do for the common cold, doctor? Two dozen clean linen handkerchiefs. Yes, it's a good joke— I'll laugh. And what do you do for a boy when you know he's dying, doctor? Take a silver half-dollar out of his ear. But it kept the Lane kid quiet and his fever went down that night. I took the credit, but I don't know why it went down.

"I've only got one brain. And one pair of hands.

"I could have saved. I could have done. I could have.

"Guess it's just as well you can't live forever. You make fewer mistakes. And sometimes I'd see Bates looking at me as if he wondered why I ever thought I could practice.

"Pigheaded, opinionated, ineffective old imbecile! And yet, Lord, Lord, I'd do it all over again."

He lifted his eyes from the pattern of the road in front of him. There were white markers on it now and Lizzie seemed to be bouncing down a residential street.

There were trees on the street and it reminded him of town. He rubbed his eyes for a second and Lizzie rolled on by herself—she often did. It didn't seem strange to him to stop at the right house.

"Well, mother," he said rather gruffly to the group on the lawn. . . . "Well, dad. . . . Well, Uncle Frank." He beheld a small, stern figure advancing, hands out-stretched. "Well, grandma," he said meekly.

Later on he was walking up and down in the grape arbor with Uncle Frank. Now and then he picked a grape and ate it. They'd always been good grapes, those Catawbas, as he remembered them.

"What beats me," he said, not for the first time, "is why I didn't notice the Gates. The second time, I mean."

"Oh, that Gate," said Uncle Frank, with the easy, unctuous roll in his voice that Doc Mellhorn so well remembered. He smoothed his handlebar mustache. "That Gate, my dear Edward—well, of course it has to be there in the first place. Literature, you know. And then, it's a choice," he said richly.

"I'll draw cards," said Doc Mellhorn. He ate another grape.

"Fact is," said Uncle Frank, "that Gate's for one kind of person. You pass it and then you can rest for all eternity. Just fold your hands. It suits some."

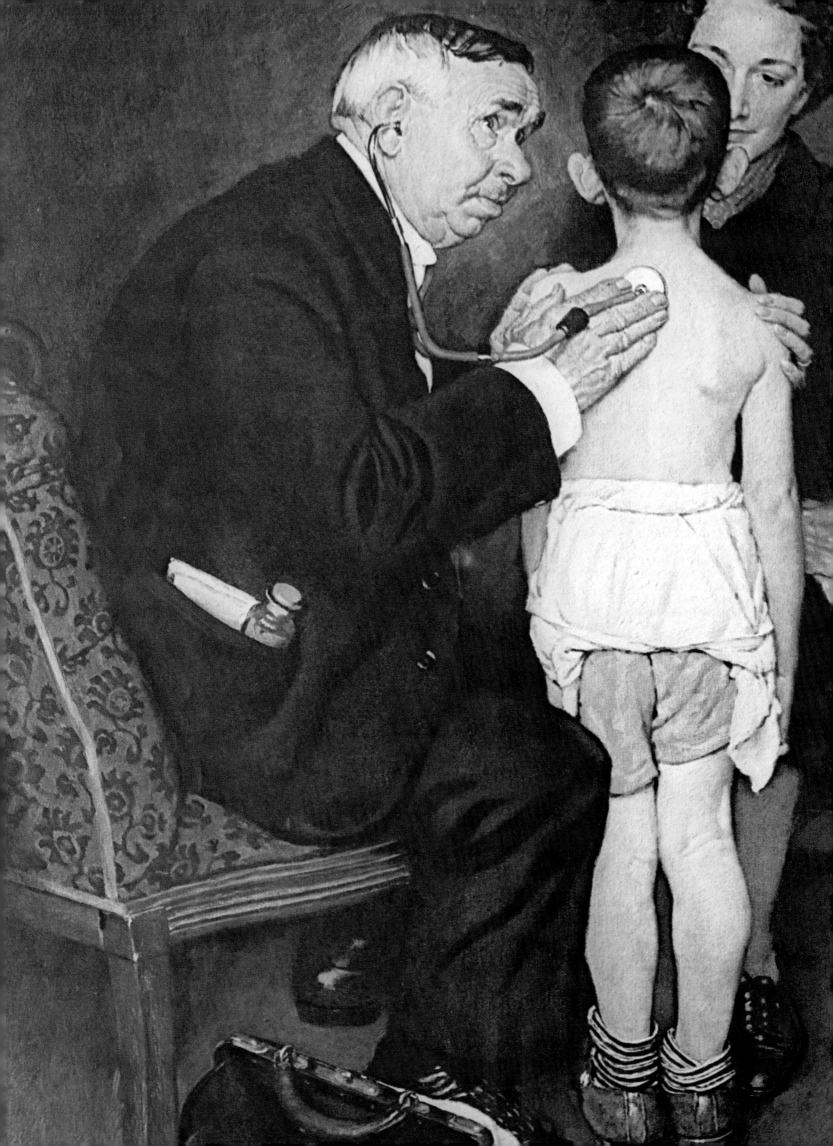

"Nobody ever called him a man in white or a death grappler. Doc Mellhorn was just a good doctor who knew us inside out."

"I can see that it would," said Doc Mellhorn.

"Yes," said Uncle Frank, "but it wouldn't suit a Mellhorn. I'm happy to say that very few of our family remain permanently on that side. I spent some time there myself." He said, rather self-consciously, "Well, my last years had been somewhat stormy. So few people cared for refined impersonations of our feathered songsters, including lightning sketches. I felt that I'd earned a rest. But after a while—well, I got tired of being at liberty."

"And what happens when you get tired?"

"You find out what you want to do."

"My kind of work?" said Doc Mellhorn.

"Your kind of work," said his uncle. "Been busy, haven't you?"

"Well," said Doc Mellhorn. "But here. If there isn't so much as a case of mumps in——"

"Would it have to be mumps?" said his uncle. "Of course, if you're aching for mumps, I guess it could be arranged. But how many new souls do you suppose we get here a day?"

"Sizable lot, I expect."

"And how many of them get here in first-class condition?" said Uncle Frank triumphantly. "Why, I've seen Doctor Rush—Benjamin Rush—come back so tired from a day's round he could hardly flap one pinion against the other. Oh, if it's work you want—— And then, of course, there's the earth."

"Hold on," said Doc Mellhorn. "I'm not going to appear to any young intern in wings and a harp. Not at my time of life. And anyway, he'd laugh himself sick."

"Tain't that," said Uncle Frank. "You've left children and grandchildren behind you, haven't you?"

"Yes," said Doc Mellhorn.

"Same with what you did," said Uncle Frank. "I mean the inside part of it—that stays. I don't mean any funny business—voices in your ear and all that. But haven't you ever got got clean tuckered out, and been

able to draw on something you didn't know was there?"

"Pshaw, any man's done that," said Doc Mellhorn. "But you take the adrenal——"

"Take anything you like," said Uncle Frank placidly. "I'm not going to argue with you. But you'll find it isn't all adrenalin. Like it here?" he said abruptly.

"Why, yes," said Doc Mellhorn.

"No, they wouldn't all arrive in first-class shape," he said to himself. "So there'd be a place." He turned to Uncle Frank. "By the way," he said diffidently, "there wouldn't be a chance of my visiting the other establishment now and then? Where I just came from? I'd like to keep in touch."

"Well," said Uncle Frank, "you can take that up with the delegation. Sister's been in a stew about it all day. She says there won't be enough chairs."

"Delegation?" said Doc Mellhorn. "But——"

"You don't realize," said Uncle Frank. "You're a famous man. You've broken pretty near every regulation except the fire laws, and refused the Gate first crack. They've got to do something about it."

"But——" said Doc Mellhorn.

"Sh-h!" hissed Uncle Frank. "It won't take long—just a welcome. My," he said with frank admiration, "you've certainly brought them out. There's Rush, second from the left, third row, in a wig. And there's——"

Then he stopped, and stepped aside. A tall grave figure was advancing down the grape arbor—a bearded man with a wise, majestic face who wore robes as if they belonged to him, not as Doc Mellhorn had seen them worn in college commencements. In his left hand, Doc Mellhorn noticed without astonishment, was a winged staff entwined with two fangless serpents.

The bearded figure stopped in front of Doc Mellhorn. "Welcome, brother," said Aesculapius.

"It's an honor to meet you, doctor," said Doc Mellhorn. He shook the outstretched hand. Then he took a silver half-dollar from the mouth of the left-hand snake.

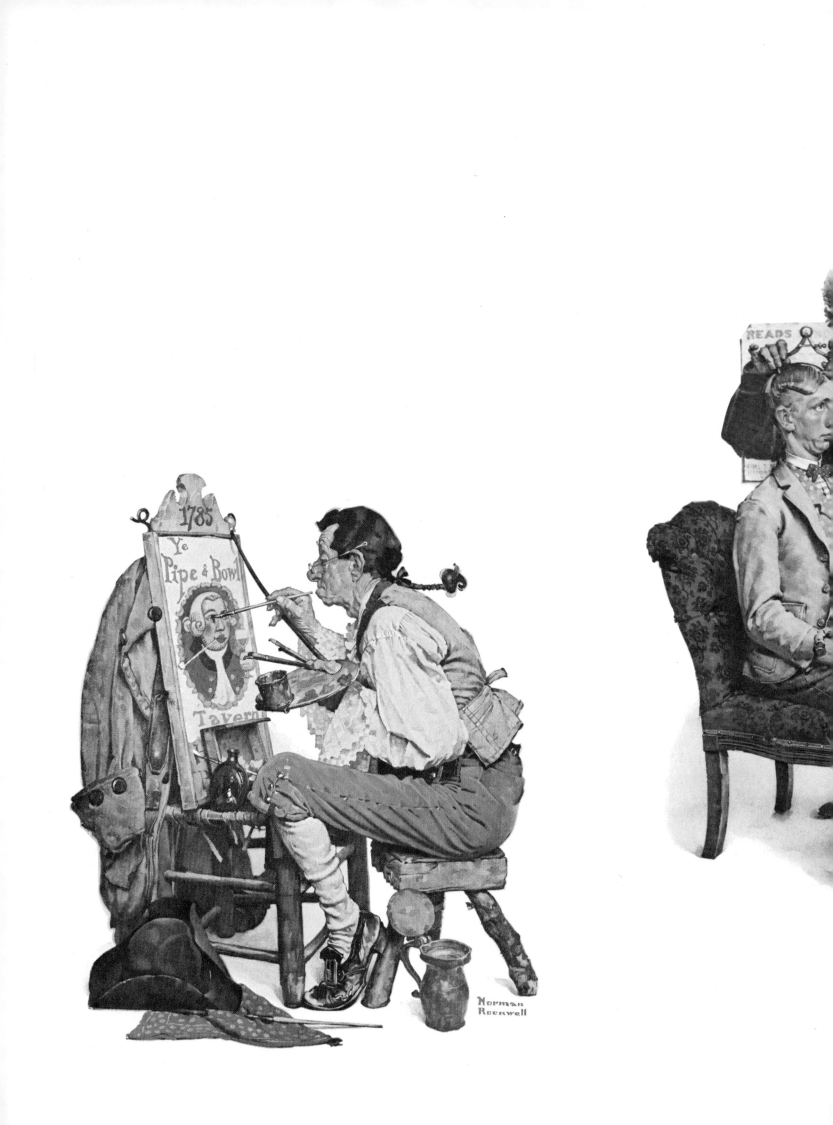

Mark Twain
Riverboat Days

WHEN I WAS A BOY there was but one permanent ambition among my comrades in our village on the west bank of the Mississippi River. That was to be a steamboatman. We had transient ambitions of other sorts but they were only transient. When a circus came and went, it left us all burning to become clowns; the first Negro minstrel show that ever came to our section left us all suffering to try that kind of life; now and then we had a hope that, if we lived and were good, God would permit us to be pirates. These ambitions faded out, each in its turn; but the ambition to be a steamboatman always remained.

Once a day a cheap, gaudy packet arrived upward from St. Louis, and another downward from Keokuk. Before these events, the day was glorious with expectancy; after them, the day was a dead and empty thing. Not only the boys but the whole village felt this. After all these years I can picture that old time to myself now, just as it was then: the white town drowsing in the sunshine of a summer's morning; the streets empty or pretty nearly so; one or two clerks sitting in front of the Water Street stores, with their splint-bottomed chairs tilted back against the walls, chins on breasts, hats slouched over their faces, asleep—with shingle-shavings enough around to show what broke them down; a sow and a litter of pigs loafing along the sidewalk, doing a good business in watermelon rinds and seeds; two or three lonely little freight piles scattered about the "levee"; a pile of "skids" on the slope of the stone-paved wharf, and the fragrant town drunkard asleep in the shadow of them; two or three wood flats at the head of the wharf but nobody to listen to the peaceful lapping of the wavelets against them; the great Mississippi, the majestic, the magnificent Mississippi, rolling its mile-wide tide along, shining in the sun; the dense forest away on the other side; the "point" above the town, and the "point" below, bounding the river-glimpse and turning it into a sort of sea, and withal a

"One of my better illustrations, I think," Rockwell said of this pilothouse scene painted for a 1940 Post story about a steamboat race.

very still and brilliant and lonely one. Presently a film of dark smoke appears above one of those remote "points"; instantly a Negro drayman, famous for his quick eye and prodigious voice, lifts up the cry, "S-t-e-a-m-boat a-comin'!" and the scene changes! The town drunkard stirs, the clerks wake up, a furious clatter of drays follows, every house and store pours out a human contribution, and all in a twinkling the dead town is alive and moving. Drays, carts, men, boys, all go hurrying from many quarters to a common center, the wharf. Assembled there, the people fasten their eyes upon the coming boat as upon a wonder they are seeing for the first time. And the boat *is* rather a handsome sight, too. She is long and sharp and trim and beautiful; she has two tall, fancy-topped smokestacks, with an ornate gilded device of some kind

In the 1840's there was glory in riverboating—flags flying, bells ringing, black smoke rolling.

swung between them; a fanciful pilot-house, all glass and "gingerbread," perched on top of the "texas" deck behind them; the paddle-boxes are gorgeous with a picture or with gilded rays above the boat's name; the boiler-deck, the hurricane-deck, and the texas deck are fenced and ornamented with clean white railings; there is a flag gallantly flying from the jack-staff; the furnace doors are open and the fires glaring bravely; the upper decks are black with passengers; the captain stands by the big bell, calm, imposing, the envy of all; great volumes of the blackest smoke are rolling and tumbling out of the chimneys—a husbanded grandeur created with a bit of pitch-pine just before arriving at a town; the crew are grouped on the forecastle; the broad stage

is run far out over the port bow and an envied deckhand stands picturesquely on the end of it with a coil of rope in his hand; the pent steam is screaming through the gauge-cocks; the captain lifts his hand, a bell rings, the wheels stop; then they turn back, churning the water to foam, and the steamer is at rest. Then such a scramble as there is to get aboard and to get ashore, and to take in freight and to discharge freight, all at one and the same time; such a yelling and cursing as the mates facilitate it all with! Ten minutes later the steamer is underway again, with no flag on the jack-staff and no black smoke issuing from the chimneys. After ten more minutes the town is dead again and the town drunkard asleep by the skids once more.

This famous native son of Hannibal, Missouri, was talking about his river's hold on the imagination of youngsters in the 1840's. Some things never change. Boys still dream of a life on the river and, even in the 1970's, young men leave a comfortable home to live and work on the riverboats. One such is M. J. Sebastian Smith, just 21 years old when he wrote "Of Time and Two Rivers" for the September, 1976, Post.

THESE DAYS I AM A RIVER RAT, a deckhand on the towboats, a catechumen in the rain of the Ohio and Mississippi Rivers. An occupation that never fails to elicit the same reaction from sod walkers, landbound people.

"Oh really," they say with whitewash showing round each iris. "What do you do out there?"

I try to tell them. "Well, we wire up the tow, make locks, pick up barges, throw lashings."

"You what?"

End of conversation, beginning of monologue.

First, towboat is a misnomer; the vessel does not pull, it pushes. Barges, held in a formation called a tow, by heavy steel wire rope, are the object of the boat's shoving. Paddle wheels have become rare, the great steering wheels are even further gone. Propeller blades and levers have won out. The company that keeps me hauls mostly steel and coal: bituminous coal from Kentucky up to Pittsburgh; from the mills there comes finished steel bound for New Orleans and ports between. The return run finds ore in the barge coffers. Treasures of mines, furnace and foundry.

It takes roughly twenty-eight days to make the crescent city/Pittsburgh run up and back. The standard crew is eleven: four deckhands, a watchman, cook, mate, chief engineer, oiler, pilot and captain. Every six hours the watches change. From twelve to six is the after watch, manned by the mate, two deckhands and pilot. From six to twelve is the forward watch, presided over by the

In the 1970's, more power, less glory. The towboat's engineer and captain have radar and voice phone but no wheel, just a lever for steering.

watchman (who relieves the mate), the remaining deckhands, the captain (who relieves the pilot) and the oiler, who cons the engine room. The chief engineer is on twenty-four-hour emergency call; normally he wakes and rests as he wills. To provide three square meals a day, order supplies and keep the galley in order is entirely up to the cook.

So much for base lines. The color, the texture, we and the river fill in together, alone. Except for our ghosts.

Inevitably, the man in the white suit, cigar in hand and age-lined voice, strides with each syllable. Much as we owe him, Master Clemens's river is not our river. In his day the sound of vessels was a steam whistle, a calliope cry: full, rich, mellow. Gabriel would have been hard pressed to better it. Now, on-board compressors vent their anxious blast out of horns. Their sound is a wail, strident and piercing; a warning not a greeting. The archangel's revenge.

I can't identify with Samuel. The boats under his hand knew ladies in perfumed dresses, kisses by moonlight and diamond-studded gamblers. Our floating world is steel rather than wood and we know only coal dust and rust.

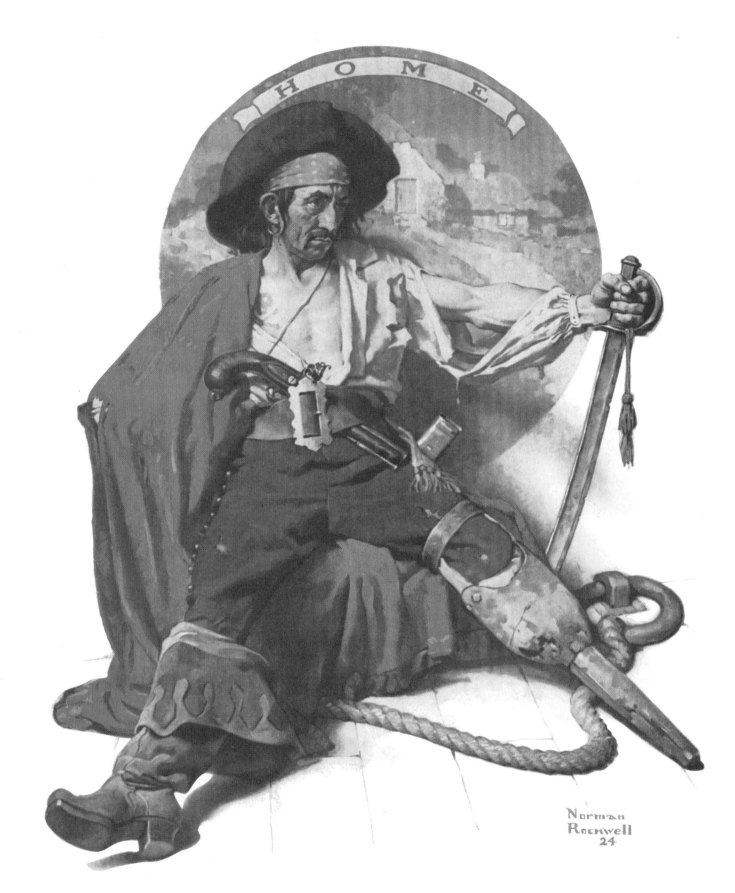

Whenever I find myself growing grim about the mouth; whenever it is damp, drizzly November in my soul; whenever I find myself involuntarily pausing before coffin warehouses, and bring up the rear of every funeral I meet; and especially whenever my hypos get such an upper hand of me, that it requires a strong moral principle to prevent me from deliberately stepping into the street, and methodically knocking people's hats off—then, I account it high time to get to sea as soon as I can. This is my substitute for pistol and ball. With a philosophical flourish Cato throws himself upon his sword; I quietly take to the ship. There is nothing surprising in this. If they but knew it, almost all men in

their degree, some time or other, cherish very nearly the same feelings towards the ocean with me . . . Why is almost every robust boy with a robust healthy soul in him, at some time or other crazy to go to sea? . . . Surely all this is not without meaning. And still deeper the meaning of that story of Narcissus, who because he could not grasp the tormenting, mild image he saw in the fountain, plunged into it and was drowned. But the same image, we ourselves see in all rivers and oceans. It is the image of the ungraspable phantom of life; and this is the key to it all.

from Moby Dick *by Herman Melville*

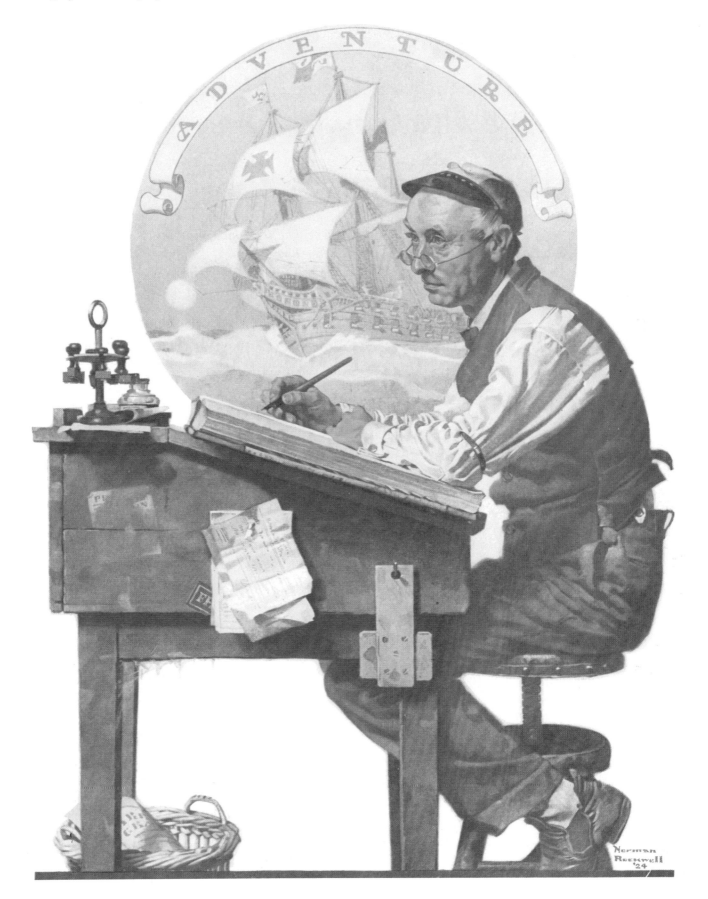

Edward W. O'Brien
The Blacksmiths' Contest

The year is 1907, the place is a small-town blacksmith's shop. "I got fifty dollars, Frank, says no man in this locality can heel and toe, in a day's goin's, as many shoes as McCann."

Frank Farrell takes up the challenge, and the great horseshoe forging contest is on. Frank, who is a town man and the father of the boy telling the story, and Jack McCann, an itinerant horseshoer with an awesome reputation, are to work side by side for ten hours. The shoes they handle have already been shaped to the curve of a horse's hoof. The men are to heat the shoes, a few at a time, until the metal is softened and they can bend up the ends (the heel) and weld a plate on the curve (the toe), by skillful blows of their heavy hammers. The one who completes the most shoes by the day's end will be the winner.

McCann is the first to complete a shoe. At noon he is three shoes ahead but neither man is tiring. A crowd gathers. Tension mounts. The scene is described by Frank's son in the excerpt that follows:

BY THREE-THIRTY, McCann's lead was cut to under two, and his red-haired, freckled arms swung the four-pound hammer as though it were a toy, and his anvil block quivered. But for all his pounding, pop edged up, and Jimmy talked to me, low.

"See how it is, sonny? Your daddy doesn't seem to strike as hard as Jack; but he does. Besides, he hits exactly the right place, in exactly the right way, and doesn't have to undo some he's already done. Jack thinks an arm like his can't be beat, but Frank's catching up. And when he does, he'll belt it out with that McCann at McCann's own game. So, by and by, we'll show McCann a little muscle work too."

The afternoon wore on; three-forty-five and four; four-thirty, and close to five, and pop worked to within one shoe of McCann, in spite of all that McCann did, and he did plenty. Then a man came in with two kettles, the workers and judges had a glass, and the others took a seventh-inning stretch. The bench overflowed with men; every keg was a seat, and half a dozen squeezed onto the loft stairs. Tom Jackson ordered the hasp put on the door, but men outside rubbed dirt from the windows and peered in.

I'll never forget that last hour. And never, I imagine, will any of those who watched. McCann peeled down to his red undershirt, pop was still behind that one shoe, and it was hard for me to breathe, because my stomach was in a ball. Both men were lost to everything now but the swing from the forge to the anvil, the heels to be turned and the toes to be welded. Nip and tuck they went, almost heel-and-toe abreast, but when pop started singing Molly Brannigan, I knew McCann's dog was as good as dead. Pop's hair glistened with sweat where it showed in front of the derby that rode his head the way a shield fronts the prow of a war galley, and all of him, natural and acquired, was black. Hands, arms, neck and face were blacker than his hair. His dark eyes sparkled in that black mask of a face, and the thought came to me that with all the brutal work of it, this was what he really loved best; best of all: The smell of soft coal, hot-iron scale, his own healthy sweat, and the feel of the ball-peen hammer in his big right fist, whaling away, up and down, up and down, let 'er have it! Above his own blows and those of McCann, his voice rose in the rapid, sing-song, minstrel beat of the piece:

Oh! Man dear, did ye niver hear, of pretty Molly Brannigan?
And troth she's gone and left me and I'll niver be a man ag'in!
Not a spot on me hide will the summer sun e'er tan ag'in,
Since Molly's gone and left me, here alo-one, fer t'die.

McCann's red mane shook to the beat and nodded to the words, like a Percheron stallion prancing to music,

Rockwell illustrated this story for the Post in 1940, using black and white for the wintry exterior scene, full color for the firelit interior.

and before pop could start another verse, McCann's baritone took it up, in a ringing, bellowing challenge, wild as the wild Irish moors around Inishcarra, where he said he was foaled.

And both forges driving like fury, for all the song. Pop had a Stillson-wrench grip on his tongs, as though he'd just begun, instead of whaling away at that anvil since seven a-morning, and his arm, from the strong fulcrum of his elbow, rose and fell the same as it did ten hours ago, and like black magic, the iron, the black metal from which comes the name of his trade, shaped itself hurriedly at his will. Striking or not, his hammer never idled. Often, squinting a moment at his shoe, he'd keep his hammer dancing on the face, and he'd break the tempo; clatter the heel and ball. Then, swiftly, "Wallop! Wallop! Wallop—wallop!" he'd strike in miniature thunder, and McCann'd dance a challenging answer from the back forge, as though they were two fiddles, one dropping the melody, the other taking up the tune, and, as old Jimmy said about McCann, the big devil having himself a fine time of it, still confident as all hell.

Then pop called to McCann, "Now Jackie, old boy, old boy; tune up your anvil, for it's a lively piece we'll play this last part of the hour."

"I'm your man, Frank! The back turn of the track's ahead, comin' into the stretch. The bit's in me teeth, and my stride ain't faltering. Let 'er go!"

McCann went, and the Lord knows his stride *wasn't* faltering; not that any of us could see, it wasn't! He surprised everyone, maybe even pop, for no one believed mortal man could work harder or faster than he had, the last brace of hours. He drove like an iron man, his undershirt was wet across the chest and shoulders, and he scattered the men in front of his anvil, the way he flung hot scale, taking shoes out of the fire.

"Ah! But pop looks good to me, pop looks good to me!" I told myself happily, for with all Jack's lambasting, pop was coming on, coming on; part of a heel, then a heel, then part of the other heel, and nobody was sitting now. Men still pounded on the door, and in my pockets, where nobody could see, I clenched and unclenched my fists, and my palms were sticky.

His heats came out of the fire just as fast as McCann's, and he flung his own hot scale in a flashing semicircle. Glittering sparks flew around his bare arms and beat against his leather apron as his hammer bit into the hot iron with vicious, sullen thumps. His anvil strained against its block clamps, and when he rounded out on the horn, the hollow booming thundered through the shop, up to the peaked roof and down again, as though trying to find a way out. The cadence changed to the sharp, clear ring of the face; then back to the melodious horn, like a big bell tolling, but fast and insistent.

That last quarter hour was something grand to see, and remember! Two black maniacs in a welter of muscle and sweat and skill. McCann, for a brief part of that last quarter, hung tenaciously to the pace, the way a bur clings to a filly's tail, sweating out the best that was in him, but in that final, inhuman drive, pop inched up, up, irresistible, with a surge of power and speed that McCann couldn't stem, and when the whistles blew six, he was ahead two heels and almost a toe; almost a whole shoe, and bedlam broke loose, drowning out the whistles. Men pounded one another on their backs, shook hands, and let out whoops could be heard over at Thropp's pattern shop. McCann loosed a yell that cut through the others like a power saw whining through

65

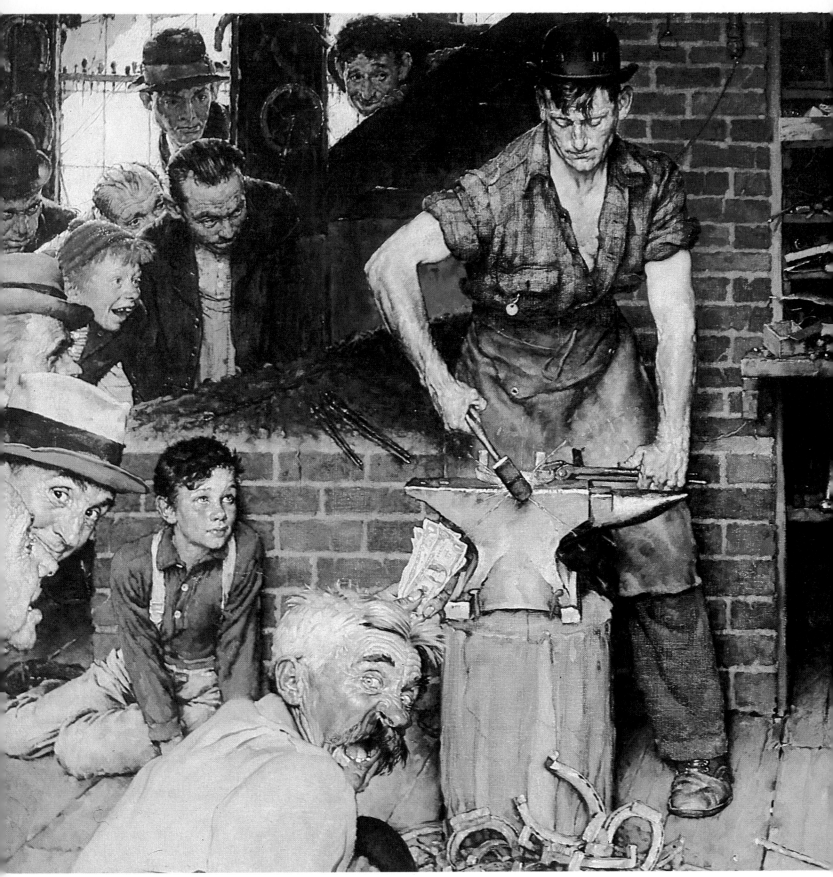

"Tom Jackson ordered the hasp put on the door, but men outside rubbed dirt from the windows and peered in to see how the race was going.

oak, and I heard the pigeons flying around upstairs.

McCann threw his hammer on the floor, strode over, and with both hands shook pop's right, and said he'd never swung against a better man, or one as good. The outcome had changed him; the cocksureness had come out with the sweat, and a better man stood forth. "Now, Frankie, me boy," he said, "do you please be sending old Jimmy up to Lou's and nail a handle on that keg, just for me. A dram less wouldn't quench the thirst that's on me."

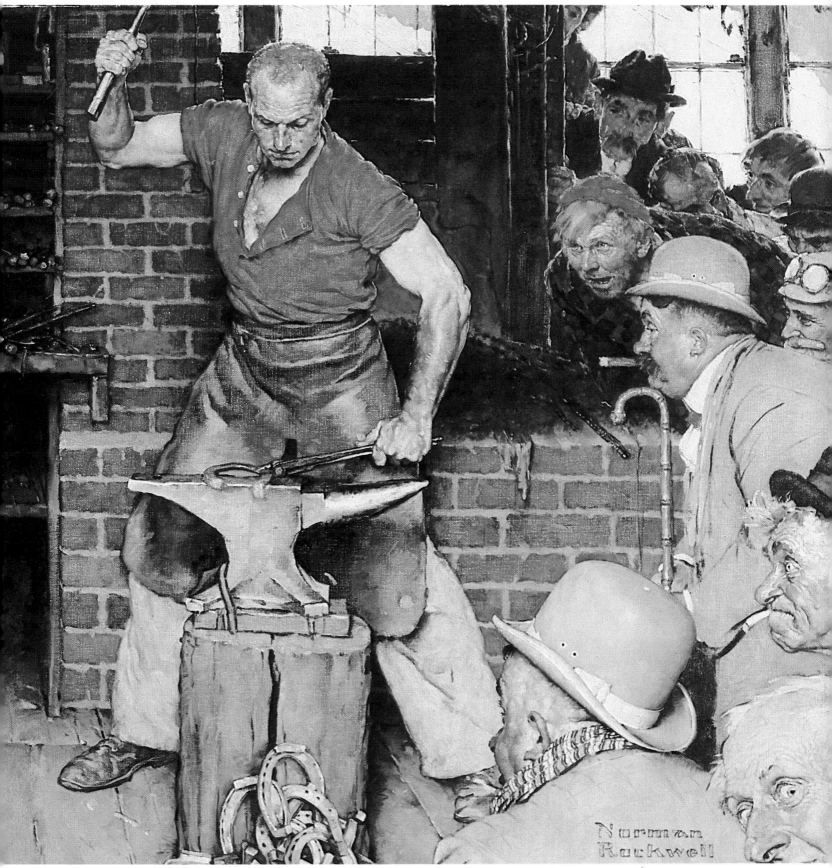

"Both men were lost to everything now but the swing from the forge to the anvil, the heels to be turned and the toes to be welded."

Through the alley window I saw mother looking out between the curtains, resting her hands on the sill. She wore a dark dress and a white collar, and white lace down the front, and she waved to me, and smiled.

All the men went up the street to Lou's. I watched them go, and I can see them yet; pop and McCann striding in front, where they belonged, shoulder to shoulder, black derby and flaming hair, both in their prime, young and strong. Two good men!

from "Blacksmith's Boy—Heel and Toe" (1940)

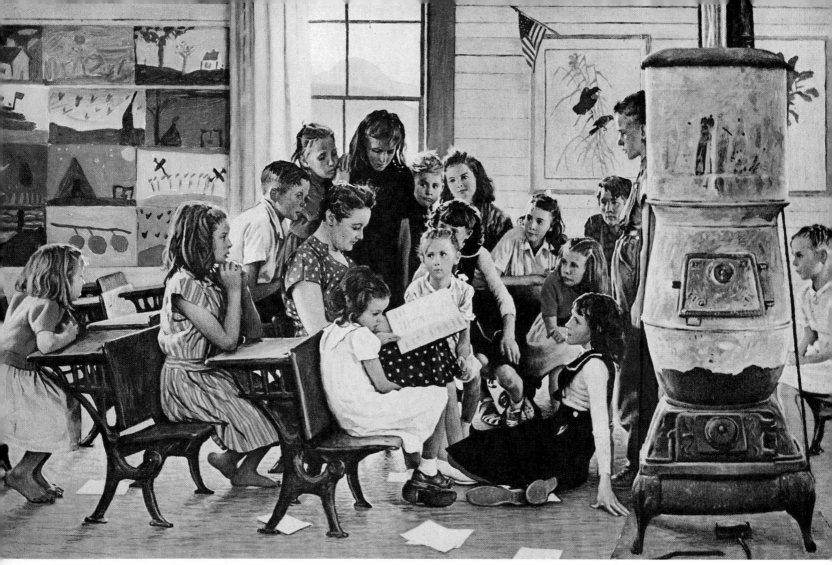

Mrs. Effie McGuire and her pupils in Oak Mountain, Georgia, a 1946 Post feature.

School Days

FIRST, can anyone tell why the one-room country school is famous? That's right, it is where millions of Americans had their first brush with education, where they first had to learn that Montana is west of the Mississippi, that 9 times 9 is 81, and that words which ought to end in "ible" invariably double-cross you and end in "able." And what else? Yes, because it was to schools like this that some of our most succesful citizens trudged heroic distances through snow piling higher every time they tell it. . . . It is a good thing that Mrs. McGuire loves the work, for this weather-beaten schoolhouse has all the shortcomings of its kind. The plumbing is outdoors, the washbowl on the porch, someone has to tote coal for Big Joe, the stove. The pay is thin soup; it has been as low as $420 a year, and even now is only $878.

from "Norman Rockwell Visits a Country School"
November 2, 1946

At left, teachers and pupils from another era.
(1926 and 1935) At right, Happy Birthday, Miss Jones! (1956)

The border text reads:
Knights of the Table Round · Old King Cole · Robin Hood of Sherwood Fore[st] ... ... The Jester · Aladdin · The Wisdom of ... ... Little Boy Blue · Robin Hood · King Arthur · The Last of the ... The Cat and the Fiddle · Old Mother Goose and her Book of Nursery Rhymes

THE LAND OF

The man who commissioned this storybook mural for his children's playroom lost heavily in the stock market crash of 1929 and had to cancel the order.

"Reading," Sir Francis Bacon said a good many years ago, "maketh a full man." Full men are what we need to resist the tide of homogenization in our life. Full men are individuals, robust and strong. Full men might have a fighting chance of reshaping the organization of modern society so that we will still have the incalculable benefits of the mass-production age without paying the price in terms of the erosion of individuals. So let us read, and encourage everyone else to read, and do

ncHancment

Norman Rockwell

Later, Rockwell finished the painting for a 1934 Post feature. It hangs today in the Children's Room of the New Rochelle, New York, Public Library.

everything else to turn ours into a reading society. No one can tell what this nation will be like 100 years from now. But one prediction is pretty safe: that, if we as a people have lost the habit of reading, if we have become a passive people, a society of viewers rather than thinkers, we will have lost our intellectual and moral vitality; and when these are gone, everything else will be about ready to go too.

from an editorial by Arthur Schlesinger, Jr., April 18, 1959

Mary Roberts Rinehart
The Schoolgirl Crush

If there had been such a word as teenager in 1916 Mary Roberts Rinehart might have used it rather than the term "sub-debutante" to identify her young heroine who attends a boarding school where spelling is taught with notable lack of success. Babs the Sub-Deb became almost as popular with Saturday Evening Post *readers as Mrs. Rinehart's other unlikely heroine, the elderly but adventurous maiden lady named Tish. Humor was not the chief element in all Rinehart offerings, however; still others were tightly plotted and suspenseful detective stories. Her work appeared in the* Post *more than 100 times between 1910 and 1949.*

JANUARY, 2ND. Today I wrote my French theme, beginning "*Les hommes songent moins à* leur Ame qú *à leur* corps." Mademoiselle sent for me and objected, saying that it was not a theme for a young girl, and that I must write a new one, on the subject of pears. How is one to develop in this atmosphere?

Some of the girls are comeing back. They stragle in, and put the favers they got at cotilions on the dresser, and their holaday gifts, and each one relates some amorus experience while at home. Dear dairy, is there something wrong with me, that Love has passed me by? I have had offers of Devotion but none that apealed to me, being mostly either to young or not atracting me by physicle charm. I am not cold, although frequently acused of it. Beneath my fridgid Exterior beats a warm heart. I intend to be honest in this dairy, so I admit it. But, except for passing Fansies—one being, alas, for a married man—I remain without the Divine Passion.

Today's helpfull Deed—asisted one of the younger girls with her spelling.

JANUARY 4TH. Miss Everett's couzin's play is comeing here. The school is to have free tickets, as they are "trying it on the dog." Which means seeing if it is good enough for the large cities.

JANUARY 10TH. I have written this Date, and now I sit back and regard it. As it is impressed on this white

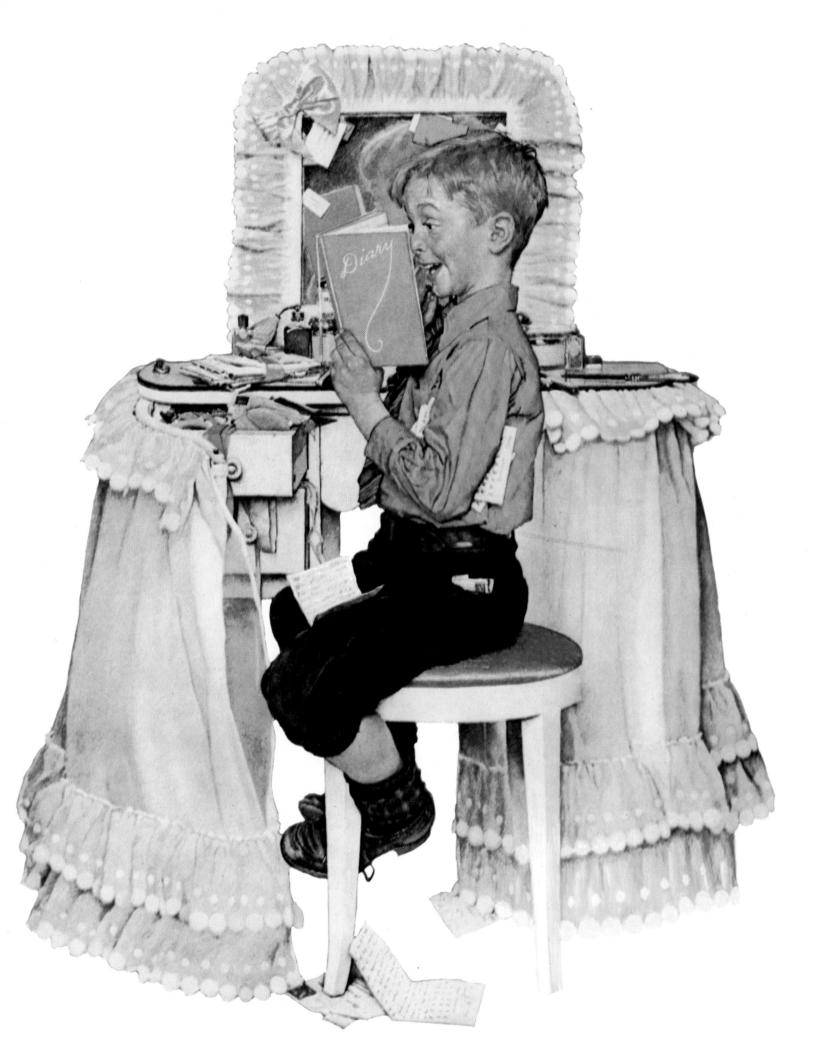

Model Tommy Rockwell was "the kind of kid who would have read his sister's diary—if he had a sister." (1942)

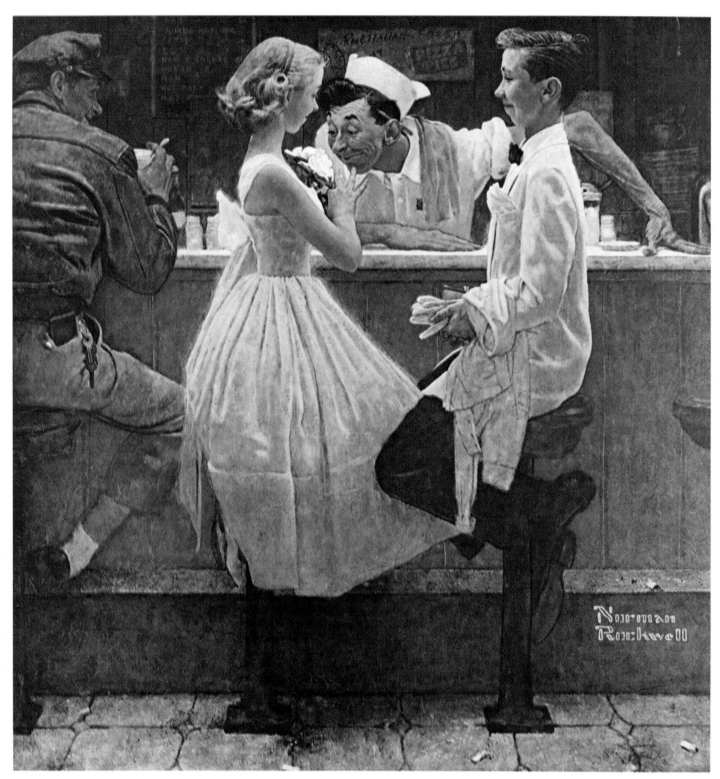

For young Americans the marble-topped soda fountain with swiveling stools was a town's center of communications. (1957)

paper, so, dear dairy, is it written on my Soul. To others it may be but the tenth of January. To me it is the day of days. Oh, tenth of January! Oh, Monday! Oh, day of my awakening!

It is now late at night, and around me my schoolmates are sleeping the sleep of the young and Heart free. Lights being off, I am writing by the faint luminocity of a candel. Propped up in bed, my mackinaw coat over my *robe de nuit* for warmth, I sit and dream. And as I dream I still hear in my ears his final words:

"My darling. My woman!"

How wonderful to have them said to one Night after Night, the while being in his embrase, his tender arms around one! I refer to the heroine in the play, to whom he says the above raptureous words.

Comeing home from the theater tonight, still dazed with the revalation of what I am capable of, once arouzed, I asked Miss Everett if her couzin had said anything about Mr. Egleston being in love with the Leading Lady. She observed:

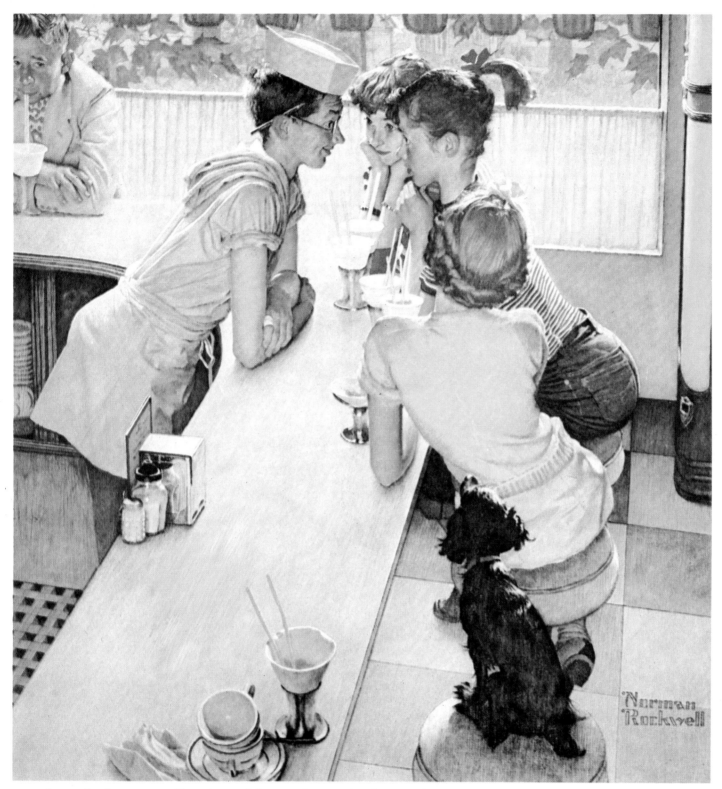

It was the place to see and be seen, to celebrate one's joys and to drown one's sorrows in hot fudge and whipped cream. (1953)

"No, but he may be. She is very pretty."

"Possibly," I remarked. "But I should like to see her in the morning, when she gets up."

All the girls were perfectly mad about Mr. Egleston, although pretending merly to admire his Art. But I am being honest, as I agreed at the start, and now I know, as I sit here with the soft, although chilling breeses of the night blowing on my hot brow, now I know that this thing that has come to me is Love. Morover, it is the Love of my Life. He will never know it, but I am his.

He is exactly my ideal, strong and tall and passionate. And clever, too. He said some awfully clever things.

I believe that he saw me. He looked in my direction. But what does it Matter? I am small, insignifacent. He probably thinks me a mere child, although seventeen.

What matters, oh Dairy, is that I am at last in love. It is hopeless. Just now, when I had written that word, I buried my face in my hands. There is no hope. I shall never see him again. He passed out of my life on the 11:45 train. But I love him. *Mon Dieu,* how I love him.

Phillip Gunion
The Girl...

HALLIE OPENED HER EYES for one bright flash of sunlight, then closed them and smiled sleepily. Although it was a school morning, and getting late, she was still more Lana Turner than she was Hallie.

It was like walking through a moonlit field where every flower that grew was a pair of admiring masculine eyes, and they were all on her. It was a great deal more fun being Lana Turner than it was being Hallie Peters. . . .

Hallie was what is known as "pretty too." This was always said without a great deal of enthusiasm or conviction, and she was darned sure that it was meant to convey an opposite meaning.

Of course, she would admit that her eyes were too blue and too large, but she fervently hoped that Time would widen her face and steal the surprise from her expression. This was the same Time that was to slim her hips and waist. And she had heard that when one was old enough, certain things could be done about the color of one's hair. Only "old enough" was like waiting for a horsecar to drive down the street, or for the Democrats to give up, or something.

Ten years wasted on that man, and the dance was only two days away and he hadn't called. Her only invitation had been from John Smith. Even that had been a disappointment. It hadn't been couched in very romantic terms; his manner had been about as unusual and exciting as his name. "Care to go to the dance with me lemme know by Thursday by." One breath, no expression. . . .

She covered herself with several ounces of clothing and laced up her dirty brown-and-whites.

She did a quick turn in front of the mirror and looked at herself.

She was just beginning to admit to herself that she had breasts, but she wasn't quite sure that she wanted anyone else to know.

from "It Wasn't So Much What He Said" by Philip Gunion (1942)

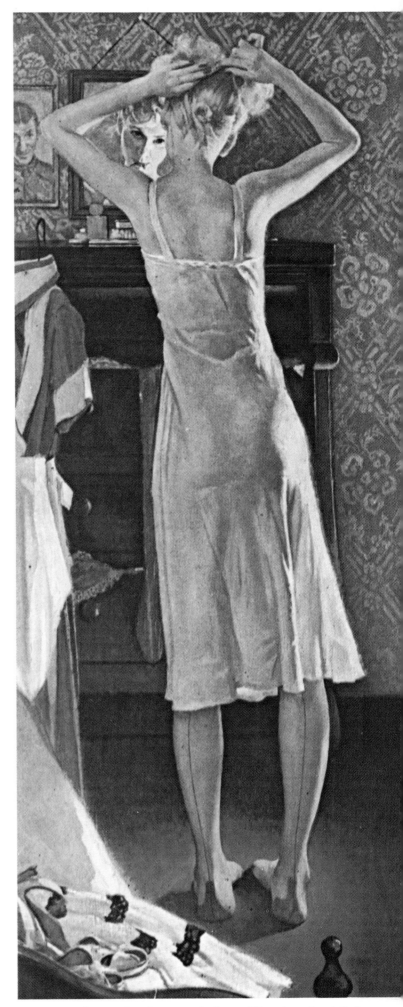

A few minutes from now the boy will knock on the girl's door.

Her father will say, "Come in; she's not quite ready." (1949)

Carson McCullers
The Boy...

MAYBELLE was somehow mixed up in what happened so I guess I ought to start with her. Until I knew her I hadn't given much time to girls. Last fall she sat next to me in General Science class and that was when I first began to notice her. Her hair is the brightest yellow I ever saw and occasionally she will wear it set into curls with some sort of gluey stuff. Her fingernails are pointed and manicured and painted a shiny red. All during class I used to watch Maybelle, nearly all the time except when the teacher called on me. I couldn't keep my eyes off her hands, for one thing. They are very little and white except for that red stuff, and when she would turn the pages of her book she always licked her thumb and held out her little finger and turned very slowly. It is impossible to describe Maybelle. All the boys are crazy about her but she didn't even notice me. For one thing she's almost two years older than I am. Between periods I used to try and pass very close to her in the halls but she would hardly ever smile at me. All I could do was sit and look at her in class—and sometimes it was like the whole room could hear my heart beating and I wanted to holler or light out and run for Hell.

At night, in bed, I would imagine about Maybelle. Often this would keep me from sleeping until as late as one or two o'clock. Sometimes my brother would wake up and ask me why I couldn't get settled and I'd tell him to hush his mouth. I suppose I was mean to him lots of times. I guess I wanted to ignore somebody like Maybelle did me. You could always tell by Sucker's face when his feelings were hurt. I don't remember all the ugly remarks I must have made because even when I was saying them my mind was on Maybelle.

That went on for nearly three months and then somehow she began to change.

In the halls she would speak to me and every morning she copied my homework.

from "Sucker" by Carson McCullers (1963)

O, tender yearning, sweet hoping!
The golden time of first love!
The eye sees the open heaven,
The heart is intoxicated with bliss:
O that the beautiful time of young love
Could remain green forever.

Friedrich von Schiller

The confident prime of the day
And the dauntless youth of the year,
When nothing that asks for bliss,
Asking aright is denied.
And half of the world a bridegroom is,
And half of the world a bride.

Sir William Watson

"Her body was as expressive as her face," Rockwell said of Mary Whalen. He called her "the best little-girl model I ever had." (1954)

The young couple who posed for this 1955 cover were engaged at the time, and they were later married.

Rockwell's wife Mary appears as the bride, bored and ignored at the breakfast table, in a 1930 Post *cover.*

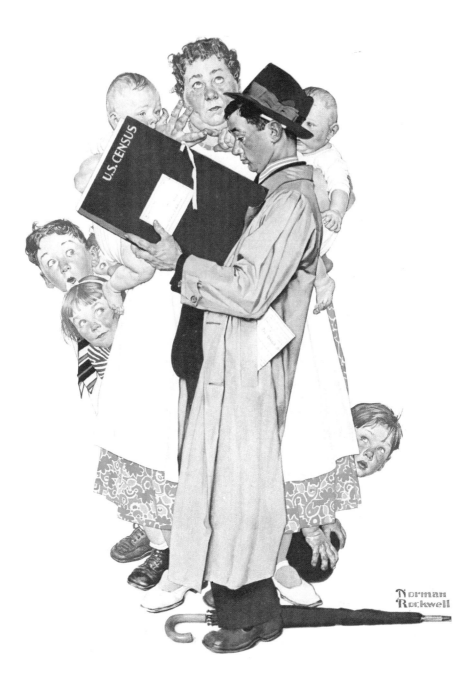

Arthur Schlesinger, Jr.
Love and Marriage

SO FUNDAMENTAL IS THE ROMANTIC DREAM to our lives that we do not realize how small a part of mankind through history has shared it. All ages and cultures, of course, have known marriage and family. Some peoples, like the old Romans or the Indians of the Kamasutra, have thought deeply and ingeniously about sex. But the idea of romantic love as cherished by Americans—the belief in passion and desire as the key to happy marriage and the good life—is relatively new and still largely confined to the Christian world.

"In China," Francis L. K. Hsu has reminded us, "the term 'love,' as it is used by Americans, has never been considered respectable. Up until fairly recent times the term was scarcely ever used in Chinese literature."

And even on the continent of Europe, except as the young in recent years have succumbed to the processes of Americanization, passion has been generally kept distinct from marriage and family. There romantic love, that ennobling emotional experience, has remained an improbable hope, to be pursued outside the normal conventions of life and doomed to tragedy.

Only the Americans have assumed that passion is destined to fulfillment. Only the Americans have attempted on a large scale the singular experiment of trying to incorporate romantic love into the staid and stolid framework of marriage and the family.

Norman Rockwell
The Changing Scene

THINKING UP IDEAS was the hardest work I did in those days. I never saw an idea happen or received one, whoosh, from heaven while I was washing my brushes or shaving or backing the car out of the garage. I had to beat most of them out of my head or at least maul my brain until something *came* out of it. It always seemed to me that it was like getting blood from a stone except, of course, that eventually something always came.

There was one kind of idea which I didn't have to struggle over— the timely idea. I'd just keep my ear to the wind and, when I heard of a craze or fad or anything which everyone was talking about, I'd do a cover of it: the ouija board, the first radios, crossword puzzles, the movies.

In 1920 the whole country was talking about Model T Fords and Henry Ford, so I did a cover (July 1920) of a family riding in a Model T.

The day after Lindbergh flew the At-lantic I called up the art editor at the *Post*. "How about a cover on the pioneers of the air?" I asked. "Okay," he said. "When can you get it to us? It'll have to be fast or we'll miss the boom; it won't be news." "Tomorrow afternoon," I said. I hired a model, dug up an aviator's cap, and set to work. Twenty-six hours later I finished the cover, sent it to Philadelphia, and staggered off to bed.

Nineteen twenty-nine was the year of the speed traps. Instead of asking their citizens to pay taxes, all the small towns hired cops who set up speed traps and fined their victims heavily. Two or three industrious, clever cops could rake in over a thousand dollars a day. The towns grew fat. Finally the newspapers and the automobile clubs began to make a fuss and I heard about it and did a *Post* cover of a policeman holding a stopwatch and hiding behind a town-limits sign.

I did a cover based on the jazz craze (1929), one on the stock market crash (a butcher's boy, a housewife, a grandmother, a millionaire, and a dog, all staring at the stock market reports), one on the hundredth anniversary of baseball in 1939, the 1940 census, the hitchhiking fad (1940), the blackout, women war workers (Rosy the Riveter), the USO, soldiers returning from the war, television.

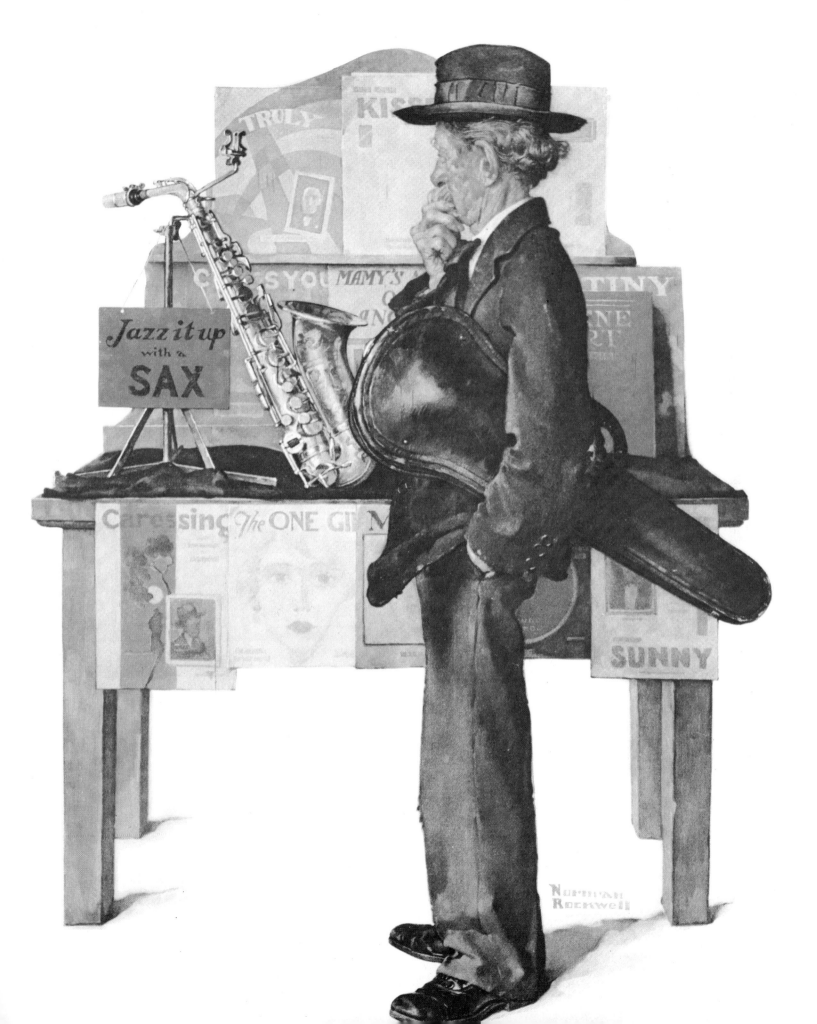

Jazz was new and the saxophone
a sensational novelty in 1929.
Manufacturers had trouble meeting the
demand for the new instrument.

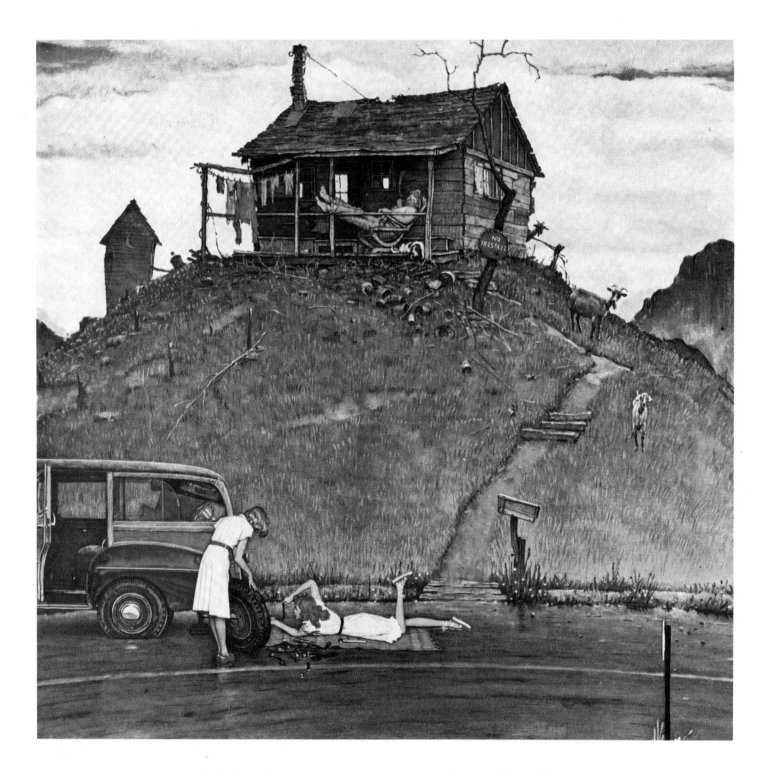

40 Memories to the Gallon

WE SAT ON THE PORCH under the yellow bug light until it got so hot my father said, "Let's take a ride." It meant more to us than his saying "I'm going to give each of you a million dollars." The dog thought so, too.

The car was a Packard, a good car that was to last us for the "duration," that indeterminate block of time in which the war, Roosevelt and all the horrors of the world were to be disposed of. Most people longed more for a new car than for peace, though.

There was no gasoline and they said a man who lived down the street went to sea at night and met German submarines to swap food for gas, and when he got home (late, presumably, since we were 150 miles from the ocean) he would sell scrap metal to the Japanese. We knew it must be true because he had a new car.

The starvation effect of the duration without cars produced such a distortion of time that many of us still think, in terms of cars, that anything postwar is brand-new.

Starkey Flythe, Jr. (1976)

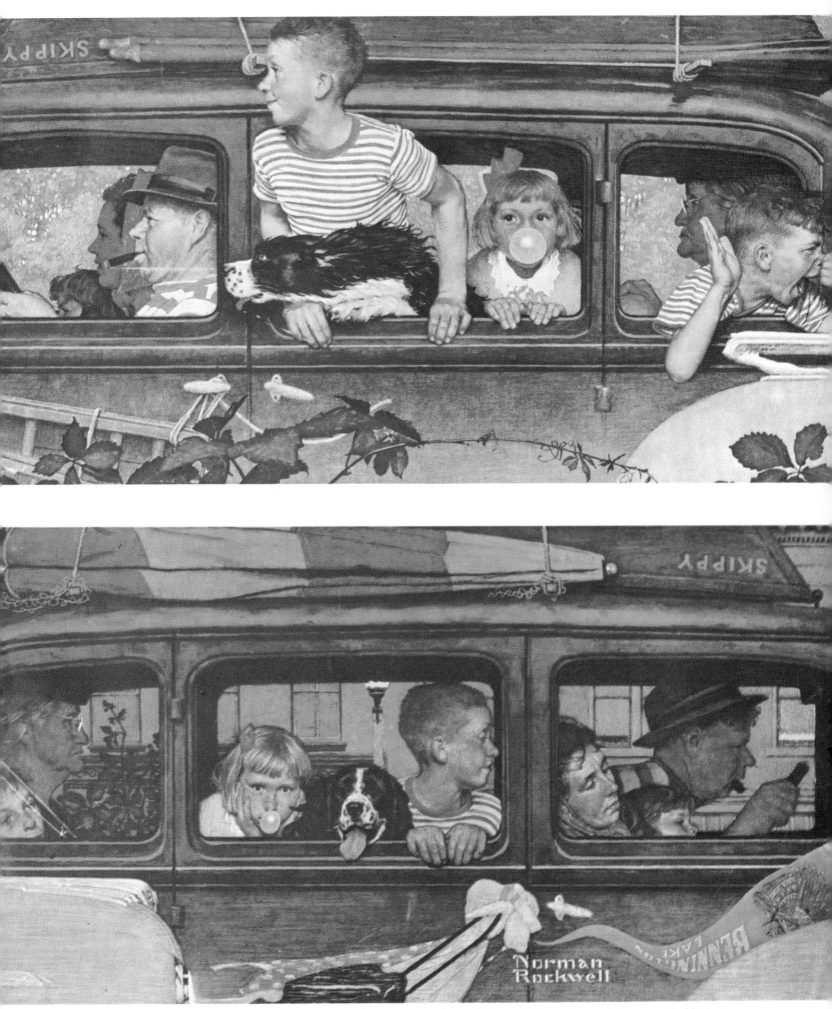

Getting there may be half the fun, but getting home again is clearly not the other half. These 1947 vacationers drive a pre-World War II car.

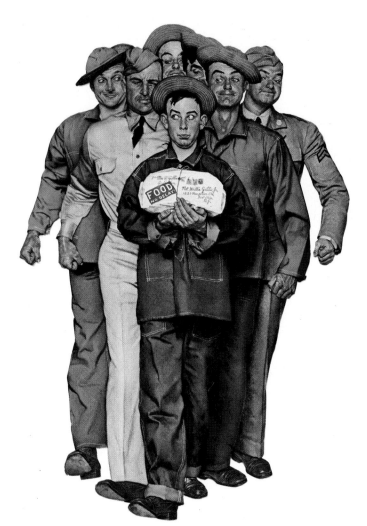

Draftee Willie gets a parcel from home. (1941)

Willie Gillis

HE WAS THE BOY NEXT DOOR, catapulted by fate from the normal world of Saturday night dates, jalopies and chocolate sodas into the Army. Mary Rockwell chose the name Willie Gillis for the hero of the series; the model was Bob Buck, spotted at a West Arlington, Vermont, square dance. Bob later enlisted in the Navy, leaving Rockwell without a model to use in satisfying the demand of *Post* readers for "more Willie covers." Ingeniously, Rockwell painted Willie's girl asleep on New Year's Eve under Willie's picture; then portraits of Willie's wartime ancestors (page 106). The last Willie Gillis cover showed him in college on the G.I. Bill. The original was given to Bob Buck who proudly carried it to the *Post* in Philadelphia himself.

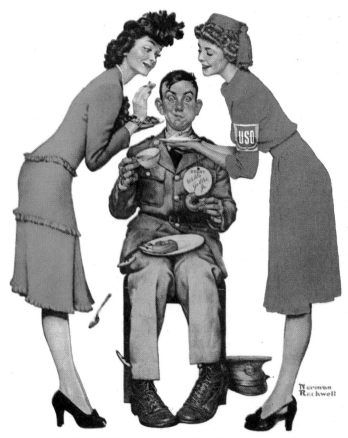

Private Willie is welcomed to the U.S.O. (1942)

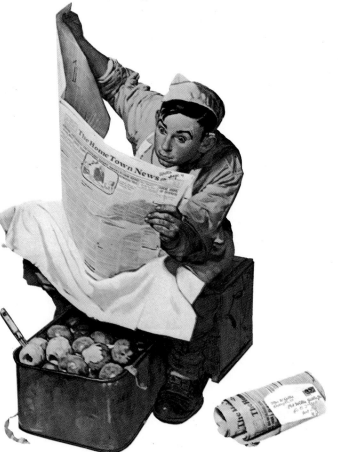

K. P. Willie devours the hometown news. (1942)

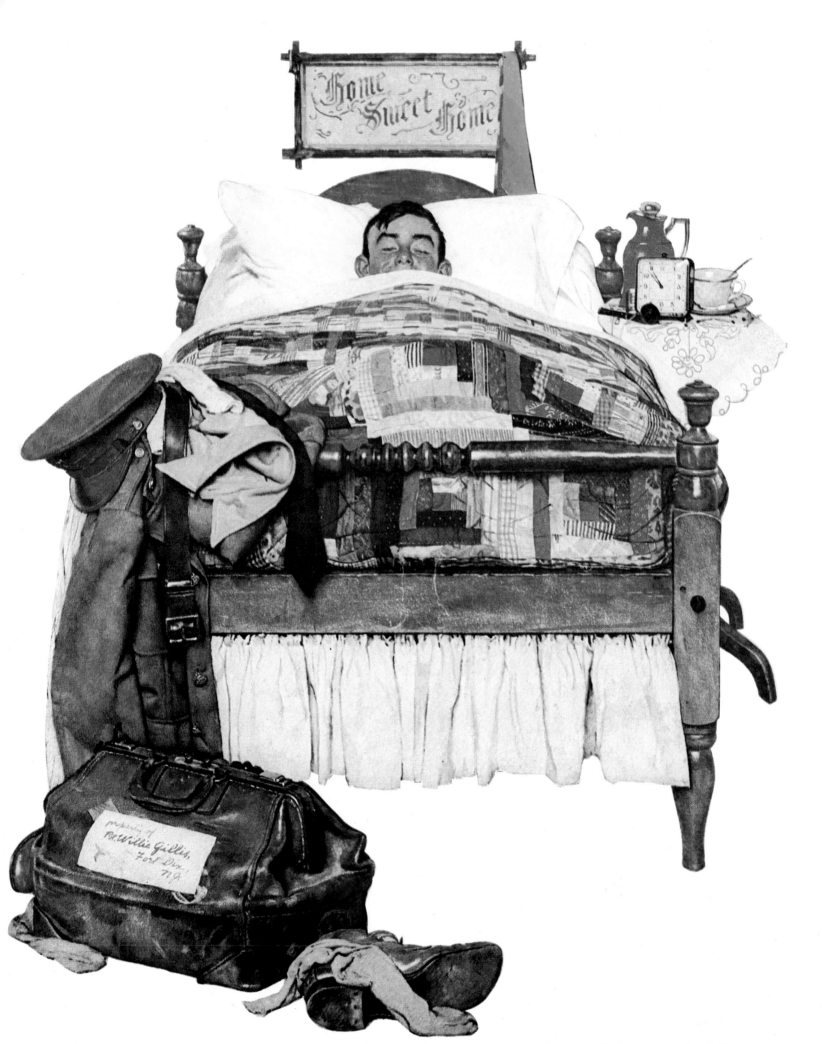

Home on leave, Willie blissfully sleeps past time for reveille. (1941) There were 11 covers in the series; the last appeared in 1946.

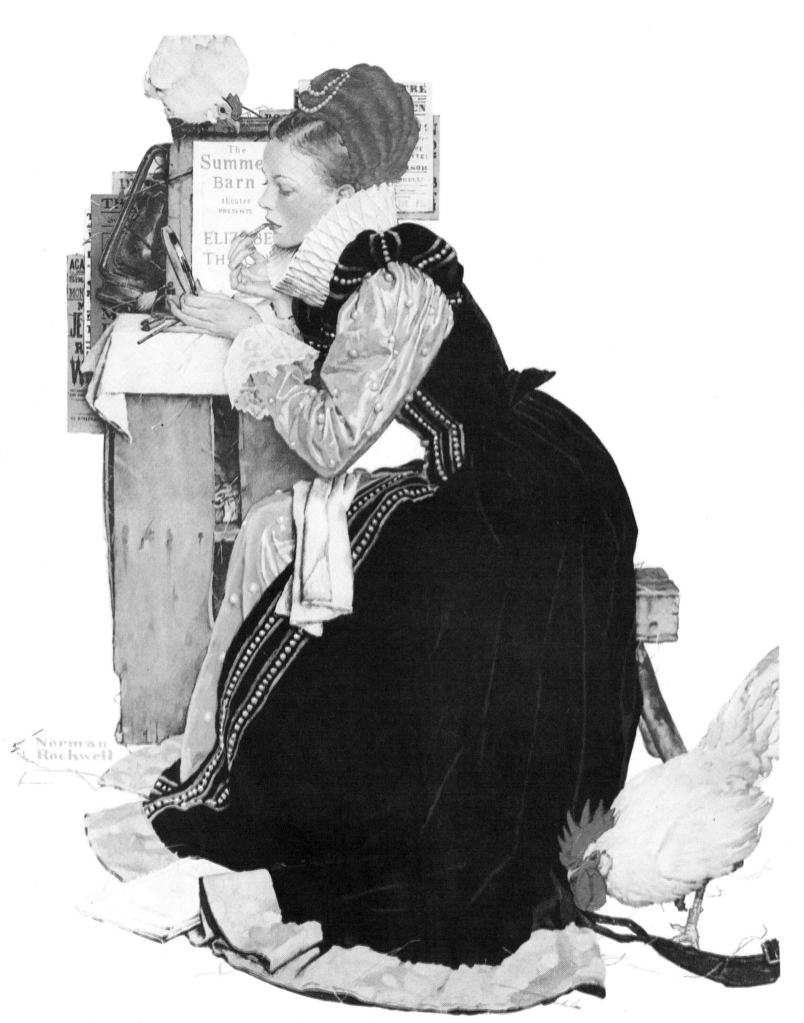

Summer theater was born when aspiring but unemployed actors improvised stages in barns and began performing for tourists. (1939)

William Shakespeare
All the World's a Stage

ALL THE WORLD'S A STAGE,
And all the men and women merely players:
They have their exits and their entrances;
And one man in his time plays many parts,
His acts being seven ages. At first the infant,
Mewling and puking in the nurse's arms.
And then the whining school-boy, with his satchel,
And shining morning face, creeping like snail
Unwillingly to school. And then the lover,
Sighing like furnace, with a woful ballad
Made to his mistress' eyebrow. Then a soldier,
Full of strange oaths, and bearded like the pard,
Jealous in honor, sudden and quick in quarrel,
Seeking the bubble reputation

Even in the cannon's mouth. And then the justice,
In fair round belly with good capon lin'd,
With eyes severe and beard of formal cut,
Full of wise saws and modern instances;
And so he plays his part. The sixth age shifts
Into the lean and slipper'd pantaloon,
With spectacles on nose and pouch on side,
His youthful hose well sav'd, a world too wide
For his shrunk shank; and his big manly voice,
Turning again toward childish treble, pipes
And whistles in his sound. Last scene of all,
That ends this strange eventful history,
Is second childishness, and mere oblivion,
Sans teeth, sans eyes, sans taste, sans everything.

Margaret Mead
Grandparents

IN SCHOOLS in small towns and neighborhoods, there used to be teachers who taught two generations of children and mellowed in the process, there to remind the children that their parents had once been young, played hooky, and passed forbidden notes in school, and there to moderate the zeal and sustain the inexperience of young teachers. In such neighborhoods there were also other people's grandmothers and grandfathers, even if a child's own were dead, left behind in a foreign land, or living far away in this country. One good grandmother went a long way with her stories, her store of old-fashioned songs, and her vanishing skills in making gingerbread men and cookies. With these pleasures children absorbed a sense of the past, could measure time in meaningful biological terms, when grandmother was young, when mother was young, when I was young. Dates became real instead of contentless numbers in a history book, and progress, measured by steamships, telegraph and automobiles, could be related to the pictures of grandmother and grandfather as bride and groom, or as paterfamilias with a parent and aunts and uncles in a family picture.

For the last hundred years it is the grandparents who have seen more change than any generation in the history of the world. When my grandmother died in 1928 at the age of eighty-two, she had seen the whole development of the horseless carriage, the flying machine, the telegraph and Atlantic cables, telephone, radio, silent films. In my lifetime, I have lived through driving a horse and buggy, making butter, going to bed with a kerosene lamp, the appearance and disappearance of the great airships; and because I have been able to go back and forth to the world of peoples still in the stone age, I have also been a participant in their leap into the modern world.

Grandparents—and great-grandparents—have now become the living repositories of change, living evidence that human beings can adjust, can take in the enormous changes which separate the pre-1945 generation from those who were reared after the war. When, under simpler conditions, it was the parent-reared child who was more likely to accept change, participating as the child did in the active, young, unfinished lifeline of the parent, today the reverse is true. Today's parents of young children were born into the world of TV, computers, space exploration, the bomb, and they have seen much less change than their parents and their grandparents. *(1977)*

Once every neighborhood had a resident grandmother who served tea amid Victorian bric-a-brac, as in this 1940 story illustration.

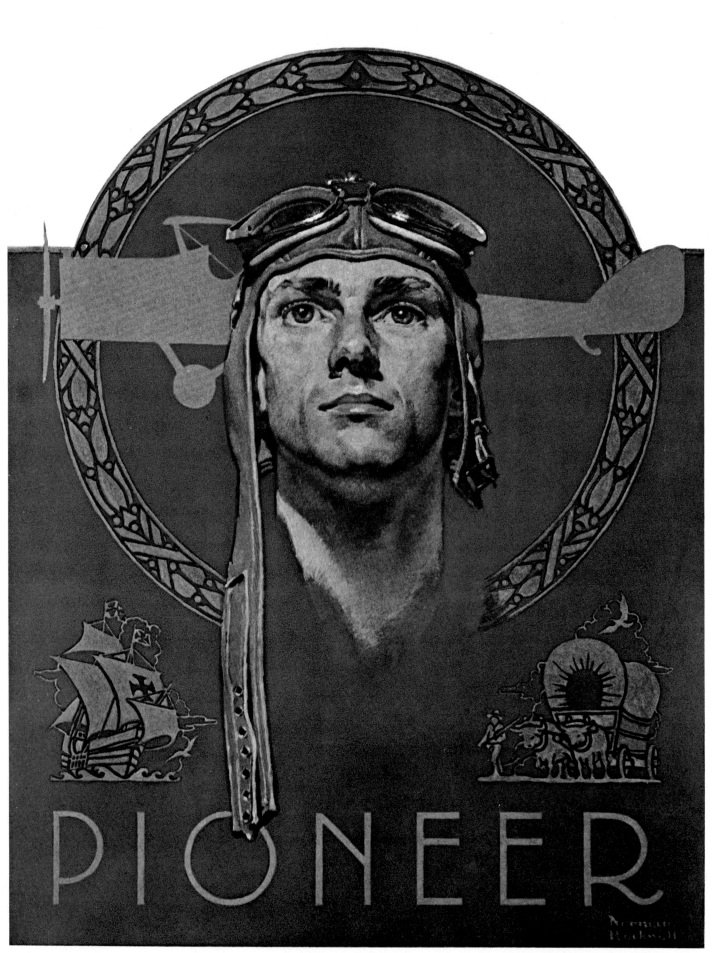

Painted just hours after Lindbergh's flight, this 1927 cover had to bear a symbolic face rather than the hero's portrait.

Charles A. Lindbergh
Dreams of Flying

WHEN I WAS A CHILD on our Minnesota farm, I spent hours lying on my back in high timothy and redtop, hidden from passersby, watching white cumulus clouds drift overhead, staring into the sky. It was a different world up there. You had to be flat on your back, screened in by grass stalks, to live in it. Those clouds, how far away were they? Nearer than the neighbor's house, untouchable as the moon—unless you had an airplane. How wonderful it would be, I thought, if I had an airplane—wings with which I could fly up to the clouds and explore their caves and canyons—wings like that hawk circling above me. Then, I would ride on the wind and be part of the sky, and acorns and bits of twigs would stop pressing into my skin. The question of danger did not enter into my dreams at the time.

One day I was playing upstairs in our house on the riverbank. The sound of a distant engine drifted in through an open window. Automobiles had been going past on the road quite often that summer. I noticed it vaguely, and went on sorting the stones my mother and I had collected from the creek bed. None of them compared to the heart-shaped agate I'd found at the edge of a pool the week before—purple crystals outlined by strips of red and white. Suddenly I sat up straight and listened. No automobile engine made that noise. It was approaching too fast. It was on the wrong side of the house! Stones scattered over the floor. I ran to the window and climbed out onto the tarry roof. It was an airplane!

Flying upriver below higher branches of trees, a biplane was less than two hundred yards away—a frail, complicated structure with the pilot sitting out in front between struts and wires. I watched it fly quickly out of sight, then rushed downstairs to tell my mother.

There had been a notice in the *Transcript*, my mother said, about an aviator who had come to our town. She'd forgotten to tell me about it. He was carrying passengers from a field over on the east side of the river. But rides were unbelievably expensive. He charged a dollar for every minute in the air! And anyone who went up took his life in his hands—suppose the engine stopped, or a wing fell off, or something else went wrong.

I was so greatly impressed by the cost and the danger that I pushed aside my desire to go up in a plane. But I used to imagine myself with wings on which I could swoop down off our roof into the valley, soaring through air from one river bank to the other, over stones of the rapids, above log jams, above the tops of trees and fences.

Dream became reality before many years passed. Lindbergh was a pilot at 21; he made his epochal solo flight from New York to Paris when only 25.

from 33 Hours to Paris, *1953*

Through most of humankind's history, individual people have been relatively immobile. They have walked and run, to be sure, and hopped and jumped for that matter, but the distance they could travel in this way was small and they personally experienced only their native town and its immediate environs.

It was only with the coming of the Industrial Revolution; with the steamship, the locomotive, and most of all the automobile and airplane, that the average person became able to call the whole planet his stamping ground; to move from point to point at will, whatever the distance and in a matter of hours.

Isaac Asimov

In the beginning of this record I tried to explore the nature of journeys, how they are things in themselves, each one an individual and no two alike. I speculated with a kind of wonder on the strength of the individuality of journeys and stopped on the postulate that people don't take trips—trips take people. That discussion, however, did not go into the life span of journeys. This seems to be variable and unpredictable. Who has not known a journey to be over and dead before the traveler returns? And the reverse is also true: Many a trip continues long after movement in time and space has ceased.

John Steinbeck

Eleanor Roosevelt
Why I Travel

WHAT DO WE TRAVEL FOR? No doubt we all have different reasons. I, for one, know that I started simply because my parents were travelers. My father, who traveled for adventure, imbued me with a little of his own excitement at seeing new scenes and new faces, even when I was a very young child.

My first attempt at travel, at the age of two, was not very successful. We were shipwrecked and returned to New York City, and it made such a bad impression on me that a few weeks later, when my family made a fresh start, I refused to go along! But a few years later we went for another long trip to Europe, and the memories stayed with me until I went abroad to school and was again able to travel in Europe.

I knew very little of my own country, and that I now consider a great drawback. In the days when I was growing up, particularly in the group to which I belonged, travel to Europe was considered essential, and travel in our own country not very important. That was because a great many people only traveled to see the things other people had seen and to be able to talk about the things other people talked about—in short, in order to give the impression of being what was known as "cultured."

I remember quite well one member of that generation who lived all her life in New York City and ultimately in Europe. Only a few years ago, on hearing that one of her relatives had gone to live in Florida, she remarked with horror: "I fear I shall never see her again. I wonder what kind of place Florida is. Could one have a garden, or is it all sand?"

That same lady thought the method of night travel in this country simply barbarous compared with European style, yet I can remember many uncomfortable nights spent in European travel. It is all in your point of view, I imagine, or in the environment in which you live.

Since babyhood I had heard people discuss the relative merits of some of the "Old Masters." In a vague way I knew that one should like a Botticelli or a Velasquez or a Rembrandt, that there were different styles of architecture, and different periods of furnishings, and that some were more admired than others, but I had no idea why. Finally I went abroad to school, aged 15, and suddenly discovered that travel included knowing the people of the country.

Since most of my sight-seeing in those early days was done alone, nobody said to me: "That is a good picture; you must look at it. Don't bother about anything else." I looked at everything and discovered the joy of deciding for myself what I liked and what I did not like, regardless of the experts' opinions. That was a great advantage, for I never could learn all the things in the world that are supposed to be good. It is very much more comfortable to be able to say I like that picture in that gallery, without having first to find out whether it is one the experts agree is worthwhile!

Later in my life I was to travel a great deal in my own country, but again instead of going in search of beauty or remarkable artistic collections, or any of the things for which we usually journey to strange places, I traveled to see and meet people. Many times I traveled because I had agreed to do lectures. My reason for accepting these lecture engagements was largely that I knew I never would travel and meet the people and see how they lived and find out what was on their minds, unless I had an obligation to be at a specific place at a definite time.

After a good deal of this traveling, much of the real adventure had worn away, and I was doing things because they seemed to be the things that needed to be done. All people, as they grow older, probably have a tendency to stay at home. You are surrounded by your own friends; you have your daily occupations. It is altogether pleasant to move without effort in the accus-

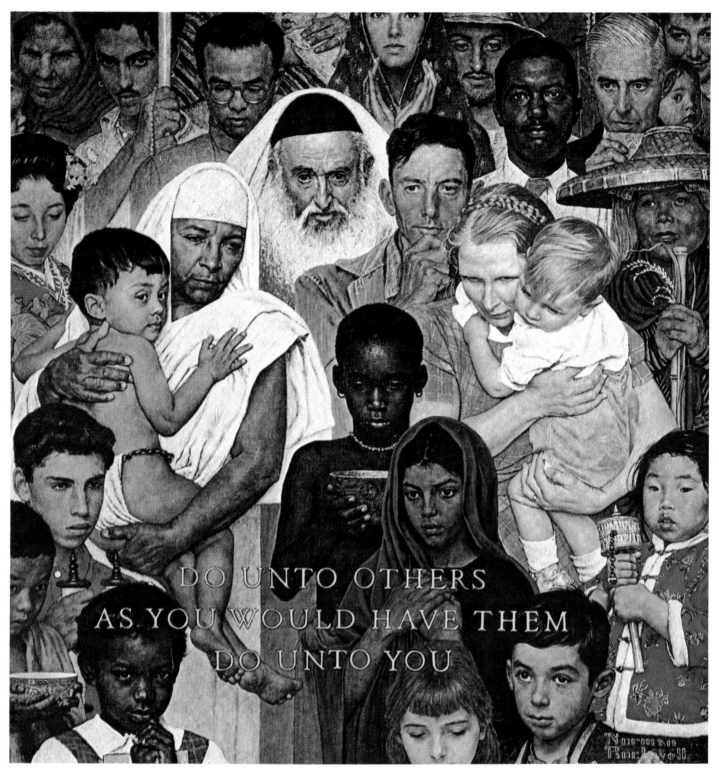

Four months of work and 28 separate portraits (some painted at the UN) went into the 1961 "Golden Rule" cover design.

tomed groove. However, with age there also comes an understanding of some of the objectives we have worked for throughout our lives. One of them, in my case, is how to promote better understanding among the peoples of the earth.

If I travel now, it is always with interest, because my love of people and interest in them can never grow less—but to start me off there must be a signed contract for a specific date when I must appear ready to work. Otherwise I would never leave my busy but familiar daily routine.

The young will travel for adventure, I imagine, as long as we are on this planet. Some older people will always thirst for more knowledge, but the great majority of us who grow older will travel either to be with the people we love, or because the work we have undertaken in the world makes it imperative to see something or do something or make some contacts which we cannot achieve at home. In the doing, we will all have adventure and enrich our minds and hearts and, pray God, be more useful in the great adventure of learning how to live in the Brotherhood of Man.

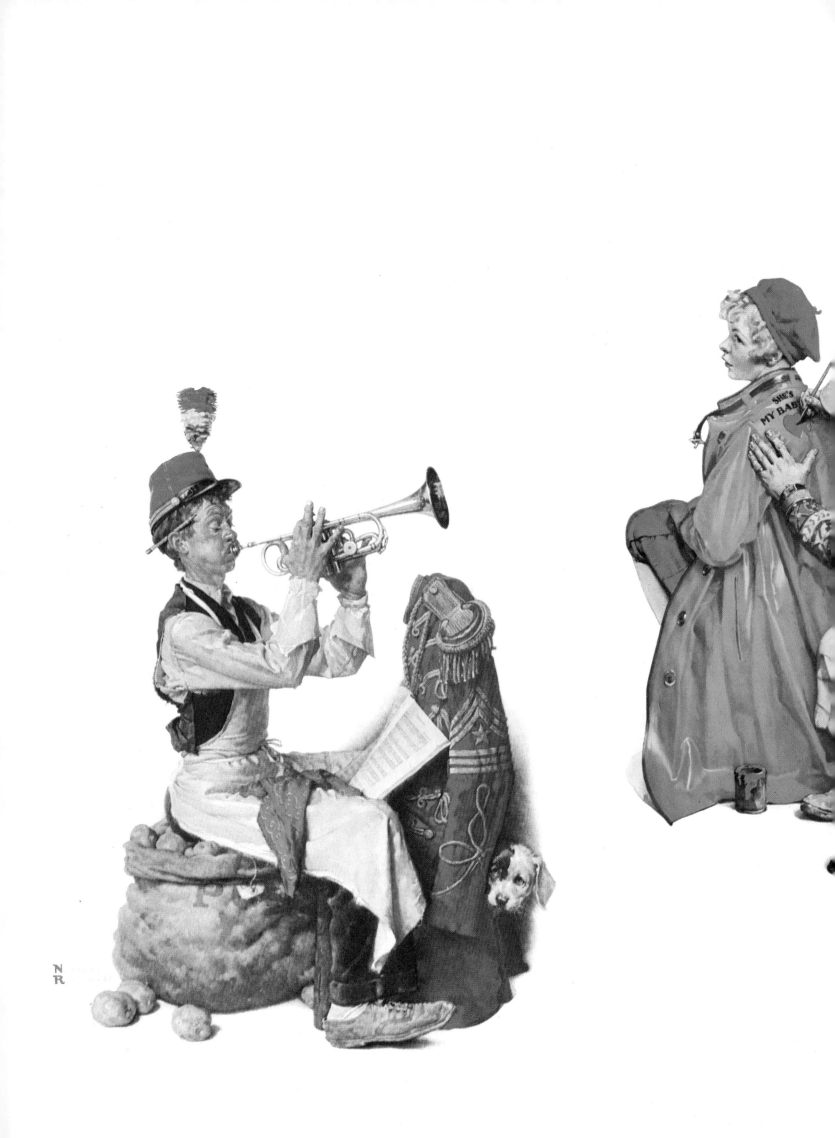

Make a Magazine Cover Quilt

CHRIS EDMONDS of Lawrence, Kansas, looked at the November, 1975, *Post* and thought "quilt." The cover showed George Washington kneeling to pray at Valley Forge; it was a painting by J. C. Leyendecker that had first appeared on a 1925 *Post*. Chris cut and stitched until she had duplicated the picture in fabric. She added a border of traditional piecework in patterns that date back to Washington's day, then quilted the background in swirling lines that suggest falling snow. Completed in 90 days, the Washington quilt won top honors in half a dozen Bicentennial Year quilt contests, including one competition in which more than 700 quilts were entered.

Could she make a quilt version of a Norman Rockwell *Post* cover?

"Of course," she replied, as nonchalantly as if she were promising to make cookies for a bake sale.

A few weeks later the quilt arrived in our office, complete with the magazine's name and price (5 cents) and even the Rockwell signature embroidered in tiny stitches. All this is even more impressive when you know that the quilt is entirely hand-made (*no* machine sewing, even on the border seams).

If you now see, in your mind, a Mrs. Edmonds who is gray-haired and grandmotherly, stitching away in her rocker, think again. Chris is young, very attractive and busy. She lives on a farm with a husband and two small children, and to make time for quilting she gets up and threads her needle at 5 a.m. before the rest of the family awakens. She has completed more than 20 quilts; she makes two or three new ones each year and now teaches quilt-making classes.

The quilt Chris made for us is based on a 1929 cover called "The Little Spooners." Because she is interested in the traditions that surround old quilt designs, Chris chose the pattern for the patchwork border with special care. Its suitably romantic name is Cupid's Arrow Points (the red squares in the centers of the blocks are supposed to represent heart's blood) and it was published in the Kansas City *Star* in 1929, the same year the Rockwell painting appeared.

This quilt is sized for a child's bed; the finished size is 64 by 76 inches. The center panel alone could serve as a wall decoration, or one could enlarge the center panel and add more rows of border to make the quilt full-size.

Here's all you need to know to make your own.

Charles Brackett—Jesse Lynch Williams—Wallace Irwin—Ben Ames Williams
C. E. Scoggins—Richard Connell—Elizabeth Frazer—Richard Washburn Child

Buying the Materials

Fabrics made from 100 percent cotton, soft rather than stiff and not too tightly woven, are best for this kind of sewing. Wash all the fabrics in hot water before cutting

Quilt-maker Chris Edmonds in her workroom, and the prize-winning quilt based on a 1924 Post *cover painting by J. C. Leyendecker.*

them. This will avoid their shrinking later; it will also make them softer and easier to work with. Buy dacron batting for the padding (it won't bunch up when the quilt is washed) and white fabric for the backing (color or a print would show through).

Cutting the Fabric for Background and Border

The pattern for the patchwork blocks and the measurements given here for border strips and background *do not include seam allowance.* You will add the seam allowance along all edges when you cut the fabric. Chris adds ¼ inch; you may add more if you wish. You will need:

White background: 1 piece 36" x 48"
Blue print border: 2 pieces 1" x 38", 2 pieces 1" x 50"
White border: 2 pieces 3" x 44". 2 pieces 3" x 56"
Inner dark green border: 2 pieces 2" x 48", 2 pieces 2" x 60"
Outer dark green border: 2 pieces 2" x 64", 2 pieces 2" x 76"

For the patchwork border, trace drawings on page 102 and then cut from cardboard patterns for the four different pieces: square, triangle, diamond-shaped, and the special corner strip. Draw and cut very carefully when making the patterns, as a small error here can cause big trouble later. You will need:

36 dark red squares
40 white triangles
144 red print diamond-shapes
152 tan diamond-shapes
4 white corner strips

At each corner you will combine one special corner strip with 2 tan diamond-shapes.

Allow extra dark green fabric to make wide bias binding with which to finish the edges of the quilt.

For patchwork pieces, place the cardboard pattern on the wrong side of the fabric and draw around it with a sharp pencil, then add the seam allowance when you cut. The pencil line will become the seam line.

Enlarging the Working Drawing

With a sharp pencil and a good ruler, draw a grid of ¼-inch squares over the drawing on page 103. Use a yardstick and a ballpoint pen to draw a similar grid of 1-inch squares on a piece of paper 3 by 4 feet in size (tape two strips of shelf paper together if you haven't access to paper this large).

Using a pencil, sketch in each square of the large grid just what appears in the corresponding square on the book page. When you go wrong, you can erase your pencil line without destroying the grid. When you are satisfied, go over the pencil lines with a felt-tip pen.

Note that our drawing has both heavy and light lines.

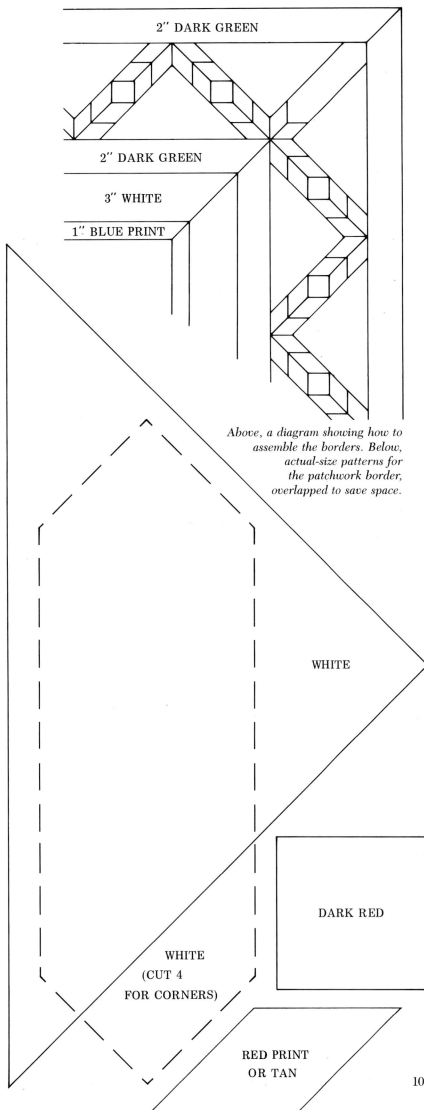

2" DARK GREEN

2" DARK GREEN

3" WHITE

1" BLUE PRINT

WHITE

Above, a diagram showing how to assemble the borders. Below, actual-size patterns for the patchwork border, overlapped to save space.

DARK RED

WHITE
(CUT 4
FOR CORNERS)

RED PRINT
OR TAN

Chris' work table with the quilt half finished.

With a few exceptions, the heavy lines indicate the finished edges of appliqué patches, while the lighter lines indicate quilting (on clothing or bench) or embroidery (on hair). The letters of THE SATURDAY EVENING POST and the horizontal black lines are appliqué, while the other letters, the numbers, and the artist's signature are embroidered in satin stitch.

Transferring the Picture to Cloth

Lay the full-size working drawing on a large table and spread the white background cloth over it. Pin securely so the cloth won't shift. You should be able to see the pattern well enough to outline the main parts lightly with a sharp pencil. To make sure your lines will not show on the finished quilt, draw inside rather than outside the heavy black lines of the working drawing. Trace clearly and carefully the letters and lines that are to be embroidered.

Next, trace individual parts of the picture on pieces of paper to make patterns for the appliqué patches. Do not add a seam allowance when making a pattern. You will place the pattern, right side up, on the right side of the colored fabric and draw around it, then add a seam allowance of approximately ¼ inch when you cut. Clip at inside corners and sharp curves. Use a sharp pencil to draw on light-colored fabrics, tailor's chalk or a dressmaker's white pencil on the darkest fabrics.

Note that edges which will later be covered need not be shaped carefully. For example, you will trace the circular edge of the yellow moon but draw and cut straight across the bottom where the children's heads and shoulders will be sewn over it.

102

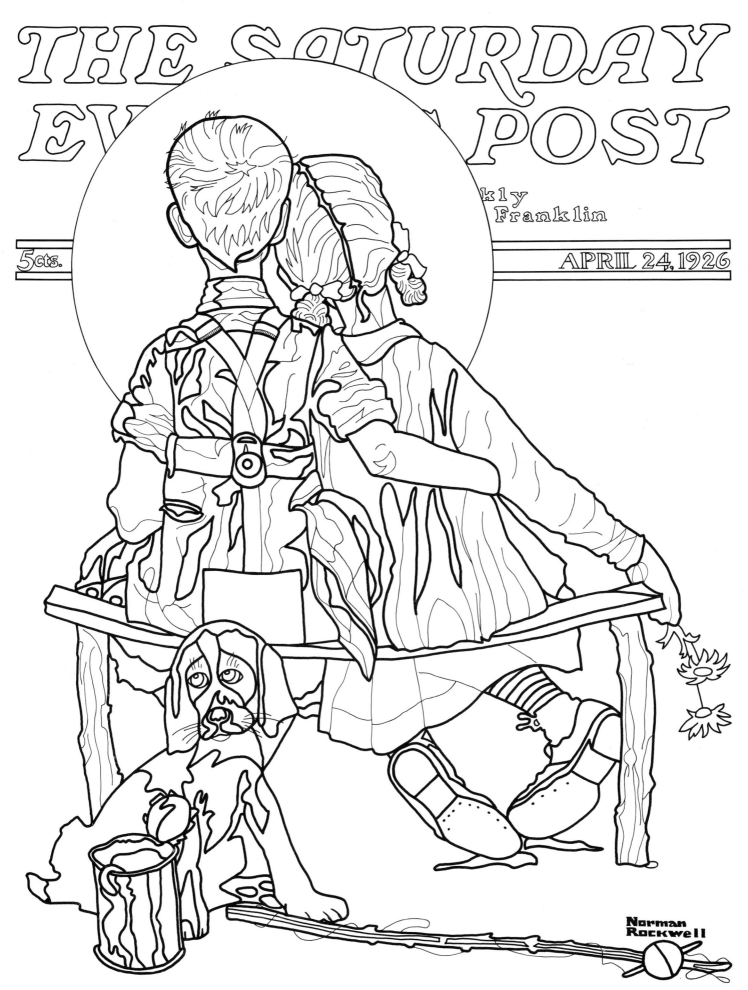

Chris' pattern for the center panel of the quilt, reduced to one-fourth actual size. The lighter lines indicate quilting or embroidery.

Pin or baste the appliqué patches in place, a few at a time. You will turn the edges under as you do the final sewing down with matching colored thread. Chris brings her needle up through the appliqué piece, catching just a few threads along the folded edge, then down through the background cloth, taking a slightly longer stitch underneath where it won't show, then up, catching the folded edge of the appliqué piece again, and so on.

Many edges will not need to be turned under and sewn down as they will be covered by other patches. This determines the order in which the pieces are put on the background.

Start with the black letters and horizontal lines, since they are covered by the yellow moon.

After the yellow moon is sewn on, add more pieces of the picture in the following order: the girl's neck, the girl's ear, the two parts of the girl's hair, the girl's hair-ribbons, the boy's neck and ears cut in one piece, and the boy's hair.

Moving to the lower part of the picture, add the girl's stocking and her shoes. Chris made the stocking of one color, then sewed bias strips of the other color across it to make the stripes. For the shoes she used three slightly different shades of brown plus olive green for the soles. The nails are embroidered.

Proceed by adding the lower part of the girl's dress, the two legs of the bench, the flowers, the girl's hand, the part of the bench she is sitting on, then the rest of her dress (blue print with a black shadow).

Next, add the lower part of the boy's clothing, his end of the seat, his arms and then the rest of his clothing. Chris used three different shades of brown for his trousers and four of tan for his shirt. The buckles on his suspenders are embroidered. Add the red handkerchief in his pocket and the patch on his pants.

Proceed to the dog, starting with his paws and ending with his eyes and nose (his whiskers are embroidered), the bait can and, finally, the fish pole. Chris, who kept count, numbered her last piece 152. Complete all embroidery at this time—the red letters and numbers, the light brown lines on the hair, green flower stems and gray or brown fishline.

Completing the Quilt

Assemble the quilt top by sewing together the patchwork blocks, the central panel and the border strips. Make diagonal mitered seams at the corners where the border strips come together. Steam-press all the seams.

Spread the white backing fabric out on a large table. Spread the batting smoothly over it and trim off even with the fabric edges. Spread the quilt top, right side up, over all. Pin together, then baste back and forth with large stitches so the layers can't shift.

You are now ready to do the actual quilting, which involves sewing the three layers together with a decorative pattern of small stitches. For best results use a quilting frame (Chris Edmonds uses a lap-size oval frame like a very large embroidery hoop), the special quilting thread that is treated to resist tangling, and a thimble.

Quilt around the letters, numbers, and all parts of the picture, then quilt the lines on the working drawing that represent wrinkles in the clothing and the grain of the wood in the bench. Quilt the white background with a simple pattern of verticals and horizontals, then quilt along the border stripes, with zigzags in the widest white stripe. Finishing on a romantic note, quilt heart shapes in the white triangles of the patchwork border.

Last of all, embroider your name and the date near one corner of the quilt. Chris Edmonds says this is very important. Your quilt will be a treasured heirloom someday, and it's nice to know there won't be arguments about who made it or when.

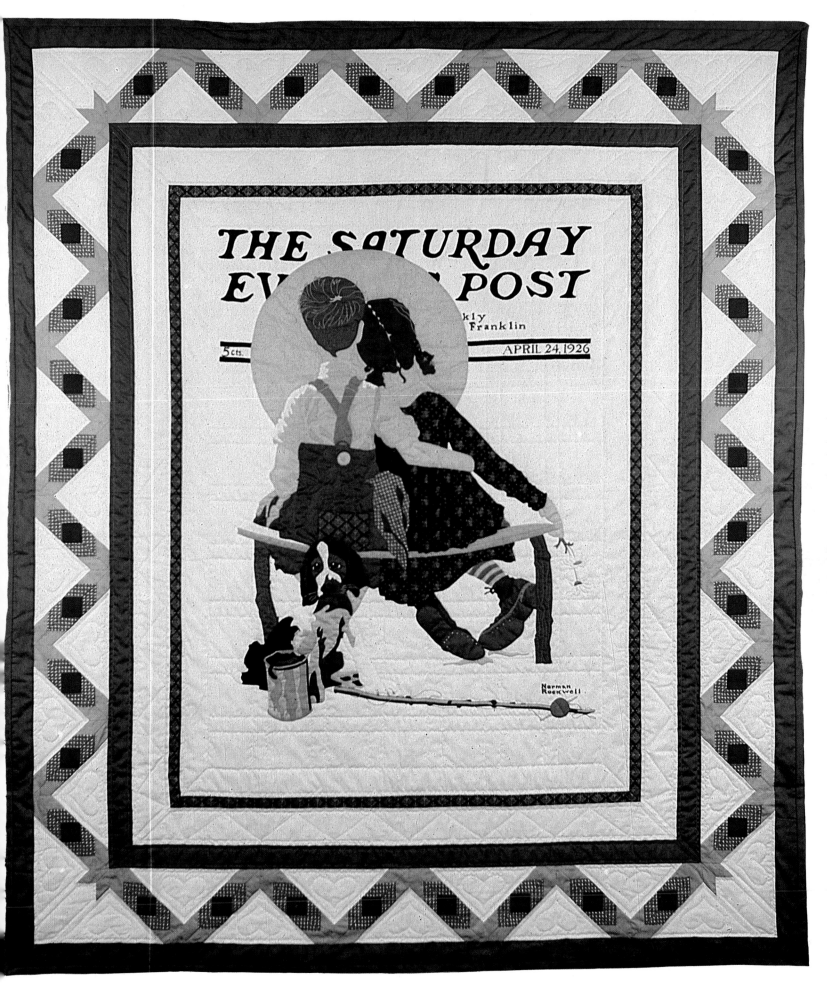

The maker's name, Chris Wolf Edmonds, and the date 1977 are embroidered in tiny stitches near one corner of this charming patchwork quilt.

Find Your Family Tree

A PIRATE ON YOUR FAMILY TREE? A duke or an earl? It's not likely, nor is it likely that you will prove yourself heir to a fortune or gain an impressive coat of arms. The unknown-to-you ancestors that you discover when you become an amateur genealogist are almost certain to be farmers, small businessmen or craftsmen who lived and died in relative obscurity, either in the eastern U.S. or, if you go back further, in Europe. That's because most of the men and women who settled this continent were ordinary hard-working people, poor in purse but well endowed with energy and ambition. (Few pirates settled down to produce sons and daughters: few dukes and earls left the comforts of their ancestral estates to establish new homes in the American wilderness.)

Why bother, then, to find out who those ancestors were?

You will understand, once you begin family-tree-climbing.

When we seek out our ancestors we find much more than the cold, hard facts of names and dates, places of birth and burial.

Sometimes, if we are lucky, we find their faces in old photograph albums. Young faces, old faces, joyful or careworn, with styles of dress and posture that tell stories or pose questions.

(Look at the stripe down the sides of Great-Uncle Matthew's trousers—he must have been wearing part of the uniform he brought home from the Civil War! And Great-Aunt Ella's dress—isn't there a scrap of that material in Grandmother's comforter? Why, in old-time wedding pictures, did the *bride* always stand?)

Fanciful portraits of Pvt. Willie Gillis's ancestors, garbed for different wars, adorned a 1944 Post cover.

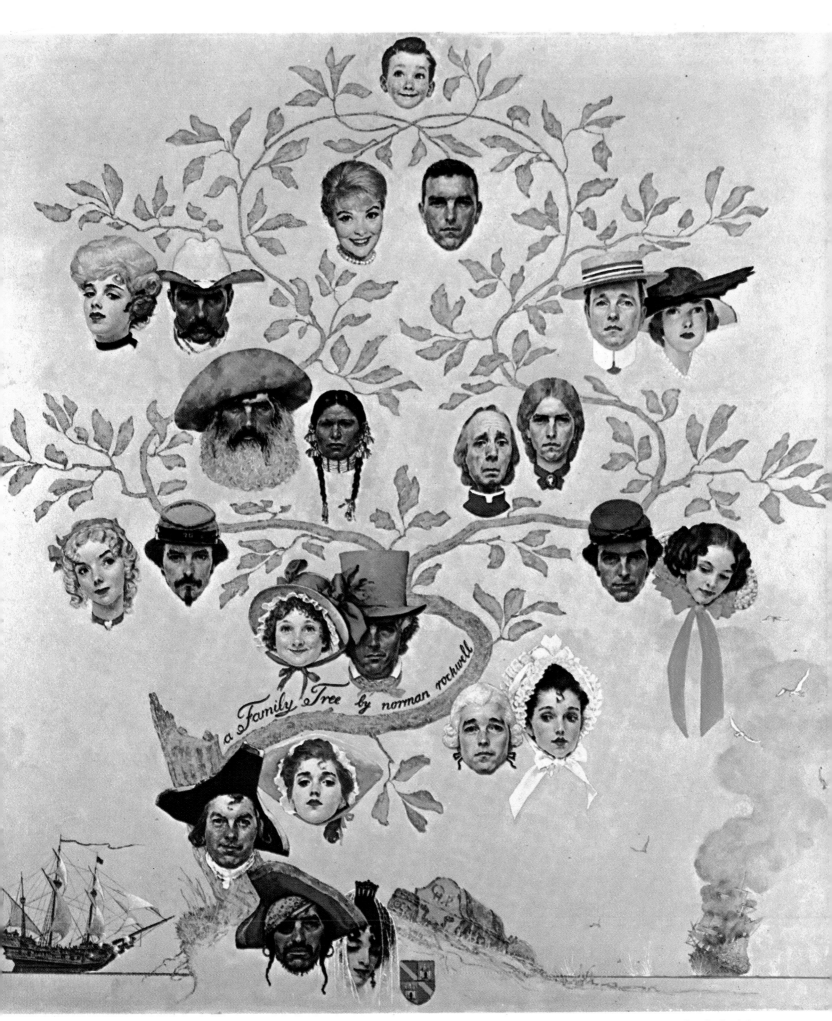

Cover the varied hats, haircuts and collars; it becomes clear that one model (Frank Dolson) posed as all the men of the family. (1959)

More often than faces we find the names of our ancestors. We find them in courthouse record books, written in the spidery script of a long-dead clerk who may well have used a hand-cut goose quill in pokeberry ink. We find information about their weddings, for marriages, like births and deaths, are vital statistics preserved by county officials. We may also find descriptions of land they bought or sold, and wills that contain fascinating lists of "goods and chattels" that tell us a great deal about how our ancestors lived.

Moving further afield, we find their names in records kept by the federal government. Old census lists. Homesteaders' claims. Muster rolls that list the names of all who served in the military, in all of our country's wars. We learn to what regiments they belonged, in which battles they fought. Still further back, the passenger lists of ships on which immigrants traveled to the New World have been collected and made available in reference books. If we find names on these lists we will know in what years our ancestors sailed and from what ports in Europe.

And, for certain, we will find the names of our ancestors carved on thin, tall slabs of lichened stone that tilt a little, this way or that, from a century of frost-heavings, in old cemeteries. (How young, when she died! And the row of little stones marked "infant" beside hers—no names here. Did parents feel they were tempting fate when they named, too soon, the baby who faced so slender a chance for survival?)

These are the warp and woof of life, these gleanings from old books and maps and tombstones. Our personal stake in the American past, these snippets of information whet the appetite for more. Soon we are caught up in an exciting paper chase that is something like a crossword puzzle and something like a detective story. (Was the William G. who was wounded at Shiloh *our* William G.? He would have been the right age. And was our Jacob Hilgeshimer, buried in Pennsylvania, the one who came over on the *Jersey Star* in 1789?)

How to get started? A professional genealogist suggests the following steps:

1. Start with yourself and what you know about your parents and grandparents. Search family photo albums, family Bibles, old letters and diaries for more information. With each name list dates and places of birth and death, the name of wife or husband.

2. Talk to your relatives, especially the older ones, but be gentle and tactful. There may be family skeletons they are hesitant about discussing, or they may hate admitting they don't remember something. When writing to elderly relatives, send along self-addressed stamped envelopes for them to use in replying.

3. Check out the resources of the local library, the courthouse, and the local historical society. Ask about old city directories, county histories and files of newspapers that may contain information about your ancestors.

4. The State Board of Health has birth and death records; the State Archives preserve land and military records; the State Library may have genealogical records of other families, published in book form.

5. On the national level, the National Archives at Washington, D.C., preserve old census lists, military and immigration records. If you can't conveniently visit Washington, write them asking how to obtain information from them. You may also obtain useful information from the Daughters of the American Revolution headquarters in Washington, and from the Mormon Church with headquarters at Salt Lake City but with branch libraries and extensive microfilm resources in numerous locations around the country.

With luck, seemingly unrelated bits of information will, for you, fit together like bits of a jigsaw puzzle, forming pictures that are poignant, sometimes humorous, but always very human, of the people we have come from.

Help Bring Back Marbles!

WHERE HAVE THEY GONE, all the Marble players?

To Little League practice, perhaps, or swimming lessons. If children are outdoors playing an organized game it is more likely to be Foursquare or Kickball, games better suited to blacktopped playground or suburban lawn than Marbles, which should be played on the hard-packed earth of footpaths, back alleys or rural schoolyards. Where will you find such a playing surface today?

Marble-playing is remembered in our speech. We use the language of marble-playing whenever we say knuckle down, play for keeps, get down to taw, or take your marbles and go home.

Also, marble-playing is remembered by the collectors who haunt flea markets and country auctions in the hope of acquiring choice "aggies" or the handblown rainbow-striped "glassies" made in pre-War Germany. Rare and very old marbles bring substantial prices at antique sales.

This is not to say that the marble, as such, is extinct. Mass-produced glass marbles neatly packaged in plastic bags may be purchased in most toy and hobby shops. They are used in Chinese Checkers games, and in jewelry-making handicraft projects.

Collectors prize antique marbles like Benningtons (top) made of glazed crockery in mottled blues and browns. Spiral core glass marbles (left) were made by skilled craftsmen who heated and twisted a multicolored glass rod, then snipped off the end and shaped it into a sphere. China marbles (right) bear hand-painted lines, circles and floral motifs. All shown here were made in Germany, probably before 1900.

Most kids have a few marbles, rolling around in the bottoms of bureau drawers and toy chests. Trouble is, they don't know what to do with them. They don't know how to play Marbles.

Here then is something you can do to make the world a better place: Find some marbles. Find some kids. Find a patch of relatively clean, hardpacked earth—and start a Marbles game.

In case you yourself have forgotten how to play Marbles (or never knew), here are the rules and procedures for the most popular of the numerous different games. This one is called Ringers, or Potsies, Dubs or 25-a-Dub, or just plain Marbles. It is so old that its origin is shrouded in mystery, but we do know that it is very similar to games played by the youngsters of Imperial Rome and Ancient Egypt with glazed clay marbles like ancient ones that are now on display in the British Museum in London.

First, use a pointed stick to mark a circle three to five feet in diameter on the ground. If you are a purist who likes a *round* circle, tie one end of a piece of string to your stick and have a child hold the other end at a fixed point that will be the center of the circle.

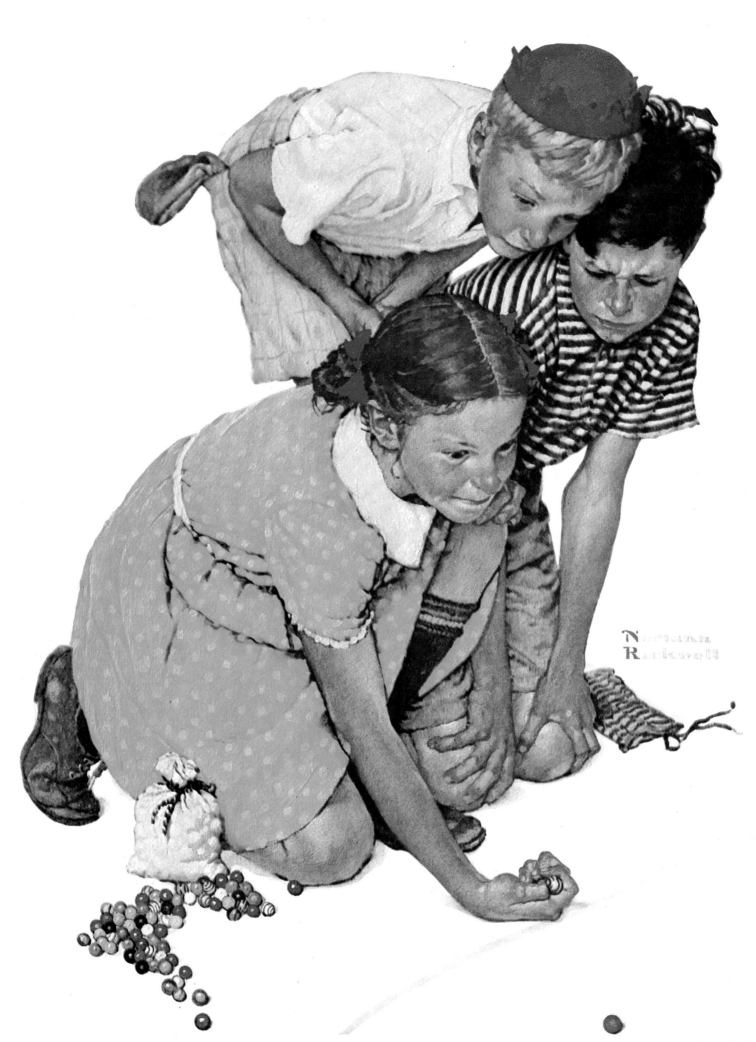

This 1939 Post *cover was one of the first Rockwell painted in Arlington, Vermont, the kind of town where Marbles games flourished.*

Three to six is the usual number of players. Each contributes an agreed-upon number of marbles—usually three or four—to the "pot." These marbles are placed inside the ring in a cross-shaped pattern or circle, or are dropped at random inside the ring.

To determine who plays first, each boy or girl pitches one marble toward a mark of some sort. The one who hits the mark or comes closest gets the first turn, the next closest the second turn, and so on.

The game begins when the first player "knuckles down" (at least one knuckle must be in contact with the ground) at the edge of the ring. A snap of the thumb propels his "shooter" marble into the ring, the object being to knock an opponent's marble out of the ring while the shooter remains inside. When this happens the player pockets the opponent's marble (this game is always played "for keeps"), retrieves his shooter and plays again. If his shooter rolls out, the next player gets a turn. Players may move around the ring, choosing the best position for each shot. The game continues until one player has pocketed all the marbles, or until the other players give up and let him take the remaining ones.

Another easy-to-learn game is Chasies, also called Boss-Out. The first player tosses his marble any distance ahead; his challenger tosses a marble at this mark. If the challenger's marble strikes the mark or lands within a hand-span of it, the challenger pockets the first marble and proceeds to throw out his marble as a mark. If the distance between the marbles is more than a hand-span but less than a step, the challenger is allowed to "bomb"—pick up his marble and drop it straight down from eye level in an attempt to hit the mark. "Chasies" is a traveling game that can cover quite a lot of territory, and it's a fine way for boys and girls to waste time while walking home from school.

If you don't want to *play* Marbles, join the collectors. The easy way to acquire old marbles is to buy them from dealers in antiques, or from other collectors.

The hard way is to hunt them down. You find them in the attics and cellars of old houses, in the corners of boxes and drawers where odds and ends have accumulated over the years. Old marbles have a tendency to turn up in the same places as old spools of thread and buttons—so try sewing boxes, dresser drawers, and the drawers of old sewing machines. Try tool boxes, too—you may find a few marbles lurking among rusty nails and broken screwdrivers.

You can literally dig for marbles, old schoolyards being the prime choice for such excavation. This can be good exercise and keep you out in the fresh air; prepare to be satisfied with these rewards in case you find no marbles.

Here are some kinds of marbles you *might* find:

Stone. Some marbles were actually made of marble and other kinds of stone. Most are dull gray in color. They are relatively heavy and feel cool to the touch.

Agates (aggies). Eyeball-like, with stripes around them and spots on the ends, these hand-polished spheres of semiprecious chalcedony are the favorites of most collectors. They are brown and white, red and white, or gray and white.

Crockery. Glazed clay marbles have a shiny and colorful surface, usually reddish brown or blue. Less valuable are the dull brown or gray unglazed marbles called commons or clayeys.

China. Smooth and shiny, these have stripes or floral designs hand painted on a white background.

Glass. The finest of these were handmade in Germany by skilled glassblowers. They are large, with elaborate patterns of swirling stripes inside them. Usually the glass is clear and the stripes are rainbow-colored.

Sulphides. Clear glass marbles with silvery-appearing figures centered inside them. (Rare and valuable.)

111

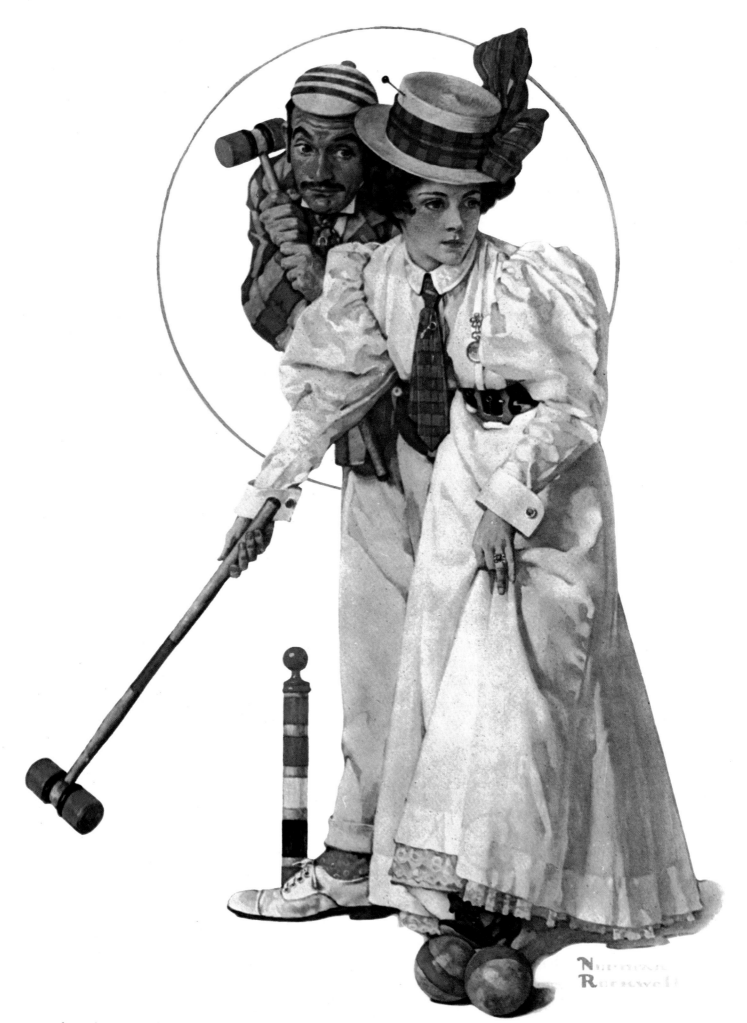

Fin de siècle *croquet players appeared in 1931. By the end of the '30s nostalgia covers evoking an earlier day were out of fashion.*

Take Up Croquet

THE NAME OF THE GAME is pronounced cro-KAY and it's been around for some 350 years, enormously popular with the French aristocracy in the late 1600's and with genteel New Englanders of the Gay Nineties. After all, what other game *could* they play, encumbered as they were with panniers, top hats, hoopskirts, even parasols?

Before you laugh croquet out of court, however, give it a try. There are some special reasons why croquet is worth bringing back.

It offers mild exercise, more appropriate than golf or tennis for the sedentary uncle or paterfamilias who has a sudden urge to shine as an athlete after a heavy Sunday dinner. The rules are simple and the procedure undemanding (anyone can swing a mallet so as to strike a five-inch ball) and this makes it one of the few outdoor games that people of all ages, kiddies to senior citizens, experts and beginners, can enjoy together. It is, nonetheless, a game that can be highly competitive and even exciting.

The equipment is relatively inexpensive and almost indestructible. If you are lucky you may find in the attic or garage the wooden mallets and balls Great-Aunt Elizabeth used to roundly defeat Great-Uncle Jason circa 1902 (see Norman Rockwell's painting to learn her technique), good as new and ready for use by a new generation of players.

You may *not* find the wickets—wire hoops—but you can replace them with bent coathangers. For safety's sake, paint these wickets white or wrap them with tape so they'll be easy to see. Many an innocent party has cursed croquet roundly after tripping over an invisible wicket left out after an evening game, and many a lawnmower has come to grief over the same.

The ball must pass through all wickets in order, as numbered.

Croquet does require a relatively large and level playing space. The ideal croquet lawn is 30 by 60 feet, with the stakes placed 52 feet apart and the side wickets 20 feet from each other (see diagram) but you can play a good game on a lawn half that size. Just place the stakes and side wickets near the edges of whatever level space you have, and start playing.

Each player uses his own ball, which is striped with color to match his mallet. He starts with his ball touching the first stake. The ball must roll through the wickets in order (see numbers on the diagram), touch the far stake, and return to touch the first stake again; the player who first accomplishes this wins.

A player gets one stroke each time it is his turn to play, plus one extra stroke each time his ball passes through a wicket, strikes a stake, or strikes another player's ball. When it strikes another player's ball he has a choice of strategies: He can (1) take one more stroke, hitting his own ball from wherever it lies; (2) he can place his ball beside the other and drive both balls off in any direction, or (3) he can place his own ball beside the other, put his foot firmly on his own ball and strike it hard enough to drive his opponent's ball off to a less advantageous position while keeping his own where it is. That's what Great-Aunt Elizabeth is doing in the painting, raising her skirt a daring inch or two so as to expose lacy petticoat and dainty slipper. She is about to hit her ball a devastating blow that will send Uncle Jason's clear off the court. Will he mind? It seems unlikely. He may not have lost the game, as yet, but he has surely lost his heart to his charming adversary. All this without perspiring or panting, mind you; she will finish the game with every hair in place.

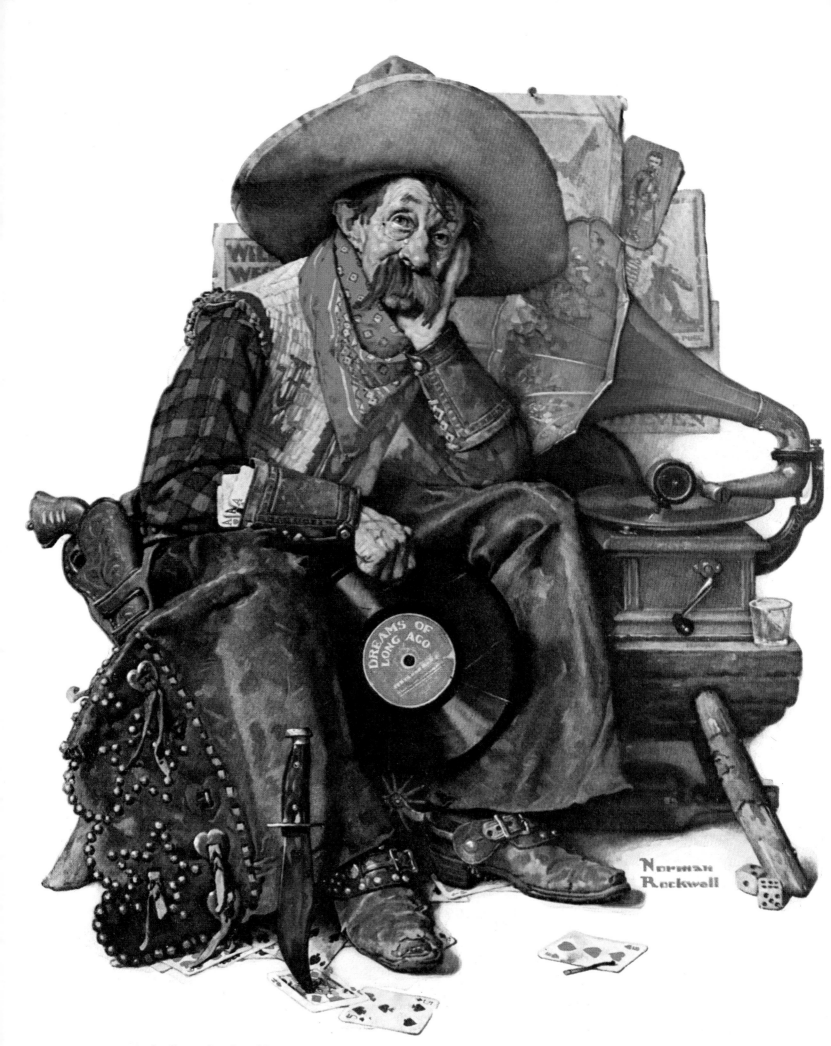

Rockwell once found model James K. Van Brunt at home reliving past glories to music, painted him just that way. (1927)

Red River Valley

Cowboy Song

Chorus: (sung to the melody above)
Come and sit by my side if you love me,
Do not hasten to bid me adieu,
But remember the Red River Valley
And the girl that has loved you so true.

2. Won't you think of the valley you're leaving?
Oh, how lonely, how sad it will be,
Oh think of the fond heart you're breaking,
And the grief you are causing me.
Chorus

3. I have promised you, darling, that never
Will a word from my lips cause you pain;
And my life, it will be yours forever
If you only will love me again.
Chorus

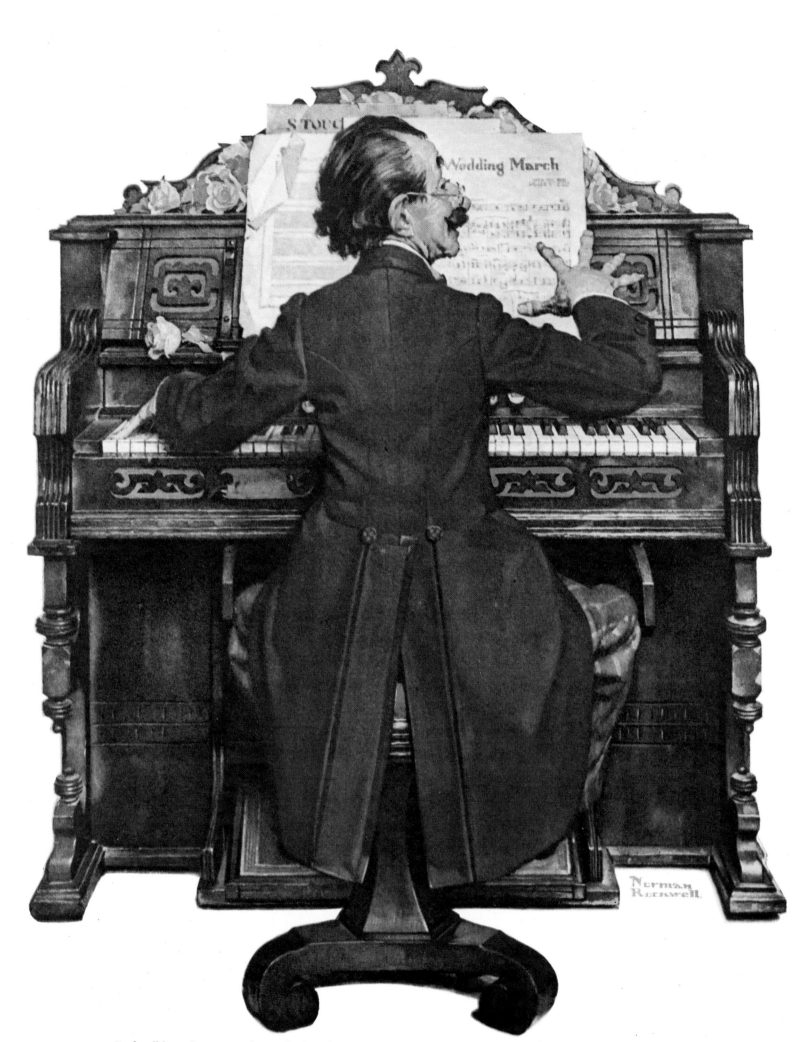

Rockwell kept the organ in his studio for a long time, later gave it to a traveling evangelist who posed for him. (1928)

I Love You Truly

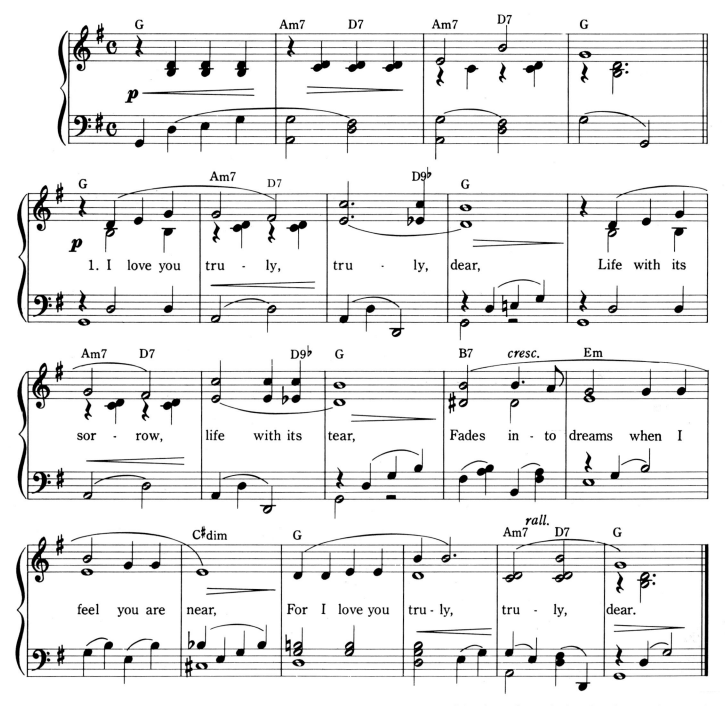

1. I love you tru - ly, tru - ly, dear, Life with its sor - row, life with its tear, Fades in - to dreams when I feel you are near, For I love you tru - ly, tru - ly, dear.

Words and music by Carrie Jacobs Bond

2. Ah! love, 'tis something to feel your kind hand,
Ah! yes, 'tis something by your side to stand;
Gone is the sorrow, gone doubt and fear,
For you love me truly, truly, dear.

117

"Flying Uncle Sam" (1928) was Yankee Doodle brought up to date, celebrating America's new love affair with aviation.

Yankee Doodle

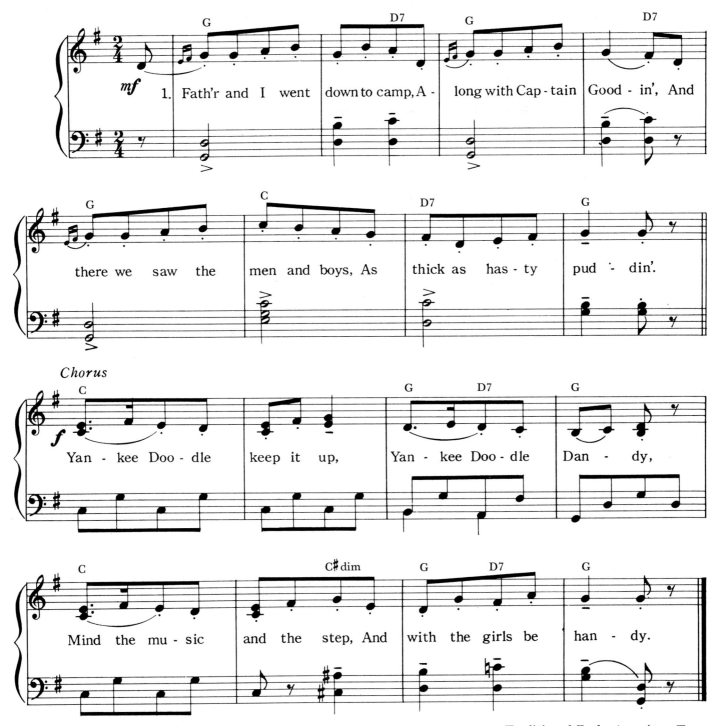

1. Fath'r and I went down to camp, A - long with Cap - tain Good - in', And there we saw the men and boys, As thick as has - ty pud - din'.

Chorus

Yan - kee Doo - dle keep it up, Yan - kee Doo - dle Dan - dy, Mind the mu - sic and the step, And with the girls be han - dy.

Traditional Early-American Tune

Another popular version:

Oh, Yankee Doodle went to town,
A riding on a pony
He stuck a feather in his hat ·
And called it macaroni.

Yankee Doodle, doodle doo,
Yankee Doodle Dandy,
All the lads and lassies are
As sweet as sugar candy.

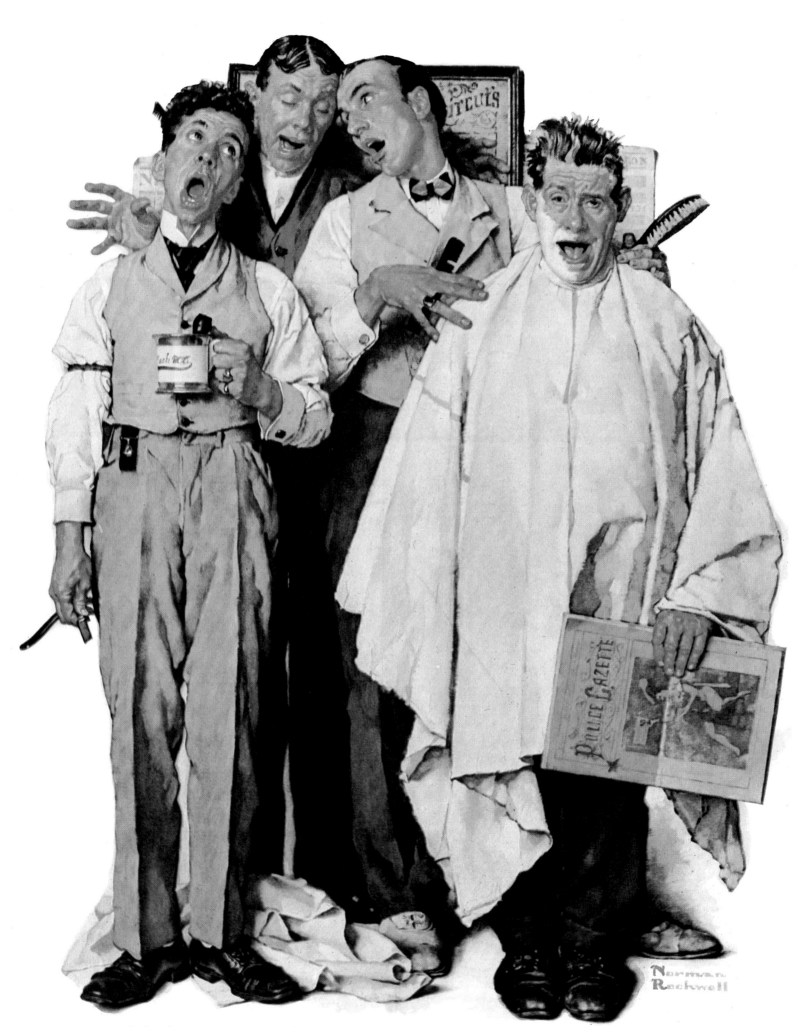

Barbershop singers are so carefully posed and painted that one can tell which sing high parts, which low. (1936)

120

Auld Lang Syne

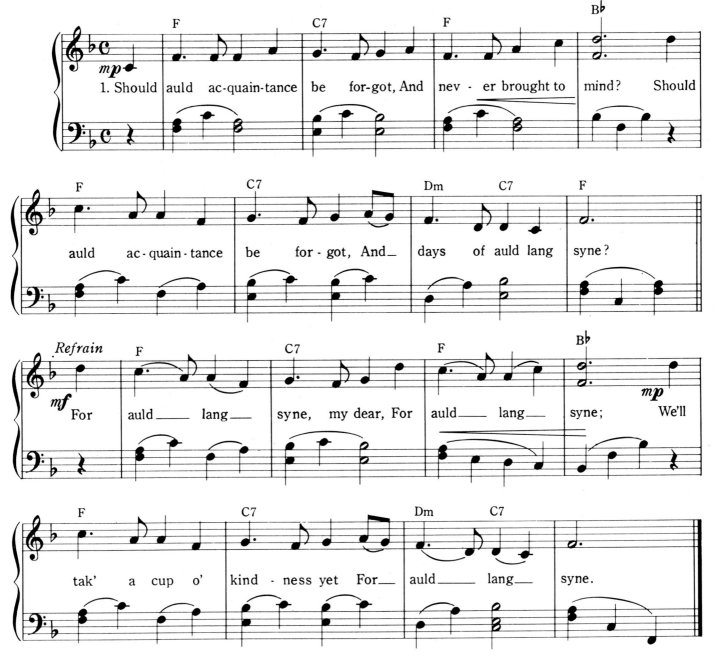

Words by Robert Burns

Old Scottish Air

2. And here's a hand, my trusty frien',
 And gie's a hand o' thine;
 We'll tak' a cup o' kindness yet,
 For auld lang syne.
 Refrain

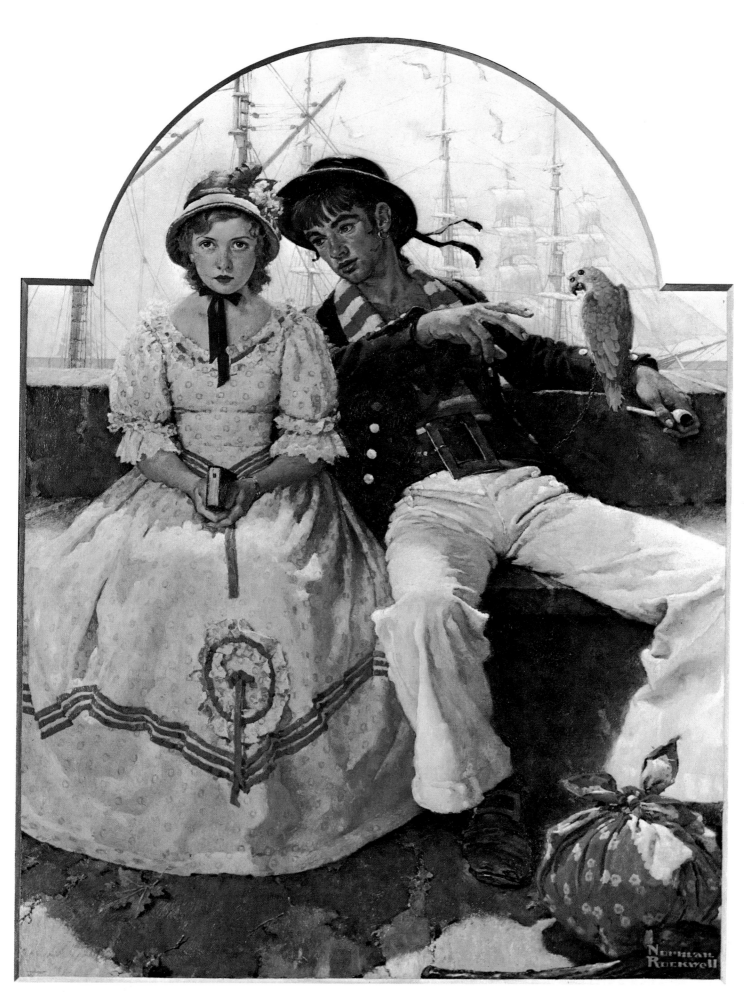

New England girls married sailors who brought molasses and spices home from the West Indies; hence Boston baked beans. (1930)

Cook a Down-East Dinner

NEW ENGLAND has produced more than its share of writers and most of them have, at one time or another, extolled the delights of old-fashioned New England food.

If it were only seafood that is praised so extravagantly this would be easy to understand. Boiled lobster, clams steamed on the beach, sea bass fresh caught from the cold waters off New England's stern and rockbound coast—these are the ingredients of gourmet dreams. But no, it is simple landsman's fare like hash, baked beans and succotash that the homesick Yankee longs to see on his table.

"My grandmother was a Maine sea captain's daughter with a profound knowledge of economy, common sense and good food; and it was in her home that I developed an unconquerable enthusiasm for Down-East cooking, to say nothing of a few pronounced beliefs along other lines," wrote *Post* editor Kenneth L. Roberts in 1938.

"To the end of my days the simple dishes that were the backbones of most of our meals will seem to me more delicious than all the 'specialties of the house' that can be produced by the world's most famous chefs.

"Others may insist on *souffles*, ragouts, *entremets*, *vol-au-vents*, but I prefer baked beans cooked the way my grandmother used to cook them."

Silas Spitzer, who wrote thousands of knowledgeable words about regional cooking for *Holiday* magazine in the '60s, gave credit to the ingredients New England cooks used. He described the cuisine of Vermont as "American food of the old school—plain, unpretentious and usually wonderful. Dishes were prepared daily from fresh, carefully selected materials, mostly grown or raised within the immediate area. Apart from these products, however, the essential ingredients were skill, patience and devotion—commodities not for sale in any market, past or present."

Evelyn Fiore, writing for the *Post* in 1976, stressed the fact that New England food is substantial and related this to the weather.

"New England winters cannot be taken lightly, even by those who are used to them," she stated. "They explain a lot about why plain food makes sense up here. It's all one needs, as long as there's enough of it. It's not that the other seasons don't do their bit. Spring and summer can be magical. But the lovely weeks are mere pleasant pauses between last year's huge snowdrifts and the ones to come. It's to the long, severe winter that living up here must be keyed.

"In such climates you don't amuse yourself with food. You stoke yourself. It has to be the kind that goes down and sits there a while, sending out warm messages of comfort, repletion and reassurance. Subtle, delicate inventions won't do this. But meat and fish protein will, especially when it's padded out with plenty of grains, starches, hot creamy soups and chowders, gravies rather than fragile sauces, and solid pies and puddings and cakes."

All who have written about New England specialties have called attention to the fact that they are economical dishes, made of low-cost ingredients (beans, corn, squash, molasses, salt pork, dried codfish). "The New Englanders were always a saving people," one author comments. "Their corner of the United States had few natural resources except a bracing climate and plenty of good harbors. They were forced to be economical, and often they managed to make a pleasure as well as a virtue of it."

Wrote Mr. Roberts: "It took me many years to realize that almost everything we ate at my grandmother's was inexpensive, and that the chief reason we ate the foods we did was because she had to economize. In my childish ignorance, I thought we had hash and baked beans and finnan haddie with baked potatoes because they were the most savory dishes obtainable."

Many New England dishes are the product of inven-

tive geniuses who "made do" with what they had. Succotash was invented (and named) by Indians who had only one pot and several different vegetables to cook, but it was eagerly adopted by some Yankee housewife who had a few beans and a little corn that would go further if combined. Boston brown bread, which is steamed rather than baked, was invented by some Pilgrim cook who needed bread but had no oven.

Boston Baked Beans

This is a recipe that takes long, slow cooking. Special electric cookers are on the market, but oven baking in a bean pot seems to give a special flavor.

3 cups pea or kidney beans
6 tablespoons brown sugar
½ cup molasses
2 teaspoons dry mustard
2 teaspoons salt
1 medium onion
6 ounces fat salt pork

Soak the beans overnight in a large bowl of cold water. Discard any imperfect ones. The following morning drain the beans, put them in a kettle, cover with cold water, and bring quickly to a boil. Drain the water from the beans, saving the liquid. Put the beans in a bean pot or in a deep casserole. Stir in the brown sugar, molasses, mustard and salt. Poke the onion down into the center. Divide the pork into 3 pieces. Stick 2 pieces down into the beans and place the third on top. Add enough liquid to cover the beans, adding more later if necessary. Bake covered all day, usually 7 to 8 hours, at 275 degrees. Check occasionally to be sure the beans are still moist, adding more liquid if necessary. Uncover the pot for the last hour of cooking. Remove the onion before serving the beans.

The recipes that follow are authentic New England ones from *The Saturday Evening Post All-American Cookbook* by Charlotte Turgeon, a native New Englander who learned Yankee cooking before attending Le Cordon Bleu and qualifying as a French chef.

"Plan ahead," she cautions. "New England-style preparations are not for the last-minute cook who dashes into the kitchen just before dinnertime."

Vermont Red Flannel Hash

4 beets (boiled or canned)
3 large cold boiled potatoes
1½ pounds lean ground chuck beef
8 tablespoons butter, margarine or bacon drippings
1 large onion, chopped
½ cup of cream or rich milk
6 to 8 eggs (optional)

Dice the beets and potatoes and mix well with the meat. Heat 4 tablespoons of the fat in a large heavy skillet. Fry the onion over low heat until soft and yellow. Add the meat mixture and stir well to incorporate the onion. Flatten the hash down smooth with the back of a large spoon. Turn up the heat to medium. Pour the cream over the surface and dot with the remaining butter.

If you want a heavy crust do not stir the hash. Cook uncovered for 20 minutes and then cover for the remaining 20 minutes.

If hash isn't hash without eggs, make little nests in the surface of the hash with the back of the spoon. Break an egg into each hollow. Sprinkle each one with salt, pepper and a little paprika and cook for the final 15 to 20 minutes of covered cooking. Serve from the skillet.

Plymouth Succotash

Succotash means corn and lima beans to most people, but New Englanders had a different idea. It could be a pot stew that included meat, poultry and vegetables and served a lot of people. Except for soaking the beans overnight, the system was to count back 4 hours from dinner time and start the cooking. This will feed 16 people.

1 quart dried lima beans
6 cups hulled white corn*
6 to 8 pounds corned beef
1 pound streaky salt pork
4- to 6-pound roasting chicken
6 white turnips
10 medium to large potatoes

*Hulled corn which was boiled in lye and considered quite a delicacy is not available everywhere. Two No. 2 cans or their equivalent of white kernel corn make an acceptable substitute.

Soak the lima beans overnight. Change the water and cover with fresh water. Cook uncovered until soft and mash enough of the beans to absorb the water. Set aside.

Four hours before dinner, wash the beef and salt pork in water to remove excess brine and salt. Put in a large kettle of cold water and bring to a boil, removing the scum that floats to the surface. Two hours before serving put the corn and 4 cups of the meat liquor into the bean kettle. Put in a little piece of the salt pork. The beans and corn should be covered with liquid. Simmer slowly. Don't let them get too dry. Add more broth if necessary. About 1¼ hours before serving, put the chicken trussed as though for roasting in the meat kettle.

Forty-five minutes before serving add the turnips, pared and cut in thick slices, and the potatoes, peeled and quartered.

This is presented ritually with the beef and salt pork on one platter, the chicken on another, the turnips in one vegetable dish, the potatoes in another and the corn and beans, which should be mashed to the consistency of a very thick soup, in a tureen.

New England Boiled Dinner

4- to 5-pound piece of corned beef
4 large carrots, scraped
1 large rutabaga, pared
3 white turnips, pared
12 small onions, peeled
6 medium potatoes, peeled
2 small parsnips, pared

Wash the beef under cool water to remove the brine. Place in a kettle with water to cover and bring slowly to a boil, removing any scum that rises to the surface. Cover the kettle and let simmer 2½ hours, then add the carrots and the rutabaga, cut in chunks. Fifteen minutes later add the turnips, onions, and potatoes, cut in half, and the parsnips, cut in similar-sized chunks. Boil until all the vegetables are tender. Theories differ about the presence of cabbage in New England Boiled Dinner. If you are on the affirmative side, quarter and core a small cabbage and cook it 12 to 15 minutes in a separate saucepan with some of the broth from the kettle.

Serve the meat on a platter surrounded by the vegetables. Horseradish and mustard pickles are traditional accompaniments to a boiled dinner.

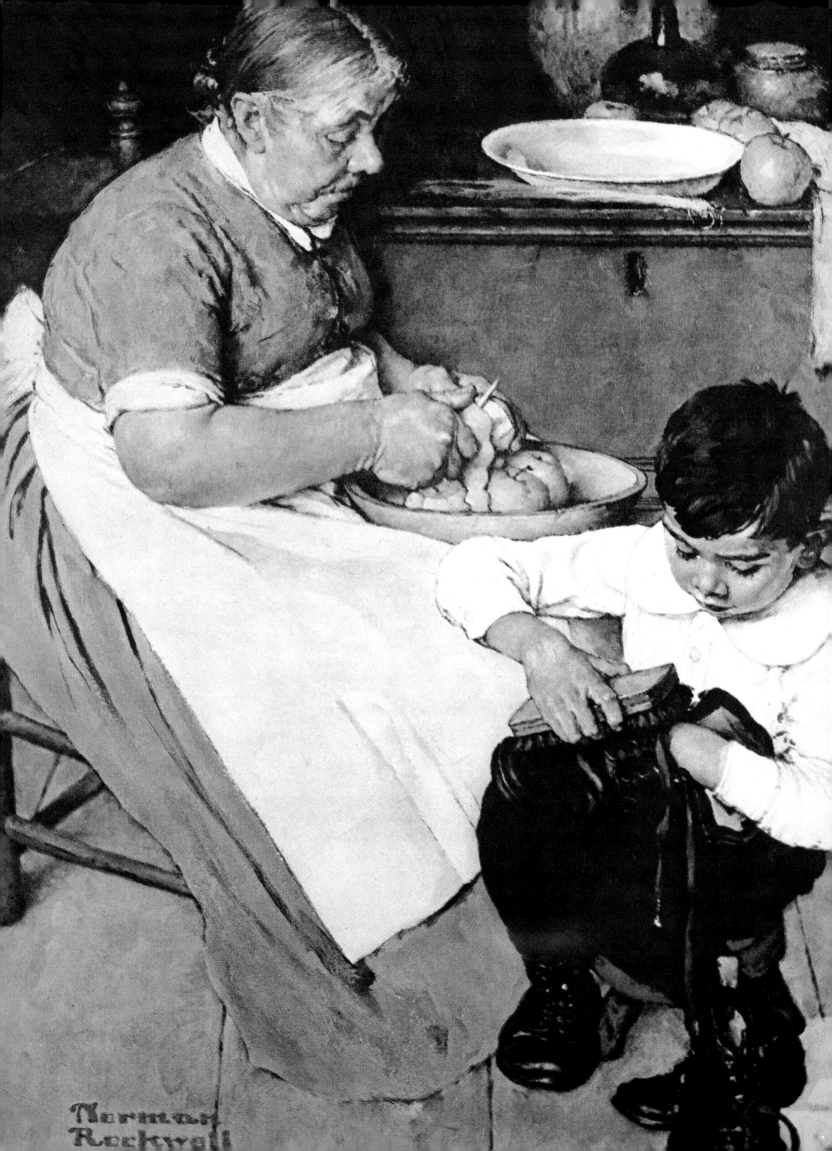

Post *Editor Kenneth Roberts remembered polishing shoes in his Maine grandmother's kitchen while delectable down east dishes were prepared.*

Pleasures and Pastimes

Vermont Corn Chowder

The corn grows high in Vermont too, and this, along with all the maple products, is one of their contributions to American cooking.

½ cup salt pork, diced
1 large onion, diced
1 quart boiling water
3 cups corn kernels, cooked fresh or canned
5 medium-size potatoes, pared and cubed
1½ teaspoons salt
1 quart milk
Black pepper
Soda crackers

Cook the diced salt pork over moderate heat, stirring occasionally, so that pork pieces become brown but not too dry. Remove them from the pan with a slotted spoon. Sauté the onion in the pork fat just until tender but not brown. Add the water, corn, potatoes and salt, and cook uncovered until the potatoes are almost soft. Add the milk and simmer very gently for 10 to 15 minutes to let the flavor ripen. Taste for seasoning, adding a good bit of freshly ground pepper. Sprinkle the surface with the salt pork and serve with a large supply of soda crackers.

Winter Succotash

2 cups dried lima beans
3 strips bacon
3 cups canned or frozen corn kernels
1 teaspoon sugar
2 cups stewed tomatoes
1 teaspoon salt
⅛ teaspoon pepper

Soak the lima beans several hours. Drain and rinse once more, discarding any imperfect beans. Cut the bacon into 2-inch pieces and place in a heavy pan with the beans and enough water to cover by 1 inch. Cover and cook 30 to 40 minutes or until tender. Add the corn, tomatoes and seasoning and stew gently uncovered for 20 to 30 minutes.

New England Cole Slaw

6 cups shredded cabbage
½ cup grated carrot
4 tablespoons grated onion
1 teaspoon caraway seeds (optional)

Boiled Creamy Dressing:
3 tablespoons flour
2 teaspoons dry mustard
1 teaspoon salt
1 tablespoon sugar
2 eggs, slightly beaten
6 tablespoons vinegar
¾ cup milk
3 tablespoons butter
4 tablespoons heavy sweet or commercial sour cream

Shred the cabbage into a large bowl. Fill the bowl with cold water and let stand in the refrigerator for at least 2 hours. Drain and dry well between towels. Place the cabbage in a salad bowl and mix well with carrot and onion and caraway seeds, if desired. Toss with Boiled Creamy Dressing shortly before serving.

Dressing: Combine all the ingredients for the sauce except for the cream in a heavy saucepan, using a sturdy whisk. Beat constantly and vigorously while cooking over medium heat until the mixture thickens. Remove from the heat, add the cream and allow to cool. This may be stored in a covered jar for several days.

Boston Boiled Tripe

2 pounds fresh tripe
1 cup white wine
Water
6 peppercorns
1 bay leaf
2 sprigs thyme
1 onion stuck with 3 cloves
1 cup melted butter
1½ cups fine cracker crumbs
1 tablespoon chopped parsley
1 tablespoon chopped chives
1 tin anchovy fillets
4 sprigs parsley

Wash the tripe carefully under cool running water. Place it in a wide pan. Add wine and enough water to cover by 1 inch. Add the peppercorns, the herbs, tied in a bouquet, and the onion. Cover and simmer 3 hours or until tender. Cool in the broth overnight or for several hours. Cut the tripe into appropriate serving pieces with a kitchen scissors. Pat the pieces dry with toweling.

Preheat the broiler and grill. Dip each piece of tripe into melted butter and coat well with the crumbs. Place on the hot grill and broil 3 inches from the heat until golden brown. Turn with a spatula and brown the pieces on the other side. Transfer to a hot platter and sprinkle each piece with the remaining butter, reheated, and a mixture of chopped parsley and chives. Crisscross with anchovy fillets. Serve with potatoes and sautéed eggplant.

Johnnycake

Johnnycake, which Rhode Island claims as its own, was originally called journey cakes because they were small cakes made of a coarse corn batter fried on a griddle and were hard enough to travel with a man on horseback for many a day without spoiling. They must have been difficult to digest and it's a far cry from the delicious baked version that we enjoy today.

2½ tablespoons melted butter, margarine or bacon fat
1 cup yellow cornmeal
1 cup all-purpose unbleached flour
1 tablespoon sugar
1 tablespoon baking powder
¾ teaspoon salt
2 eggs, beaten light
1 cup milk

Preheat the oven to 425 degrees F. Melt the fat and grease an 8-by-8-inch baking dish liberally. Save the rest of the fat.

Mix all the dry ingredients in a bowl. Combine the well-beaten eggs with the milk and add gradually to the dry ingredients, stirring *just* until blended. Add the remaining fat, give a quick stir and pour the batter into the prepared pan. Smooth the batter to the edges. Bake 20 minutes. Cut into squares and serve warm.

Steamed Boston Brown Bread

The inventor of this famous bread is unknown but not unsung. For generations in New England, Boston brown bread was as regular a part of Saturday night supper as church was of Sunday. It steamed all afternoon in a fireless cooker. Today most people buy the bread in cans and forget how good it is homemade. The bread is so tender that it used to be the custom to slice it by tying a string around the loaf and crossing the ends to give regular smooth-cut slices.

Post *Illustrator Mead Schaeffer, a neighbor of Rockwell's in Arlington, Vermont, posed as a seaport tattoo artist.*

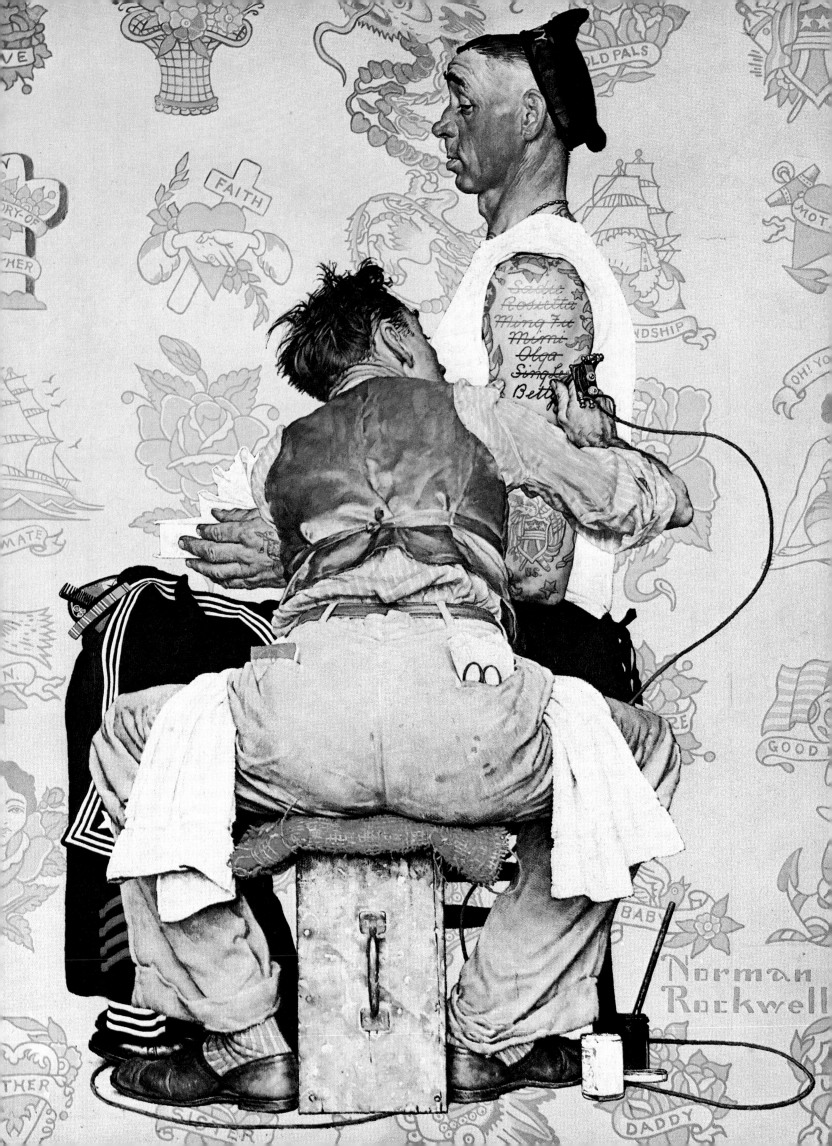

¾ cup seedless raisins
2 tablespoons all-purpose flour
1 cup rye flour
1 cup yellow cornmeal
1 cup graham flour
2 teaspoons baking soda
1 teaspoon salt
1 pint buttermilk
¾ cup molasses

Grease the insides of 2 (1-pound) coffee tins, including the top plastic lid. Cut out 2 circles of wax paper the size of the bottom of the can. Butter them lightly and place on the bottom of the insides. Put the raisins in a small bowl and stir with the white flour until coated. Set aside.

Mix all the dry ingredients in an electric mixer bowl. Stir the buttermilk and molasses until blended. Pour into the flour mixture gradually and beat slowly just until blended. Add the raisins and give one more stir. Divide the batter between the 2 cans. Cover and place on a rack in a kettle half full of warm water. Cover the kettle and bring to a slow boil. Steam 2½ hours, adding boiling water when necessary to keep the level up halfway on the cans. Remove the cans from the water and take off the tops. Put the cans in a roasting pan and allow the bread to dry out for 20 minutes in a 300-degree oven. Unmold onto 2 plates and serve one at each end of the table. Serve with butter and Boston baked beans.

Anadama Bread

Legend has it that this bread was invented by a New England farmer who, tired of his daily ration of corn-meal and molasses, grabbed the porridge bowl from his patient but uninventive housewife, added wheat flour and yeast and baked it on the hearth. Tasting his new discovery, he is supposed to have said, "There, Anna, dammit this is what I like." True or not, the modern version of his discovery makes a delicious bread.

6 tablespoons soft butter or margarine
1 cup cornmeal
6 to 7 cups all-purpose unbleached flour
1 tablespoon salt
2 packages dried yeast
½ cup molasses
2 cups very hot water

With 1 tablespoon of butter grease 2 medium-size (8½- by 4½-inch) bread pans and a large bowl for raising the bread.

Put the rest of the butter, the cornmeal, 2 cups of flour, salt and yeast in an electric mixer bowl. Mix the molasses and hot water until well blended. When lukewarm, add gradually to the ingredients in the bowl while beating vigorously with the electric beater. Gradually add more flour, still beating. When the dough gets too heavy for the beater, continue the process by hand until you have a soft, firm dough that no longer sticks to your hand. Turn onto a floured surface and knead with the palm of your hand, pushing the dough away and then reforming the ball, for 10 minutes. Place the ball of dough in the prepared bowl and turn it around to coat it with butter. Cover with a doubled clean dishcloth or with plastic and set in a warm place (80 to 85 degrees F). Let it rise until doubled (50 to 60 minutes). Punch down and cut in half. Cover and let rest 5 minutes. Shape into rectangular loaves and place seam side down in the pans. Cover again and put back in the same warm spot. Let rise again until doubled (40 to 45 minutes) and put into a preheated 425-degree oven. Reduce the heat to 375 degrees F. and bake 35 minutes. Remove immediately from the pan and place on a wire rack to cool.

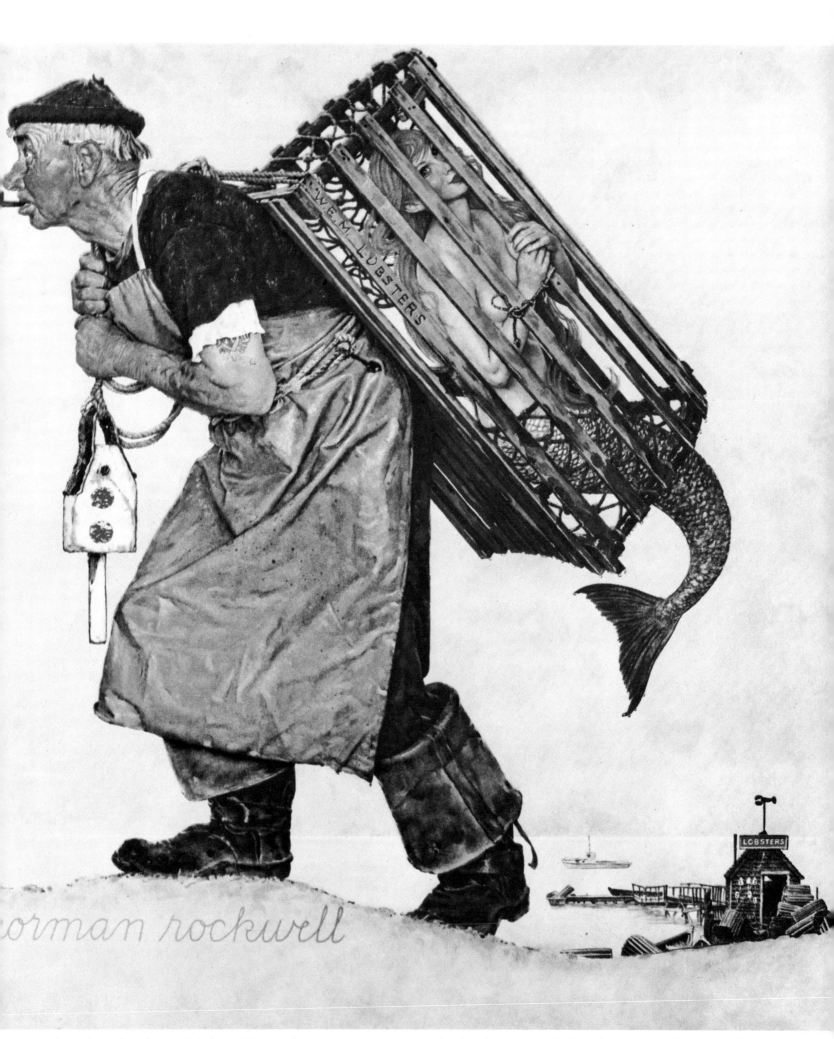

Some Post subscribers called this 1955 cover obscene. More wrote to say they loved it and to ask where they might land such a catch.

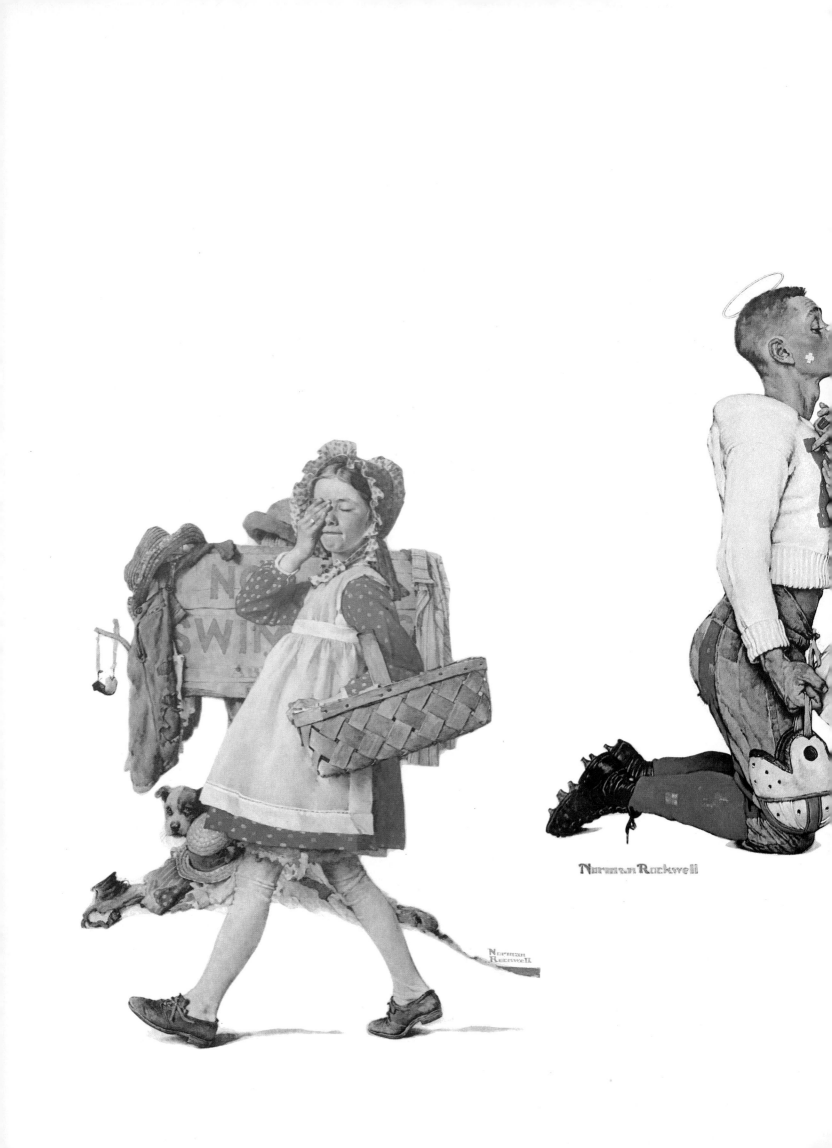

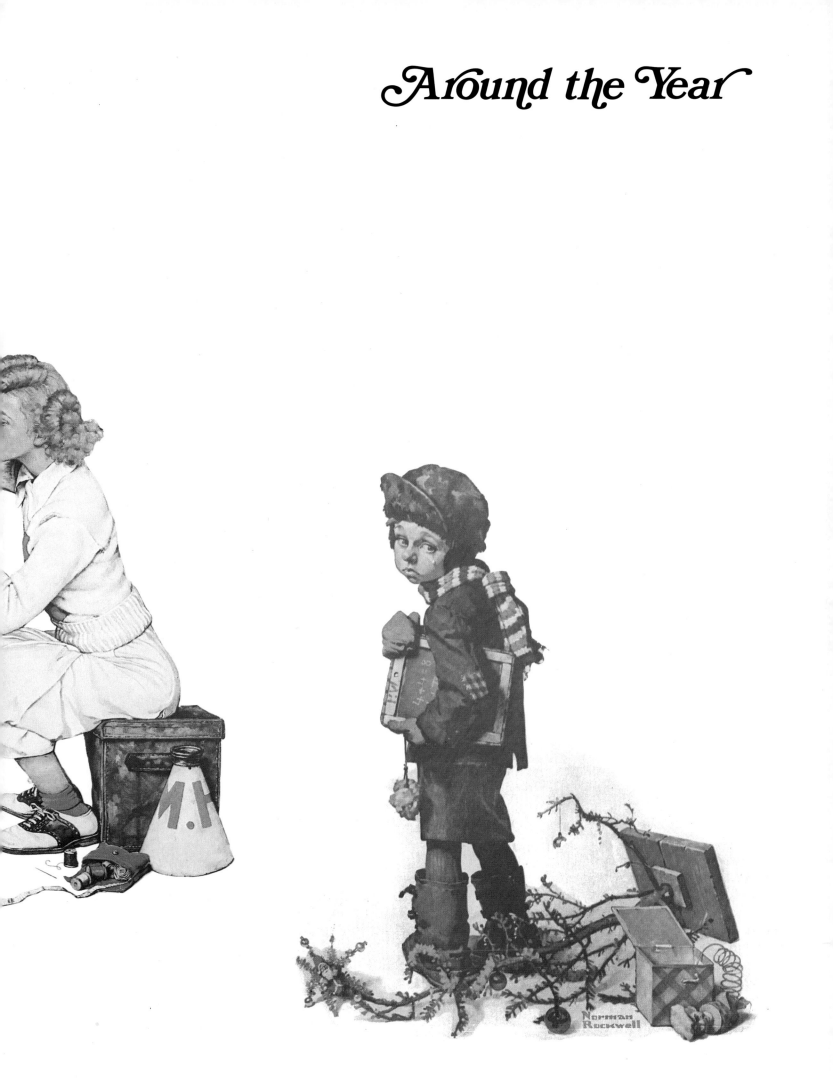

Norman Rockwell

Spring

MARCH WAS THE FIRST MONTH of the year by the ancient Roman calendar and its name honors Mars, the Roman god of war. April got its name from the Latin word that means "to open." May was probably named for Maia, the Roman goddess of spring, but it *may* (note pun) get its name from the Latin word for old men. There is reason to believe that May was a time for honoring older men, as June (from "junior") honored young men.

Special Days

March 3, Alexander Graham Bell born (1847)
March 14, Albert Einstein born (1879)
March 17, St. Patrick's Day
March 26, Robert Frost born (1874)
March 30, Alaska purchased (1867)
April Fools Day, a special time for playing tricks on friends, originated in France after Charles IX adopted a reformed calendar which moved the beginning of the year from April 1 to January 1. People who continued to observe the older date were ridiculed as "April fools."
April 5, Booker T. Washington born (1856)
April 10, Lee surrendered to Grant (1865)
April 10, Arbor Day (for planting trees) first celebrated in Nebraska (1872)
April 13, Thomas Jefferson born (1743)
April 14, Lincoln assassinated (1865)
April 18, Paul Revere made famous ride (1775)
April 23, William Shakespeare born (1564)
May 1, May Day, an important festival in old England. There were games and sports on the village green and, most important, the Maypole dance which involved the winding of colored ribbons around a tall pole. In America children made paper baskets and filled them with wild flowers, then hung them on friends' doorknobs, knocked, and ran to hide, as the gift was supposed to be anonymous.
May 8, Harry S Truman born (1884)
May 12, Florence Nightingale born (1820)
May 14, First permanent settlement in the New World founded at Jamestown, Virginia (1607)
May 21, Charles A. Lindbergh landed in Paris (1927)
May 29, John F. Kennedy born (1917)
May 30, Memorial Day, first celebrated in 1868 as a special day for decorating soldier's graves.

Other Events

Spring begins March 20 or 21, when the center of the sun is over the equator (the vernal equinox). Easter is celebrated on the first Sunday after the first full moon on or after the vernal equinox. . . . Mother's Day, established in 1907, is the second Sunday in May.

What They Said About Spring

Across the empty fields winter retreats,
Releasing his high mortgage on the weather—
Then wary Spring trips back on airy feet
And buds and grass and wind all laugh together.

Jesse Stuart

March: In like a lion; out like a lamb. . . . Beware the Ides of March (Shakespeare). . . . March brings breezes loud and shrill, stirs the dancing daffodil. April brings the primrose sweet, scatters daisies at our feet (old rhyme). . . . April showers bring May flowers. . . . He has a hard heart who does not love in May (Guillaume de Lorris). . . . The month of May was come, when every lusty heart beginneth to blossom, and to bring forth fruit; for like as herbs and trees bring forth fruit and flourish in May, in likewise every lusty heart that is in any manner a lover, springeth and flourisheth in lusty deeds. For it giveth unto all lovers courage, that lusty month of May. (Sir Thomas Malory in *Le Morte d'Arthur*)

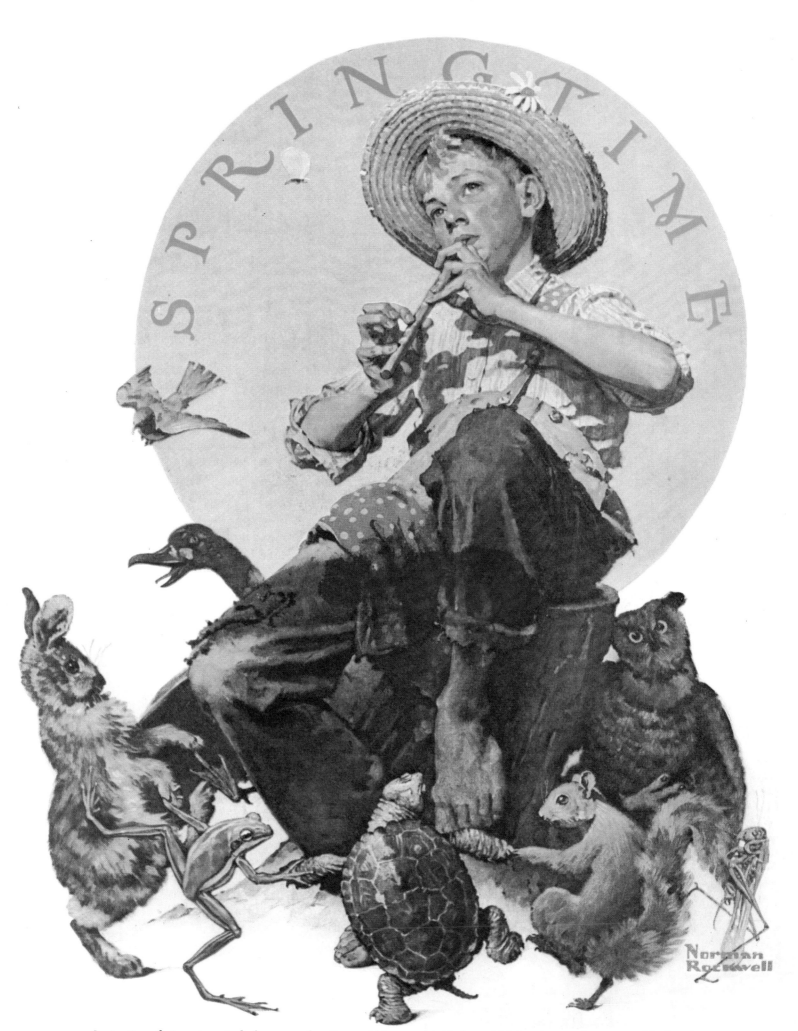

Springtime–that most magical of seasons when the world is young and in love with life, when anything is possible. (1927)

Things to Do

Begin spring housecleaning. . . . Plant a vegetable garden. . . . Hunt mushrooms. . . . Put away winter coats, scarves and mittens. . . . Fly a kite. . . . Cook spring greens: Gather fiddlehead ferns or dandelion greens when they are young and bright green. Wash well and remove any roots or tough stems. Add to boiling salted water and cook until just tender (5 minutes for the ferns, 6 to 8 minutes for the dandelion greens). Drain well and toss with butter, salt and pepper. Serve with or without a dash of cider vinegar. . . . Shop for an Easter bonnet. Color Easter eggs. Hide Easter eggs. Or hunt Easter eggs. Make a Paskha (see recipe) for the holiday dessert. . . . Mow the lawn. . . . Go fishing. . . . Get out catcher's mitt, golf clubs, tennis racket.

The Zodiac

Persons born between February 17 and March 20 are under the sign of Pisces, the fishes. They are loving but sometimes fickle, fruitful but easily led, honest, sensitive, responsive to beauty, generous, pure of mind and trustworthy. . . . Persons born between March 20 and April 19 are under the sign of Aries, the ram. They are movers and shakers, noted for energy and executive ability. They are thinkers and leaders but they may also be stubborn and too independent for their own good. . . . Persons born between April 19 and May 20 are under the sign of Taurus, the bull. They are brave, kind and gentle; also strong-minded, determined, shrewd and sometimes emotional.

Easter Paskha

Paskha is an attractive cheese dessert traditionally served on Easter Sunday in Russia: this version will fill a large mold and serve 10 to 14 persons. Plan to bake an angel food cake at the same time so as to use up the leftover egg whites.

2½ pounds pot (or cottage) cheese
9 egg yolks
1½ tablespoons vanilla extract
¾ cup sugar
½ cup heavy cream
1½ cups (¾ pound) sweet butter
½ cup blanched slivered almonds
½ pound candied fruit

Spoon the cheese into a large sieve or cheesecloth-lined colander and place a weighted plate on top. Let stand over a pan in the refrigerator overnight, to drain

Yesterday a dry brown bulb. Today a green shoot, and tomorrow a crocus full-blown. Who is so blasé he fails to marvel at this annual miracle? (1947)

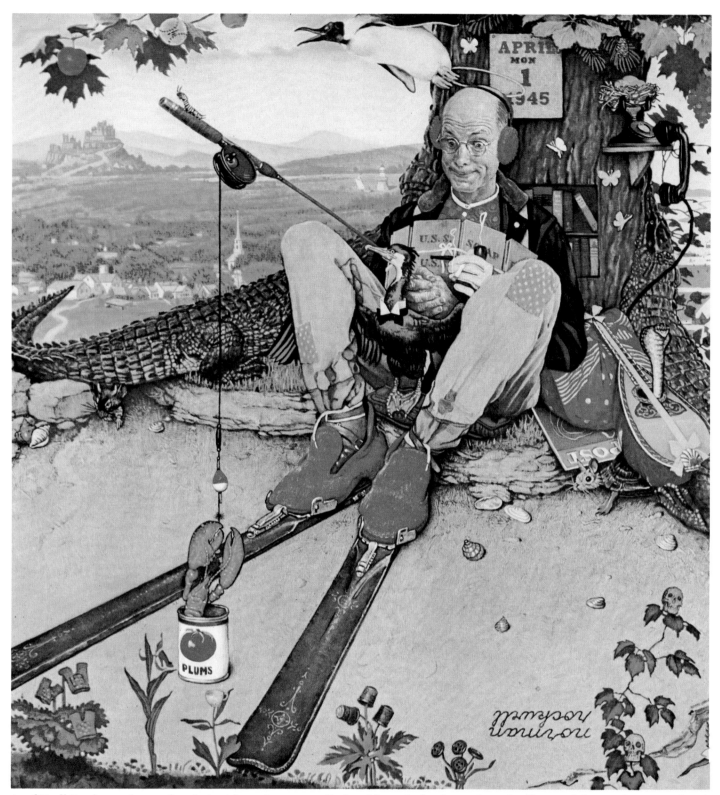

April Fool! For fun, and to confound nit-pickers who continually found "mistakes" in his work, Rockwell painted this puzzle-picture. (1945)

thoroughly. Then spin the cheese in a food processor or put it through a food mill to break up the lumps.

In a large bowl beat the egg yolks until frothy and lemon-colored. Add the vanilla, sugar and cream.

Soften the butter and add it a little at a time, beating well after each addition. Stir in the cheese, the almonds and half the candied fruit.

The traditional paskha mold is cylindrical, with holes for draining. For a substitute, use one or more large coffee or fruit juice cans with one end removed and a few holes punched in the other end. Line the mold with clean white muslin or doubled cheesecloth. Fill with the cheese mixture and refrigerate, over a pan to catch drips, 4 hours or longer.

At serving time unmold the paskha on a round serving platter and carefully remove the cloth. Surround it with the remaining candied fruit or with a wreath of fresh greenery and flowers.

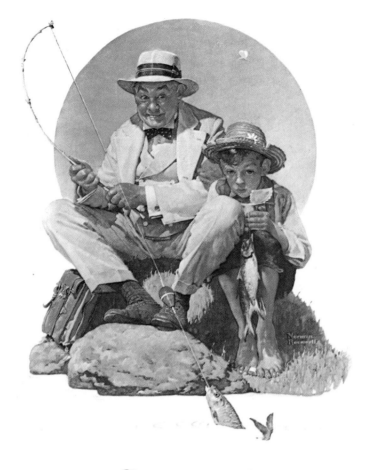

Summer

JUNE WAS NAMED to honor juniors, the younger men of Rome, as May honored the elders. July was named for Julius Caesar, who was born in that month. August was the sixth month, called Sextiles, until the Roman calendar was reformed by Emperor Augustus, who renamed this month for himself.

Special Days

June 1, John Masefield born (1878)
June 6, D-Day (1944)
June 8, Frank Lloyd Wright born (1869)
June 14, *Flag Day*, first officially proclaimed by President Harry S. Truman in 1949. On June 14, 1777, Congress adopted the Stars and Stripes.
June 15, Edvard Grieg born (1843)
June 26, Pearl Buck born (1892)
June 27, Helen Keller born (1880)
July 4, *Independence Day*, celebrating the anniversary of the signing of the Declaration of Independence in 1776. Thomas Jefferson and John Adams died July 4, 1826; James Monroe died July 4, 1831.
July 11, John Quincy Adams born (1767)
July 12, Henry David Thoreau born (1817)
July 20, Man first landed on the moon (1969)
August 6, Alfred Lord Tennyson born (1809)

August 10, Herbert Hoover born (1874)
August 15, Sir Walter Scott born (1771)
August 17, Davy Crockett born (1786)
August 25, Bret Harte born (1836)

Other Events

Summer begins June 20 or 21, the summer solstice when the sun is farthest north; the longest day of the year. . . . Father's Day is celebrated the third Sunday in June. Mrs. John Dodd of Spokane, Washington, had the idea for this while listening to a Mother's Day sermon in 1908. She wanted the date to be June 5, her own father's birthday.

What They Said About Summer

Today the summer has come at my window with its sighs and murmers; and the bees are plying their minstrelsy at the court of the flowering grove. (Rabindranath Tagore). . . . Summer treads on the heels of spring (Horace). . . . June Is Bustin' Out All Over (Oscar Hammerstein II). . . . Corn should be knee-high by the Fourth of July. . . . O Beautiful for spacious skies, for amber waves of grain; For purple mountains majesties above the fruited plain (Katherine Lee Bates, born

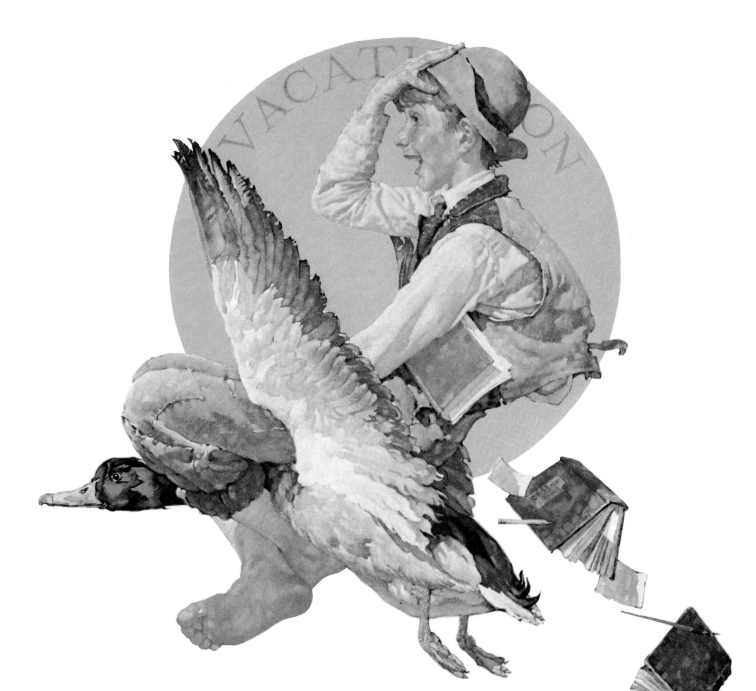

August 12, 1859). . . . June brings tulips, lilies, roses; fills the children's hands with posies. Hot July brings cooling showers, apricots and gillyflowers. August brings the sheaves of corn, then the harvest home is borne (old English rhyme).

What is so rare as a day in June?
Then, if ever, come perfect days;
Then Heaven tries the earth if it be in tune,
And over it softly her warm ear lays.

<div align="right">James Russell Lowell</div>

Summer is icumen in,
Lhude sing cuccu!
And springth the wue nu—
Sing cuccu!

<div align="right">Oldest recorded English folk song</div>

Things to Do

Go to graduations and weddings. . . . Eat strawberry shortcake. For the best shortcake, sift together 1¾ cups flour, 4 teaspoons baking powder, 1 teaspoon salt and 3 teaspoons sugar. Cut in 4 tablespoons cold butter or margarine and work with the mixture until the texture is like coarse meal. Stir in just enough milk to make a soft but workable dough. Roll out about 1 inch thick, cut into squares or circles and bake about 12 minutes at 425 degrees F. Serve warm, with generous helpings of sweetened strawberries and real whipped cream. . . . Hang a

hammock between two trees and take a nap. . . . Go swimming. . . . Make ice cream in an old-fashioned freezer that has to be cranked by hand (that makes it taste better, for some reason). . . . Fly the flag. . . . Avoid poison ivy. . . . Get to work on handmade Christmas gifts like Argyle socks (always allow at least half a year for Argyle socks). . . . Go to a beach and build a sandcastle. . . . Wade in a creek. . . . Go to a baseball game. . . . Pick berries and cherries and ride on ferries.

The Zodiac

Persons born between May 20 and June 21 are under the sign of Gemini, the twins. They are good with their hands, acquire skills easily; they are kind, creative and generous. Clear speakers, they become good teachers. . . . Persons born between June 21 and July 22 are under the sign of Cancer, the crab. They are restless and ambitious; most are fond of traveling. They are endowed with determination, intuition and purpose; they are realistic and perceptive. . . . Persons born between July 22 and August 23 are under the sign of Leo, the lion. They are courteous, gracious, conscientious, brave, sympathetic, enthusiastic and honorable. Most have qualities which make them good leaders, able to take responsibility and get things done.

Fourth-of-July Poached Salmon with Egg Sauce

This dish and this custom are attributed to Mrs. Abigail Adams, wife of the second President of the United States, John Adams, and the first hostess of the White House. A typical Massachusetts meal for that season of the year—since in early July the salmon were running, new potatoes were being dug and fresh peas were in the garden waiting to be picked—it seemed to her to be the right choice for the dinner served on Independence Day in 1776. Since then it has been the traditional meal served in many American homes every Fourth of July.

1 (5- to 7-pound) whole salmon or 5 to 6 pounds center cut
1 bay leaf
2 sprigs thyme or ¼ teaspoon powdered thyme
Celery leaves
Salt and pepper
4 tablespoons butter or margarine
4 tablespoons flour
2 cups cold milk
2 teaspoons lemon juice
4 hard-cooked eggs, sliced
Chopped parsley

A whole salmon makes a pretty presentation. Leave the head on or not, as you choose. The eyes should be removed after cooking if you leave the head on. Wash it and wrap the salmon in a large piece of cheesecloth with extending long ends to make it easy to remove the fish once it is cooked. Allow enough water to cover the salmon in a deep kettle. Measure 1 teaspoon of salt for every quart of water. Add the herbs tied in a small bouquet. Bring the water to a boil. Simmer 5 minutes.

Lower the fish into the water and simmer it for 40 to 50 minutes, allowing 8 minutes per pound.

Meanwhile make the sauce. Melt the butter or margarine in a heavy saucepan. Stir in the flour, and cook 2 minutes, stirring with a whisk. Add the milk half at a time, stirring vigorously after each addition. When sauce is thick and smooth add salt and pepper to taste, the lemon juice and the sliced eggs.

Remove the salmon and let it drain on toweling for a few moments. Turn on a heated platter, cover with the sauce and garnish with parsley. Serve with boiled new potatoes and green peas.

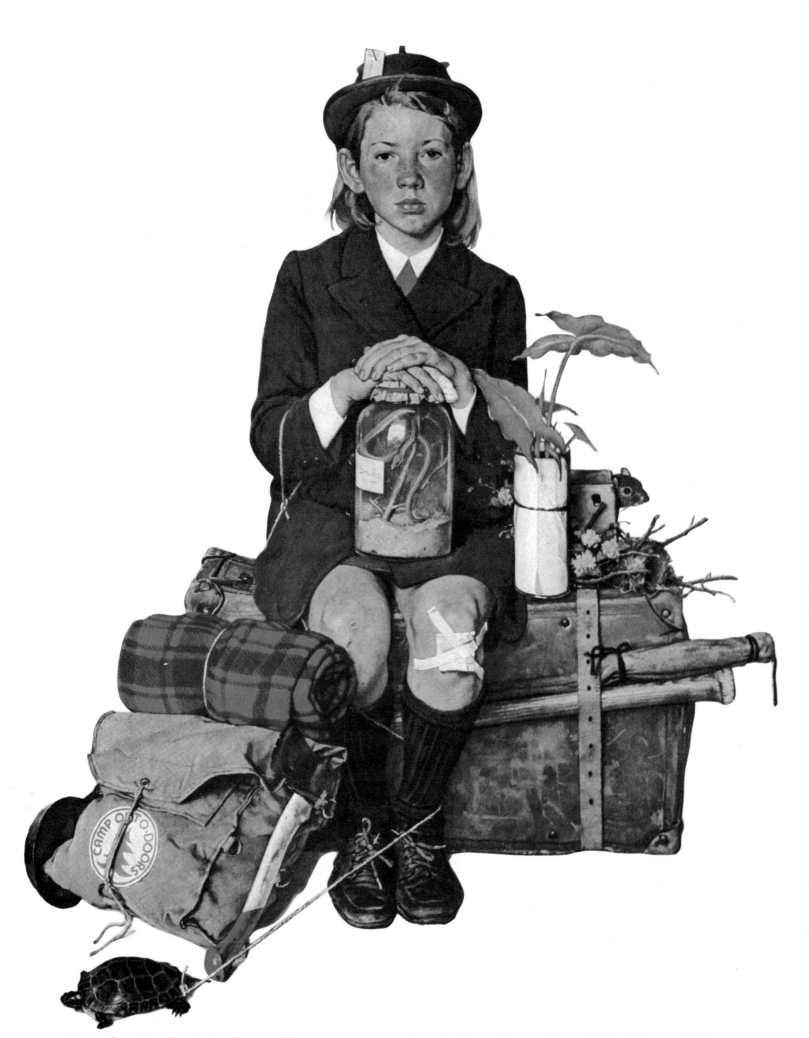

Summer's end. As a boy, Rockwell returned from summer vacations loaded with rural flora and fauna. "All died," he says. (1940)

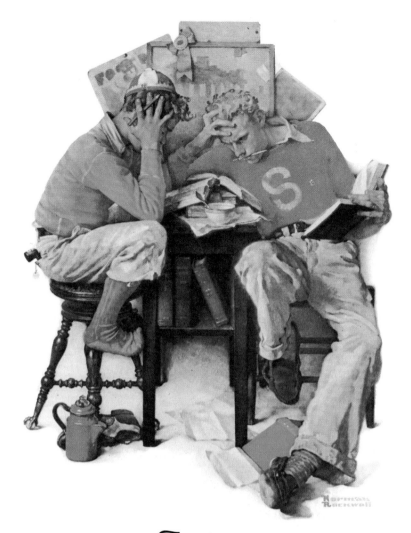

Autumn

ALTHOUGH THEY HAVE BEEN the ninth, tenth and eleventh months for nearly 2,000 years, September, October and November all retain the Latin names they acquired when they were the seventh, eighth and ninth months of the ancient calendar.

Special Days

September 2, V-J Day, 1945
September 11, O. Henry born (1862)
September 14, Star-Spangled Banner written (1814)
September 15, James Fenimore Cooper born (1789)
September 17, U.S. Constitution adopted (1787)
September 25, William Faulkner born (1897)
October 2, Mohandas Gandhi born (1869)
October 11, Eleanor Roosevelt born (1884)
October 12, Columbus Day
October 14, Dwight Eisenhower born (1890)
October 31, Halloween
November 1, Stephen Crane born (1871)
November 4, Will Rogers born (1879)

November 11, Veterans Day (anniversary of World War I Armistice, 1918)
November 19, Gettysburg Address delivered (1863)
November 22, John F. Kennedy assassinated (1963)
November 30, Mark Twain born (1835)

Other Events

Autumn begins September 20 or 21, when the center of the sun is over the equator (the autumnal equinox). . . . Election Day is the Tuesday after the first Monday in November. . . . Thanksgiving is the fourth Thursday in November.

The suns grow meek, and the meek suns grow brief,
And the year smiles as it draws near its death.

William Cullen Bryant

What They Said About Autumn

Sign a song of seasons! Something bright in all! Flowers in the summer, fires in the fall. (Robert Louis Stevenson, born November 13, 1850). . . . My little sisters, the

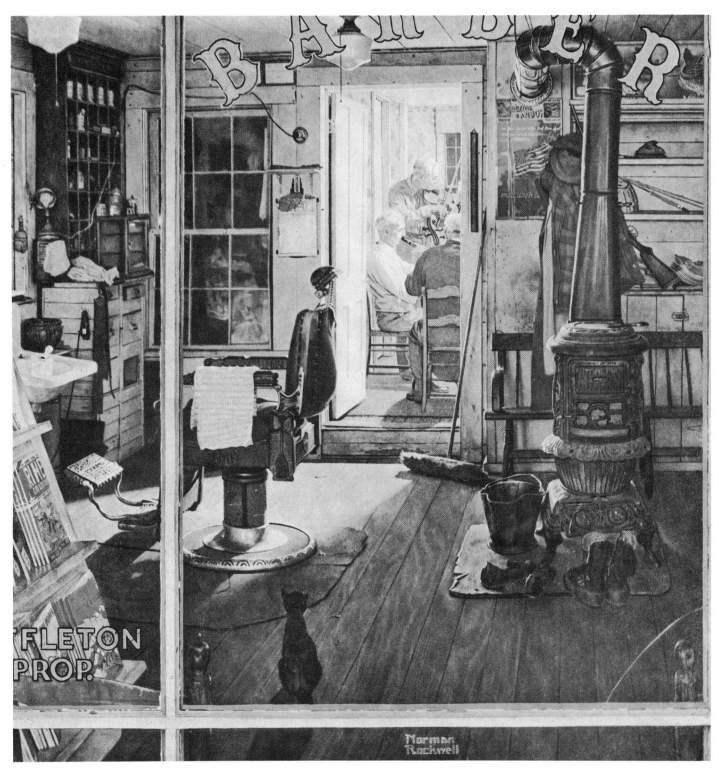

The evenings grow longer; we spend more time indoors. This is the time for good music, good books, in lamplit, fire-warmed rooms.

birds, much bounden are ye unto God, your Creator, and always in every place ought ye to praise Him, for that He hath given you liberty to fly about everywhere. (St. Francis of Assisi, born October 4, 1182). . . . November's sky is chill and drear, November's leaf is red and sear. (Sir Walter Scott). . . . Warm September brings the fruit, sportsmen then begin to shoot. Fresh October brings the pheasant, then to gather nuts is pleasant. Dull November brings the blast, Then the leaves are whirling fast. (old English rhyme)

Things to Do

Go back to school. . . . Go to a football game. . . . Rake leaves. . . . Clean up the garden debris. If there are green tomatoes that won't ripen, slice them, then dip the slices in seasoned flour and fry them in butter until tender but not mushy. . . . Make a jack-o-lantern. . . . Bake a pumpkin pie. . . . Make cookies for trick-or-treaters. . . . Put away bathing suits and get out caps, scarves and mittens. . . . Walk in the woods. Better

"Saying Grace"(1951) was suggested by a West Philadelphia lady who wrote to Rockwell about seeing an Amish family pray in a busy restaurant.

carry a basket or wear big pockets, as the woods are full of nice things to pick up and bring home. Like buckeyes which aren't good for anything *but* picking up and bringing home. . . . Pick dry weeds for winter bouquets. . . . Look for birds' nests after the leaves fall but before winter storms come to damage them. . . . To celebrate the first snowfall, build a fire in the fireplace, make a pot of tea, and sit down to write letters to old friends. . . . Get to work on homemade Christmas gifts less difficult than Argyle socks. . . .

The Zodiac

Persons born between August 23 and September 22 are under the sign of Virgo, the virgin. They tend to be well organized, careful and exact. They are active, proud of their own accomplishments and sometimes intolerant of others' stupidity. Intelligent, loyal and generous, they are often successful in business. . . . Persons born between September 22 and October 23 are under the sign of Libra, the scales. They are handsome, graceful, discriminating, peaceful, self-reliant. They tend to have good taste and a lively sense of humor but they may dislike hard work and they may be careless with money. . . . Persons born between October 23 and November 22 are under the sign of Scorpio, the scorpion. They are courageous, ambitious, well-spoken, calm, polite, and also practical and well balanced. They like to think well of themselves and appreciate compliments.

Tarte des Demoiselles Tatin

This very special upside-down apple pie is named for two impoverished French spinsters who, to earn a living, baked and sold what had been their father's favorite dessert. The distinctive feature is the caramelizing of the sugar in apple juice which forms a kind of frosting. This pie is a large one serving 8 persons; for a small family halve the recipe.

5 pounds apples (Golden Delicious)
1 cup sugar
¾ cup butter

Pastry dough:
2 cups flour
½ cup butter
1 egg yolk
2 tablespoons confectioners' sugar
½ teaspoon salt
2 tablespoons cold water
1 tablespoon lemon juice

Make the pastry: Sift the flour onto a marble slab or pastry board and make a large well in the center. Add the butter, egg yolk, sugar, salt, lemon juice and cold water, working these ingredients in the well with the fingertips until mixed. Gradually draw in the flour, working until the mixture forms coarse crumbs. Add more water as needed, to make a soft dough. Chill 30 minutes. Roll into a circle and chill 15 minutes longer.

Spread the ¾ cup butter over the sides and bottom of a heavy pan or skillet 12 to 14 inches in diameter. Sprinkle with the 1 cup of sugar. Heat briefly on top of the stove, until the sugar browns.

Peel, halve and core the apples and arrange them in overlapping circles to fill the pan. Preheat the oven to 400 degrees F, place the pan on the bottom shelf and bake 20 minutes.

Remove from the oven and spread the pastry circle over the apples. Prick it to let steam escape. Bake 15 minutes longer or until the crust is golden brown.

Let the tarte cool to tepid in the pan, then turn out on a heatproof platter. If any apples stick to the pan scrape them loose and put them in place on the tarte. Serve warm with whipped cream.

Norman Rockwell

Winter

DECEMBER WAS ONCE THE TENTH MONTH and its name comes from the Latin word for ten. Appropriately, January honors Janus, the two-faced god of beginnings (one face looks backward, one forward). February gets its name from the Latin verb *februare*, meaning to purify, because the Roman festival of purification took place at this time.

Special Days

December 6, Joel Chandler Harris born (1848)
December 7, Pearl Harbor attacked (1941)
December 10, Emily Dickinson born (1830)
December 25, Christmas
December 28, Woodrow Wilson born (1856)
December 30, Rudyard Kipling born (1865)
January 1, New Year's Day. Paul Revere born (1735)
January 4, Louis Braille born (1809)
January 6, Epiphany or Twelfth Night, celebrating the showing of the Christ Child to the three kings and marking the end of the Christmas season. The time for burning greenery and Christmas trees in a bonfire ("the last great light of Christmas") and for serving Epiphany Cake. Use any good white cake recipe; the important thing is to hide in the batter a treasure (a coin, a tiny doll or crown) which will bring good luck to the person who finds it in his portion. In ancient France the cake contained one dry bean and the person who found it became "King of the Bean" and master of the revels.
January 7, Commercial transatlantic telephone service begun (1927)
January 14, Albert Schweitzer born (1875)
January 15, Martin Luther King, Jr. born (1929)
January 17, Benjamin Franklin born (1706)
January 19, Edgar Allan Poe born (1809)
January 24, Gold discovered in California (1848)
January 30, Franklin Delano Roosevelt born (1882)
February 2, Groundhog Day, when the woodchuck comes out of hibernation to test the weather. If he sees his shadow there will be six more weeks of winter. This superstition comes from Europe where the animal weather prophet was a bear or badger and the date was a religious holiday called Candlemas.

Norman
Rockwell

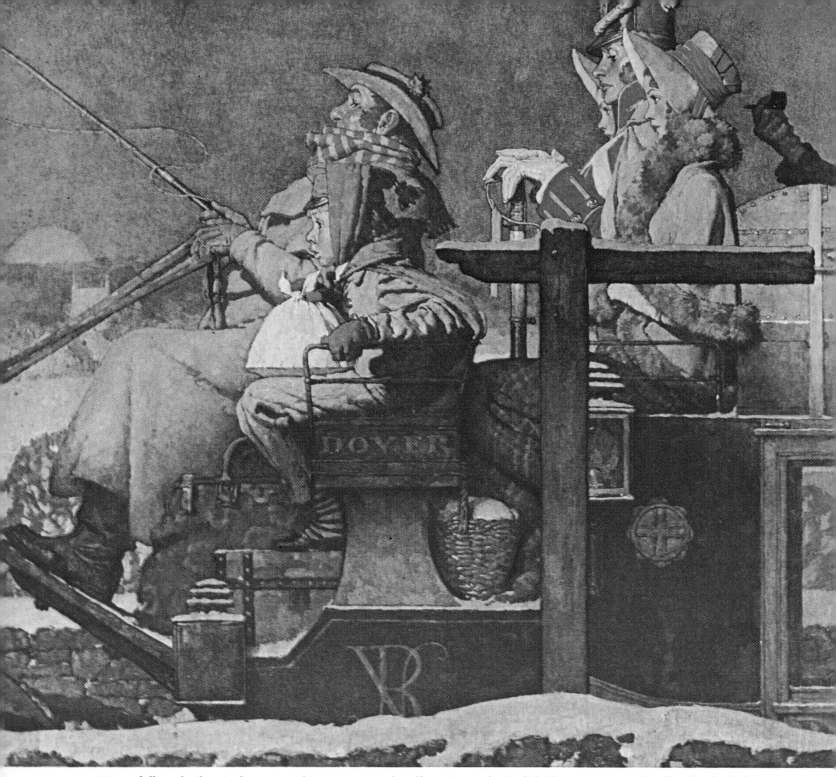

Snow, chill winds, the travelers wrapped in greatcoats and mufflers. Here is the English Christmas immortalized by Charles Dickens.

February 4, Charles A. Lindbergh born (1902)
February 11, Thomas A. Edison born (1847)
February 12, Abraham Lincoln born (1809)
February 14, *Valentine's Day*
February 22, George Washington born (1732)
February 29, Leap Day (every fourth year)

Other Events

Winter begins December 20 or 21, the winter solstice and the shortest day of the year. . . . Presidential Inauguration Day is January 20 of every fourth year.

What They Said About Winter

See, winter comes to rule the varied year, sullen and sad. (James Thomson). . . . Every mile is two in winter. (George Herbert). . . . The cold wind doth blow, and we shall have snow. . . . Christmas is coming, the goose is getting fat. Please to put a penny in the old man's hat. . . . At Christmas play and make good cheer, for Christmas comes but once a year. (old rhymes). . . . Ring out the old, ring in the new. (Alfred, Lord Tennyson). . . . This day Time winds the exhausted chain, to run the twelve-month's length again. (Robert Burns). . . . A sad tale's best for winter. I have one of sprites and

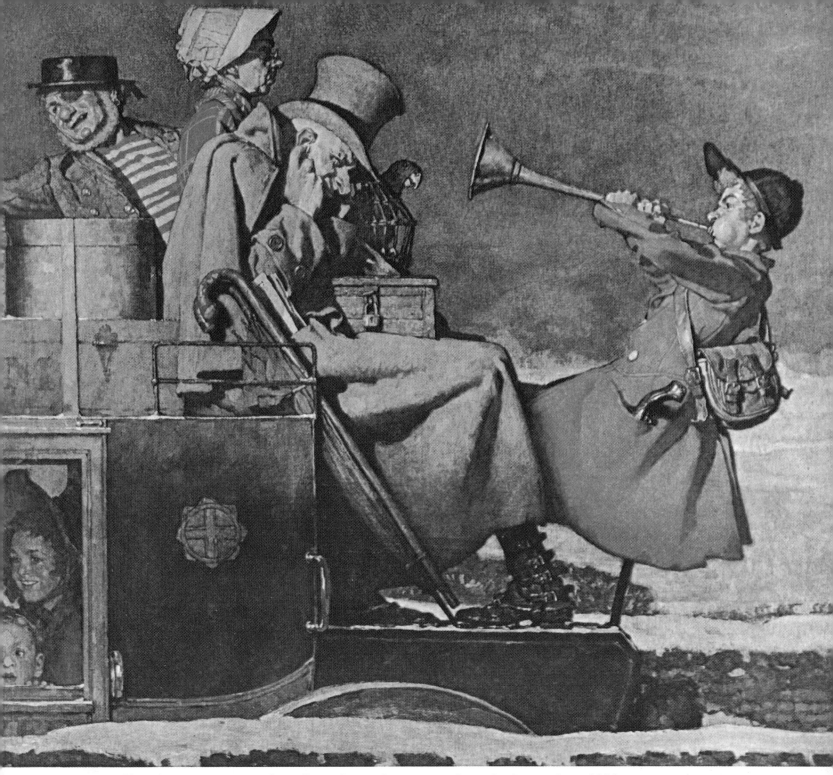

As a matter of fact, the picture was painted in Hollywood, in sweltering August heat. The shine on the models' faces is perspiration. (1935)

goblins. (Shakespeare). . . . The summer hath his joys, and winter his delights; Though love and all his pleasure are but toys, they shorten tedious nights. (Thomas Campion). . . . The trumpet of a prophecy! O wind, if winter comes, can spring be far behind? (Percy Bysshe Shelley)

The sun that brief December day
Rose cheerless over hills of gray,
And, darkly circled, gave at noon
A sadder light than waning moon.

John Greenleaf Whittier

Time has no divisions to mark its passage, there is never a thunderstorm or blare of trumpets to announce the beginning of a new month or year. Even when a new century begins it is only we mortals who ring bells and fire off pistols.

Thomas Mann

Things to Do

Feed the birds. . . Make a snowman. . . . Address Christmas cards to distant friends; make cookies and candies and fruitcakes to carry to nearby friends. . . . Hang wreaths, sing carols and trim trees. . . . Make New Year's Resolutions. . . . On New Year's Day eat

something for good luck. Easterners believe in cabbage. Southerners believe in black-eyed peas cooked with hog jowl and served with turnip greens and corn bread. People who don't like cabbage *or* black-eyed peas recommend oyster stew as just as likely to bring good luck in the new year. . . . January brings long evenings when it is snowing and blowing outside. Play Monopoly. Pop popcorn. Reread a long book (*War and Peace? Gone With the Wind? David Copperfield?*). Make a cherry pie for Washington's Birthday. . . . Plan a vacation trip. . . . Go skiing; go skating; go ice-fishing. Or, go South!

The Zodiac

Persons born between November 22 and December 21 are under the sign of Sagittarius, the archer. They are impulsive, quick, self-confident, honorable. The men are fond of active sports; the women are good housekeepers and fond of children. . . . Persons with birthdays between December 21 and January 19 are under the sign of Capricorn, the goat. They are economical, careful, secretive, sympathetic, considerate, self-controlled and resourceful. Hard workers, they usually succeed in business. They are often musically inclined. . . . Persons born between January 19 and February 17 are under the sign of Aquarius, the water carrier. They tend to be restless and perhaps a bit lazy; they are also eager to please and agreeable. They are usually calm and good-natured; their greatest fault is putting things off.

Crown Roast of Pork with Chestnut Stuffing

Song and story celebrate the boar's head and the whole suckling pig with a bright red apple in his mouth for Christmas dinner. We suggest a crown roast from the same animal as easier to purchase and easier to prepare in the modern kitchen. It is equally savory and just as attractive to look at when topped with paper frills and surrounded by a wreath of greenery (watercress or parsley) and red cranberries. It will serve 6 to 8 persons generously.

14-16 pound crown roast of pork
Salt and white pepper
½ pound chestnuts
1 medium onion, chopped
2 tablespoons butter
1 pound lean pork, finely ground
2 tablespoons chopped parsley
½ teaspoon sage
⅛ teaspoon thyme
1 teaspoon salt
¼ teaspoon black pepper
½ pound chestnuts

The crown roast is usually made by tying sections of two pork loins together. Ask the butcher to scrape the bone tips free of meat. Place the roast on a rack in an open roasting pan. Wrap the bone tips with pieces of aluminum foil, to prevent charring. Rub the roast outside and in with salt mixed with a little white pepper.

Prepare the stuffing: Place the chestnuts in a saucepan and cover with boiling water. Simmer 15 minutes, drain and allow to cool partially. Slip the shells and skins off the chestnuts and chop them coarsely.

Sauté the onion in butter 3 minutes, or until soft but not browned. Add the ground pork and cook for 5 minutes, stirring frequently. Stir in the parsley, sage, thyme, salt and pepper. Pour off any excess fat and stir in the chestnuts. Place the stuffing inside the crown roast.

Place the roast in a 300-degree oven, allowing 30 minutes per pound. When it is cooked, use a large spatula to transfer it from the rack to a round serving platter. Remove the pieces of foil and replace them with paper frills.

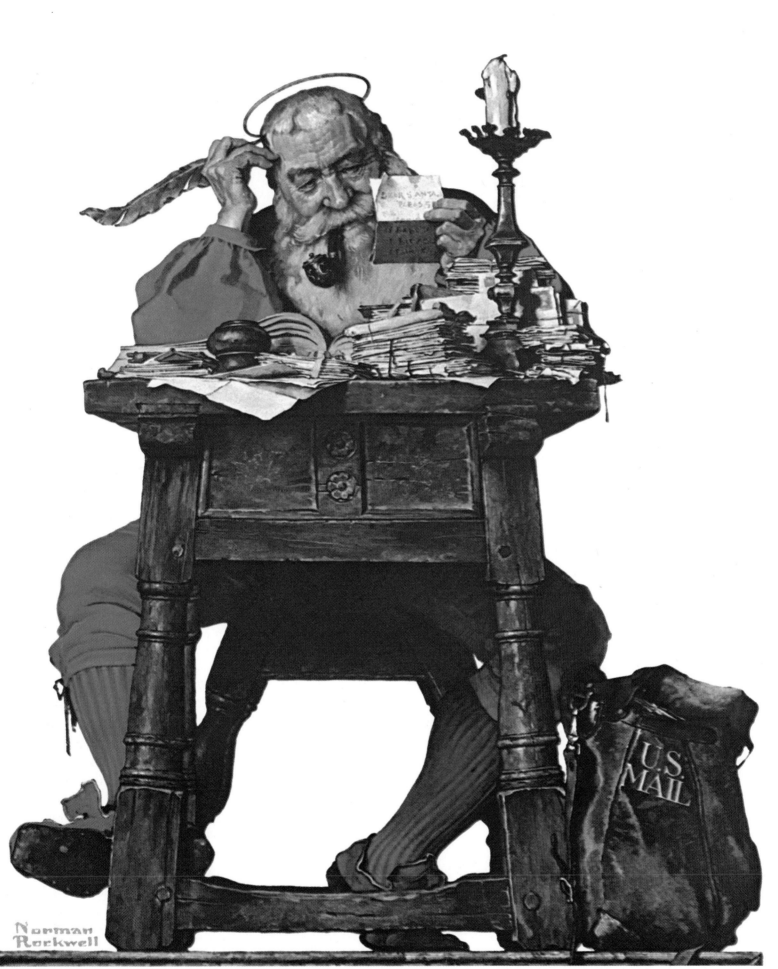

He is called Father Christmas, St. Nicholas, Santa Claus, but everyone knows how he looks. He looks exactly like this 1935 Post cover.

Acknowledgments

Text Credits

"Doc Mellhorn and the Pearly Gates" is from *The Selected Works of Stephen Benét* published by Holt, Rinehart & Winston. Copyright © 1938 by Stephen Vincent Benét. Copyright © renewed 1965 by Thomas C. Benét, Rachel Benét Lewis and Stephenie Benét Mahin. Reprinted by permission of Brandt & Brandt.

"Lassie Come-Home" by Eric Knight Copyright © 1938 by The Curtis Publishing Company. Copyright © renewed 1966 by Jere Knight, Betty Noyes Knight, Winifred Knight Mewborn and Jennie Knight Moore. Reprinted by permission.

"Dreams of Flying" is an excerpt from *The Spirit of St. Louis* by Charles A. Lindbergh. Copyright © 1953 by Charles Scribner's Sons. Reprinted by permission of Charles Scribner's Sons.

"Grandparents" is an excerpt from "Grandparents as Educators" by Margaret Mead. Copyright © 1974 by *Teachers College Record*, Teachers College, Columbia University. Reprinted by permission of Teachers College, Columbia University and Dr. Mead.

"Why I Travel" is an excerpt from "Why I Travel" by Eleanor Roosevelt Copyright © 1946 The Curtis Publishing Company. This material first appeared in *Holiday*. Reprinted by permission of Franklin D. Roosevelt, Jr.

"You Could Look It Up" Copyright © 1942 by James Thurber. From *My World and Welcome to It* published by Harcourt Brace Jovanovich. Copyright © renewed by Helen W. Thurber and Rosemary Thurber Sauers. Reprinted by permission.

"Summertime" is from *Farmer Boy* by Laura Ingalls Wilder. Text Copyright © 1933 by Laura Ingalls Wilder. Copyright © renewed 1961 by Roger L. MacBride. Reprinted by permission of Harper & Row, Publishers, Inc.

Other Credits

Musical selections "Red River Valley," "I Love You Truly," "Yankee Doodle" and "Auld Lang Syne" are from *Best Loved Songs of the American People* by Denes Agay. Copyright © 1975 by Denes Agay. Reprinted by permission of Doubleday & Company, Inc.

All recipes are by Charlotte Turgeon, Food Editor, *The Saturday Evening Post*.

Photos on page 61 Copyright © 1972 by *The Courier-Journal* and Copyright © 1974 *The Courier-Journal & Times*, Louisville, Kentucky. Reprinted by permission.

Photo on page 93, Brown Brothers.

Photos on page 101 are by Joanne Hill. Reprinted from *Kansas!* by permission of the Kansas Economic Development Commission.

Antique marbles on page 109 are from the collection of The Children's Museum, Indianapolis.

Illustrations not otherwise credited are from the pages of *The Saturday Evening Post* or *Country Gentleman* and are the copyrighted property of The Curtis Publishing Company or The Saturday Evening Post Company.